Quilt Your Own Adventure

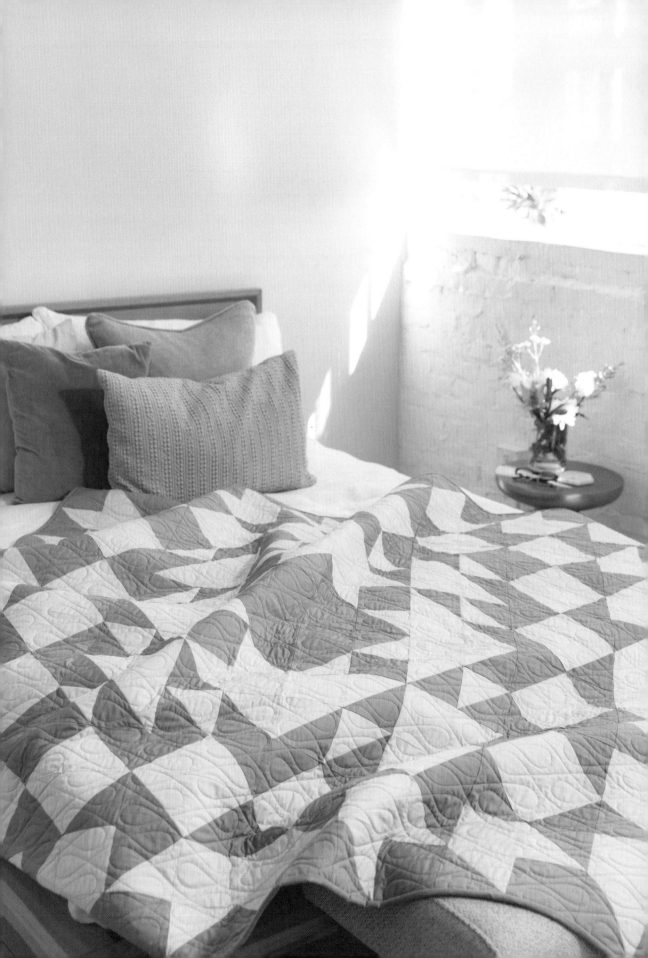

AMANDA CARYE

Quilt Your Own Adventure

Modern Quilt Blocks and Layouts to Help You
Design Your Own Quilts with Confidence

Paige Tate & Co.

Paige Tate & Co.

Copyright © 2023 by Amanda Carye

Published by Paige Tate & Co.

PO Box 8835, Bend, OR 97708

contact@bluestarpress.com | www.bluestarpress.com

Design by Megan Kesting

Photography by Hale Productions

Headshot Photo by The Crafter's Box

ISBN 9781950968756
Printed in Colombia

10 9 8 7 6 5 4 3 2 1

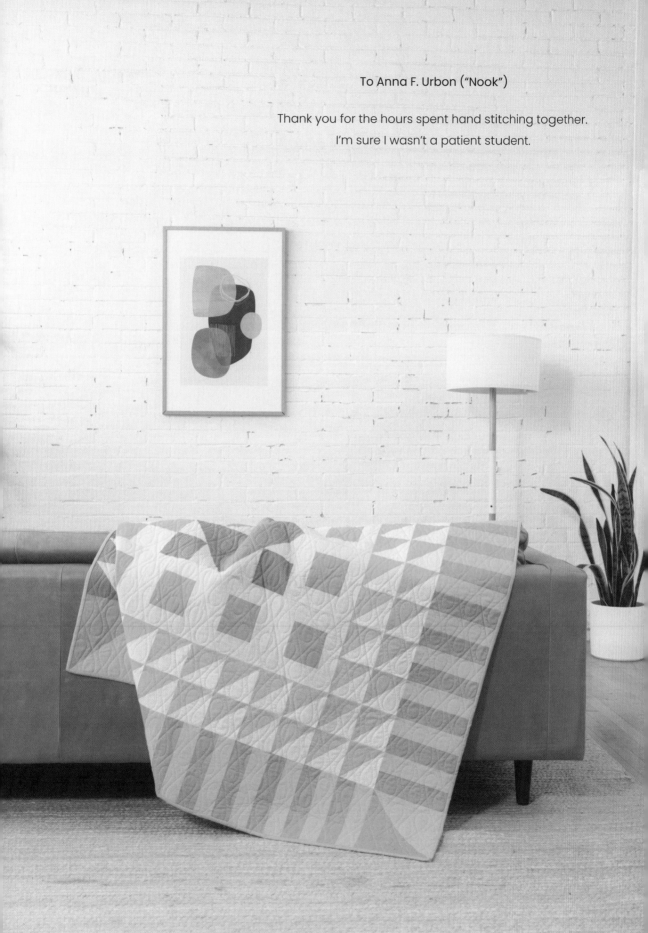

To Anna F. Urbon ("Nook")

Thank you for the hours spent hand stitching together.
I'm sure I wasn't a patient student.

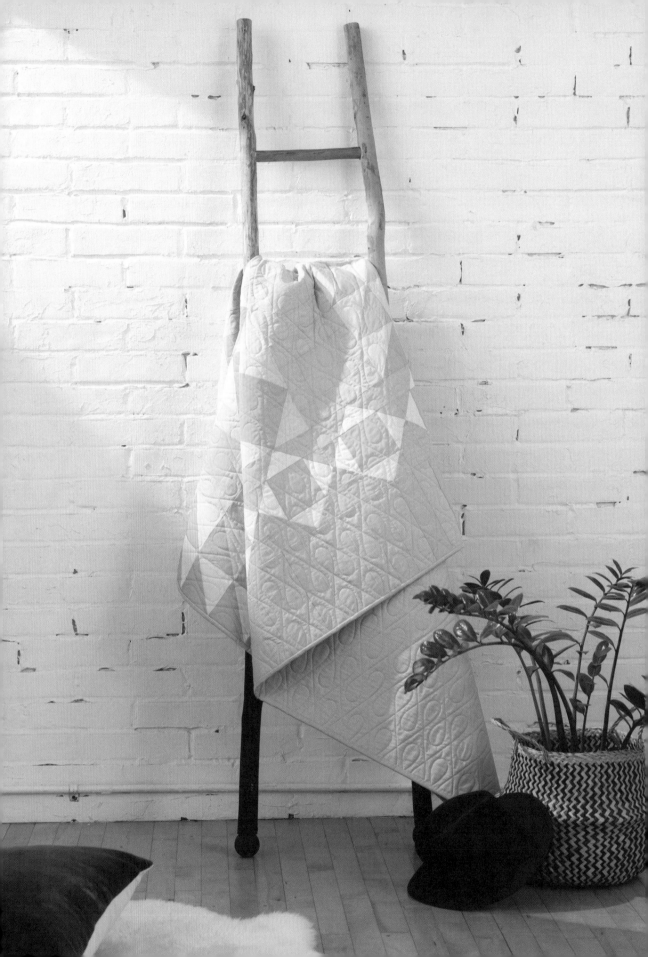

Table of Contents

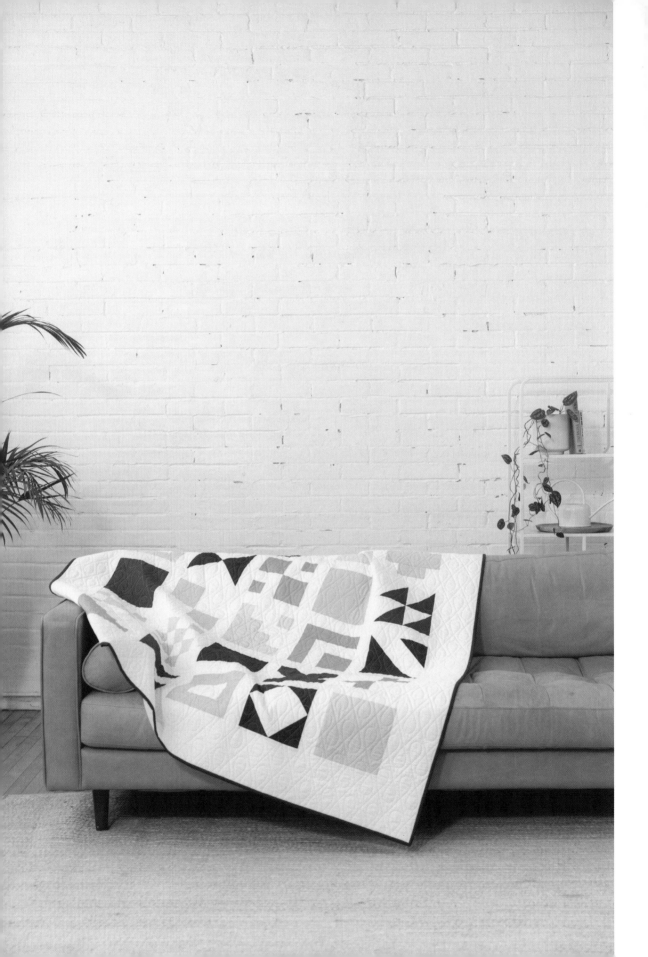

Introduction

If there's one thing that I've learned as the co-host of the *Quilt Buzz* podcast, it's that there isn't a "typical" quilting journey. There are themes and universalities and similarities, for sure, but each of us has our own stories, our own strengths, our own superpowers. We all employ our creativity with our own style and flair; sometimes it manifests through fabulous fabric choices, and other times through precision patchwork piecing, or even fearless mixing and matching of quilting styles . . . the list goes on.

My own quilting journey began in a way that may be familiar to many: I grew up in a family of needlewomen. My mom loves needlepoint (and was a fabulous garment sewer in her younger days), my maternal grandmother was a generalist who could fix pretty much anything that required needle and thread, and my paternal grandmother was drawn to knitting and needlepoint tapestry work. Continuing that tradition, my mom and maternal grandmother taught me how to sew from a young age. And when my aunt (also a sewist) signed my cousin up for a quilting course, it was a no-brainer for my mother to sign me up too.

I was one of those kids who was happiest making (anything) with my hands. And quilting was no exception. My first quilt was a very traditional sampler-style quilt, each block chosen to showcase a different technique. I started with an Ohio Star and picked eight other quilt blocks from a sampler quilt book.

I spent hours flipping through my sampler block book, daydreaming about which block to tackle next. There were so many different options to choose from! Did I want to work with acute triangles with the Storm at Sea? Did I want to tackle curves with a Drunkard's Path? Did I want to try applique and make a Dresden Fan? Did I want to fussy cut when making a house block? As I stitched, I would dream of all those future quilts to make, envisioning the color schemes, the quilting, that final feeling of triumph when finishing.

Since that first quilt, I found myself coming back to quilting when I was stressed. Adjusting to my first job? Made a quilt. Applying to grad schools? Made a quilt. Grappling with an unsuccessful first company? Made more quilts. Reentering the corporate machine? Quilts again.

It was during this last career move that I really started to revisit all those classic quilt blocks and my old daydreams. This time, though, I took the next step and started to design my own quilt tops. I'm not a designer by trade, so it's been a wild (and often circuitous) adventure teaching myself how to design quilts, as well as

figuring out how to construct them and write their accompanying instructions. And I don't know about you, but whenever I'm learning something new, I find myself relying on other skills I have at hand to help ease the way.

As I've explored new design ideas for my own patterns (often starting with a classic quilt block as a launching point), I've unexpectedly found my own corporate training kicking in when it comes time to come up with new ideas. So, while sometimes I feel like I'm making so much of it up as I go along, one skill that I can confidently share is how to efficiently and effectively ideate and brainstorm designs while dipping your toes into the wonderful world of patchwork design.

This book is my answer to helping you smooth your path to discovering your design voice and to breaking down those hurdles so you can dip your toes into designing your own quilts. This book is for those quilters who want to try designing their own one-of-a-kind designs, those who are looking to jump-start their creativity, and those who find block books a mix of exciting (all the possibilities!) and overwhelming (all the required math!).

The quilts that will be created from these pages aren't my designs. This isn't a "Broadcloth Studio Sampler Book." This is *your* design journey. You're the author of this adventure. Think of me and this book as the coach or the quirky sidekick that provides the motivation for your quest and helps keep the momentum going.

My hope is that you use this book as a way to help push the boundaries of your own creativity, whether you're feeling like you're in a rut or just looking for a new project to tackle. And, perhaps it goes without saying, but I'm so excited to see where this adventure takes you!

—Amanda

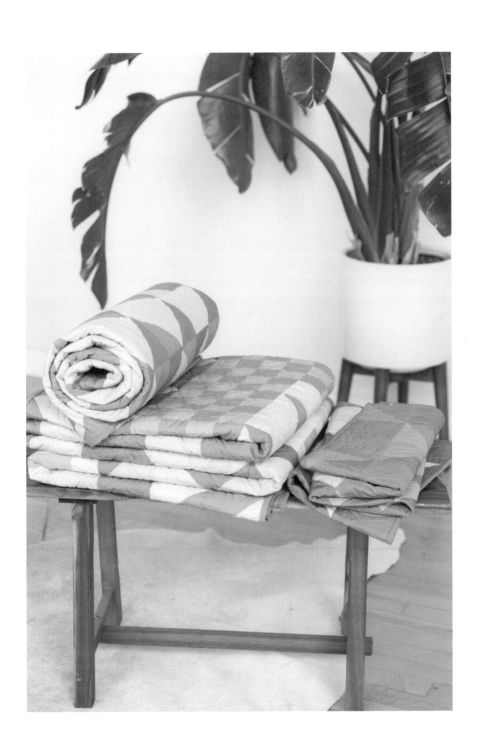

Why *Another* Block Book?

Well, this isn't really a block book.

If you're looking for a new quilt pattern to follow along, this probably isn't the quilt book for you. If you're looking for a sampler-style quilt book to guide you as you tackle new techniques, this probably isn't the quilt book for you either. If you're looking for lessons on how to make a quilt from start to finish, this definitely isn't the quilt book for you.

Sure, there is a suite of Sample Patterns included at the end of this book (there's even a sampler style pattern to boot!). And, yes, the blocks included in this book will allow you time to work on techniques. And, of course, my hope is that you'll make and finish a quilt when you pick up this book.

But, the real goal of this book is to support you as you design your own quilt top. From exercises for visualizing and experimenting with different layouts, to all the cutting instructions and fabric requirements you'll need, I hope this book includes everything you need to turn your design into a reality.

The blocks may not be as intricate as many traditional quilt blocks, but I like to think of them as elemental quilt blocks or building blocks. Whatever you want to call them, these thirty 8" blocks are meant to be played with. And in order to make that play fun and doable, I've provided some structure and created some starting points to help jump-start your creativity.

How to Use This Book

The short answer is: there is no wrong way, and no right way either! Whatever way sparks your creativity is the way to use this book.

When figuring out how to present this "choose your own quilty adventure" idea, I had to settle on a path (otherwise: anarchy). In my mind, I envisioned a journey through this book as the following:

1. Familiarize yourself with the thirty 8" blocks in the Block Index
2. Determine your quilt size
3. Choose a quilt top layout
4. Decide on the blocks you'll use
5. Figure out your fabrics
6. Calculate yardage requirements
7. Draft your cutting plan
8. Dive in and sew!

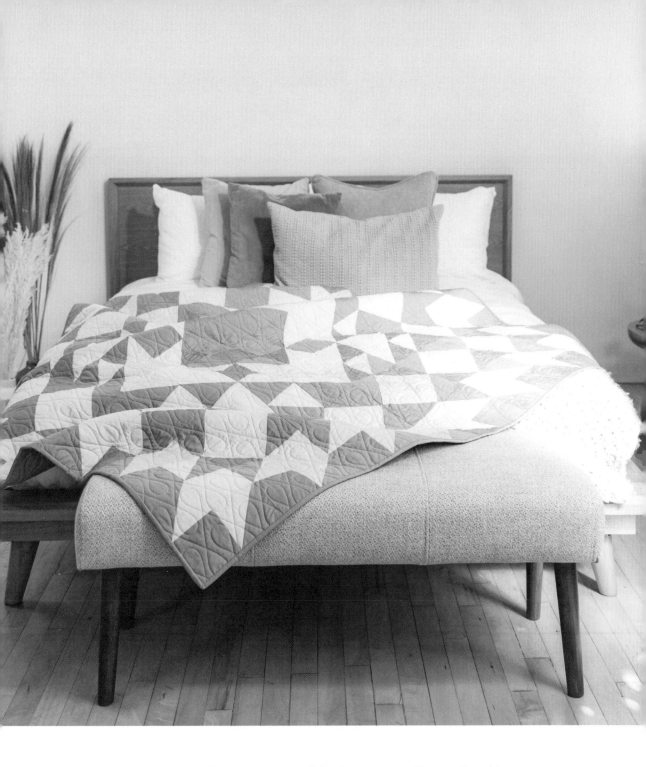

I'll go into more detail for each step in the following pages. But if you end up doing something different, straying from the path, or deciding to explore the sample patterns at the end of the book, that works too. You do you. You can also switch up the order. Try flipping through the Quilt Top Layouts section first, then settle on a size, then find your blocks. Or find your blocks, then your layout, then figure out which size. You get the idea!

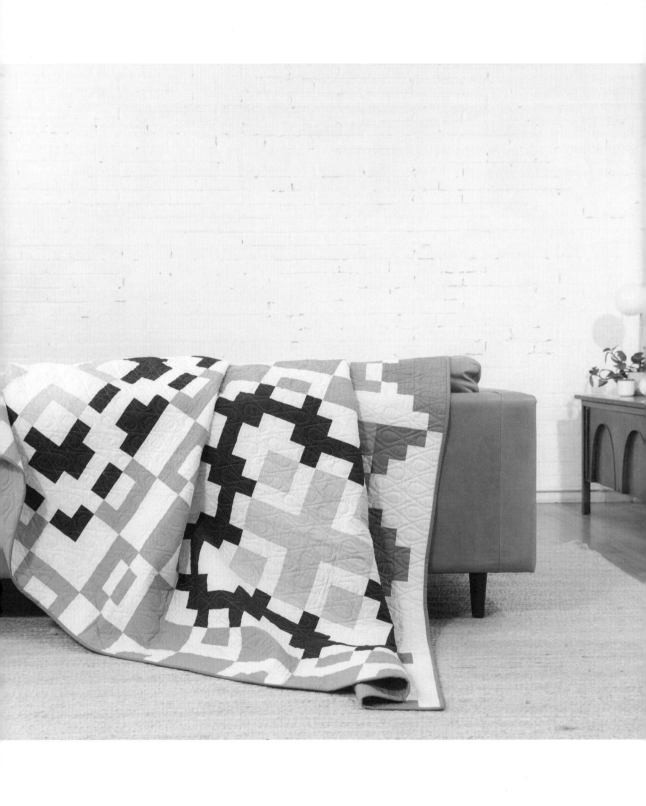

Getting into the Right Mindset

Now, before we go any further, I think it's worth taking the time to talk about mindset. Because, I don't know about you, but when I'm about to start on a new project I often feel a crushing sense of pressure that "it's time to be creative." And, spoiler alert, creativity isn't something that you can simply turn on.

There are a number of pesky myths about creativity that drive me bananas. And the one I find most annoying of all is the idea of the "eureka moment." Great ideas don't simply appear out of nowhere. Things take time, iteration, and experimentation. So, if you're anything like me and feel overwhelmed at the beginning of a new project when you're facing a blank "canvas," here are my go-to "rules of the road."

NOTE: Some of you might have heard me talk about these before or have run into similar ideas in your own lives and work. These are fairly standard best practices for brainstorming, and by far the most useful concepts from my past corporate life. If you need a physical reminder of these, I've created a printable you can access via the QR code in the Appendix for you to tape up in your workspace.

Rules of the Road

Follow the tips below for getting your mindset in the right place:

- **Don't be serious:** This is the time to be playful and silly (and definitely not the time to take yourself seriously). Channel your inner kid and let your imagination run rampant. Remember, nobody is going to see these but you.

- **Go for quantity:** The goal isn't to get one thing right; the goal is to get a lot of ideas out of your brain.

- **Hold your judgment:** This is a hard one. As soon as I create or draw something, my knee-jerk reaction is to judge it as good or bad. I'm constantly working on reframing and rephrasing my reactions. So instead of saying, "I hate that!" I'll try to look for what bugs me and say, "How fascinating is that!" instead.

- **Wait to fall in love:** If you fall in love with your first idea, you'll get stuck fixating on it. Make the effort to go beyond your first instinct, as you'll often be amazed where it'll take you. You can always return to it and fall back in love with it later!

- **Try something you (think) you hate:** Try using blocks you DON'T like or a layout that you find yourself flipping past. It's so, well, comfortable to stay playing in your comfort zone. Allow yourself to be the weirdest you can be. Because who cares?! It's worth repeating that nobody will see this but you!

Getting Started

Maybe you woke up today wanting to make a quilt. Or maybe you simply wanted to play with patterns and shapes. Or maybe you just wanted to stretch your creative muscles with some mental exercises, going through the paces of designing your own quilt top. Whatever your end goal was when you opened this book, here's how I'd suggest you dive in:

Step 1: Grab some sticky notes, scraps of paper, or even some fabric scraps to use as bookmarks/flags for things to revisit (or, if you like to dog-ear your book pages, who am I to judge?!). I also always like to have a pad of paper or some scrap paper handy to doodle on and make notes. If you're the same, grab a pen and paper now too or download the digital files via the QR code in the Appendix.

Step 2: Find a comfy place to flip through the book and settle in. Maybe it's your couch or the kitchen table or you're on the road and in the car—it doesn't really matter!

Step 3: Flip through all the blocks in the Block Index, one by one, and flag those that make you smile. Don't overthink this!

Step 4: Take a break. However you refresh your mind, now's the time to do so. When starting any creative endeavor, it's important to remember to take breaks so you don't burn out (and then lose interest in the project!). Sometimes this is ninety seconds to grab a cup of water, or maybe it's a couple days (or weeks). My personal barometer to tell whether I'm ready to go back to work is whether I actually *want* to get back to it.

NOTE: If you're in a creative slump, diving in might feel like a chore, so if I'm in a rut, I do the exact opposite of waiting till I'm recharged and force myself to work for short chunks of time. I'll set a timer for fifteen minutes and force myself to sit down and keep chipping away at it for those fifteen minutes. Even if I have nothing to show for it, the act of sitting down and not giving myself the wiggle room to wiggle out of doing it helps move things along and get me out of that slump!

Step 5: Once you're refreshed, it's time to settle on what quilt size you want to make. If you have a quilt size already in mind that's great. If you don't, it's time to give it a think. My default is always "throw size," but maybe you have a specific project or person in mind! If you're struggling to decide what size quilt you want, jump ahead to Step 6. Seeing the different quilt top layout ideas first might help.

Step 6: Turn to the Quilt Top Layout section (page 17) and look at all the different quilt top layouts. Pick a layout and size, then bookmark the page. Make a mental note (or one in your phone or on your paper pad) about how many different block designs the size and layout call require.

Step 7: Head back to the Block Index (page 27) and, starting with the ones you already flagged, whittle down to your final list of blocks. (This will be no more than seven total, though some of the smaller quilt sizes don't need all seven. To know what you need, simply refer back to your note from Step 6.) If you're having a hard time whittling down the options, listen to your quilty gut: which ones make you want to reach for your fabric and start sewing?

NOTE: If you're feeling overwhelmed by choosing your blocks or agonizing over, "what if it doesn't work," or, "what if this block would be better," take a moment. Take a deep breath. Then turn the page to try my favorite design exercise! Whenever I don't know where to begin, I always turn to this brainstorming tool. It provides a framework for experimenting and playing with different ideas while also adding some parameters to help reduce any stress from feeling like there are too many options to choose from. So go ahead, give it a try!

Step 8: Time for another break to let your brain relax after making all those decisions.

Step 9: Take a deep breath, because next you're going to do some visualization exercises!

Determining Your Layout

For me, figuring out the final layout of the blocks takes the most time, focus, and energy. I've been known to agonize over placement for ages and then decide at the end to just listen to my heart and do whatever feels right.

Step 1: Remind yourself what your final quilt size, quilt top layout, and blocks are.

Step 2: Decide which block will be Block A, B, C, D, E, F, and G within the layout. If you want to visualize and play with your layout and don't want to draw everything out by hand, head to the Appendix to find a QR code to download and print the Quilt Top Layouts and Block Cutouts so you can cut out and arrange and rearrange to your heart's content, or download the soft-copies of the files and use your computer design program of choice to finalize your layout.

Step 3: Once you've settled on your block order, head to your *Quilt Top Layout* (page 17) to figure out how many of each block you'll need and make a note of this in your *Fabric Planner Worksheet* (page 166).

Looking to take your quilt top to the next level? Here are three ways to play with the layout of your blocks:

1. **Add in corner blocks:** Instead of simply rotating your blocks to "turn" corners, try using a different block to create a corner that looks like the blocks intersect (check out the corners in my Log Cabin and Stripes case studies).
2. **Inverse blocks:** Play with inverting the colors every other block. I've included "inverted" cutouts for each block so you can easily play with how this changes the design.
3. **Alternate rotation:** Try flipping every other block or a block here and there to see what cool patterns emerge (check out my Bullseye and Offset case studies to see this in action).

To help jump-start your creativity, you can see examples of inverting and rotating your blocks, as well as how the corners will look without using a different corner block on the individual block pages, in the Block Index. And if you're not sure where to start, don't forget to turn the page and try my favorite go-to design brainstorming exercise!

My Go-To Design Exercise

When I don't have a clear idea of where I want to start or when I'm just looking to stretch my creative muscles, I immediately turn to this design brainstorming exercise. To dive in, you're going to want to grab a timer and have some of the blocks handy, whether you print and cut them out or open the digital versions in your program of choice (check out the Appendix for a QR code to all the printable hard copies and downloadable soft copies of the blocks and quilt top layouts).

1. If you're working analog, make sure you have enough blocks to play with—I'd suggest twenty-eight of each to start (we'll focus on playing with a square throw-size quilt). Don't want to cut all the blocks out? Start by cutting out enough for seven of your favorite block designs to begin.
2. Pick your favorite Quilt Top Layout and download its respective Quilt Top Layout Chart using the QR code in the Appendix.
3. Line up your cut-out blocks.
4. Set your timer for fifteen minutes.
5. Hit start!
6. Grab the leftmost block and call it "A," the next "B," etc. Fill in the Quilt Top Layout design with this order.
7. Take a picture of the layout on your phone.
8. Swap the blocks so what was once A is now the G block (and vice versa).
9. Take a picture of the new layout on your phone.
10. Keep swapping blocks, taking pictures of each new layout until the timer rings.
11. Take a break.

Once the timer-induced adrenaline wears off, take a look at the different snapshots. What do you love? What do you notice about them? Do some blocks play particularly well together? Are there secondary patterns emerging?

Give it a couple days. Revisit your snapshots. If none are making you smile, try the exercise again. Maybe try a different layout or challenge yourself to use blocks you aren't immediately drawn to.

Sometimes it takes a couple iterations of this exercise to find an idea that makes your heart sing. But I promise you, you'll know it when you feel yourself grinning (physically and/or internally) to yourself.

Planning Your Fabric

You've picked your blocks, you've picked your quilt layout, you know the quilt size you want to make. Now you need to figure out how much fabric you'll need. But first you need to decide how many fabrics you'll be playing with!

There are so many different ways and infinite possibilities for choosing fabrics for your quilt. Now, this book doesn't have the bandwidth to tackle color theory. But for those of you who would like to learn more, I've included a couple of my favorite color theory books in Quilting Resources & Further Reading (page 161).

If you'd like to focus on the pattern play of the patchwork, I suggest setting finessing your color palette aside for the time being. In order to do so, here are two of my favorite ways to make choosing my color palette easier:

1. **Background Anchor:** Pick a fabric to act as a "background fabric" and use it as Fabric 1 across all blocks, and then use a mix of different fabrics for Fabric 2.
2. **Two-Tone:** Pare things down and use just two colors! Blue-and-white quilts are one of my favorite Pinterest rabbit holes to go down; this approach is a great way to really highlight the shapes and patterns of the blocks.

Still feeling overwhelmed or unsure? Try creating your own coloring sheet to see how it'll look to help calm any lingering doubts. Graph paper and colored pencils are a great way to tackle this, or try downloading the digital files via the QR code in the Appendix to play with on your computer.

Once you've settled on your number of fabrics, it's just a hop, skip, and a jump through the individual block Fabric Requirements and Cutting Instructions in the Block Index's Math section to determine how much of each fabric you'll need. Each block is designed with a two-fabric color scheme. Once you know how many blocks you need to make for the Quilt Top Layout you're working with, you can find the yardage and cutting instructions for all the possible number of blocks needed on page 27.

To keep everything organized, you can find all the worksheets referenced in the following steps in the Appendix (page 165) to fill in and calculate your fabric yardage requirements (printable versions are also available via the QR code in the Appendix).

Step 1: Fill in the *Fabric Planner Worksheet* with how many of each block you'll be making.

Step 2: For each block, note which fabric you'll be using for Fabric 1 and Fabric 2 in the *Fabric Planner Worksheet* and fill in the inches required (you can find each block's requirements in the Block Index Math section on page 27).

Step 3: Using the *Yardage Planner Worksheet*, calculate how much of each fabric you'll need from the *Fabric Planner Worksheet*.

Step 4: In the *Yardage Planner Worksheet*, add up the number of inches you'll need of each fabric and divide by 36 to get the yardage needed. If you want a little extra, add an additional 4–10 inches before you divide by 36.

Step 5: Don't forget to include your backing and binding yardage as needed (you can find the Backing & Binding Requirements on page 169 in the Appendix)!

NOTE: If you are unsure of, or feeling overwhelmed by, how to figure out how much fabric you'll need or would like another example, head to the Case Studies section (page 131), where I've included my math for the different samples you see photographed in this book. And, of course, feel free to treat them like you would a typical quilt pattern with fabric requirements, cutting instructions (found in the Block Index Math section), and piecing instructions (found in The Designs section).

Constructing Your Quilt Top

You've got your fabrics. Maybe (like me) you've pre-washed and ironed them. Regardless, you're ready and raring to go! Here are some things to keep in mind as you start making your quilt blocks.

Cutting Instructions

Keep in mind that for each block, you can find width of fabric (WOF)–optimized cutting instructions within the Block Index's Math section. So make sure to refer back to those pages before you start to cut into your fabric!

Construction Order

There is no prescribed order of how to make your blocks. Depending on my mood, maybe I feel like making flying geese first. Or maybe I want to tackle some HSTs and all the necessary trimming. Or maybe I want to put the [foot] pedal to the metal and start strip piecing stripes!

The bottom line: make your blocks in whatever order makes you happy and keeps you making.

Staying Organized

I love to use my design wall to see the patterns emerge (and to act as a visible reminder of what I'm working on). If you don't have a design wall, you can use a little painter's tape to tape up your blocks, or tape a spare piece of batting to the wall as a makeshift design wall. At this stage, none of this is necessary: stacks of finished blocks work well too!

Quilt Top Layout

Once you've got all your blocks made, now comes the time for a little organization. Using your design wall, or any available flat surface (e.g., a dining table or the floor), lay out your blocks in their final arrangement. If you're thinking about playing with the rotation of some blocks or adding/trying some different corner units, now is the time to put those plans into action!

Quilt Top Assembly

Once you've settled on your final layout, the assembly is a breeze. Each quilt top layout is built on a straightforward 8" grid, so when it comes time to assemble your quilt top you can sew all the rows first and then sew them all together, or assemble your columns first and then sew them all together: whatever works best for you!

Quilt Top Layouts

On the following pages are the six quilt top layouts as well as instructions for making a sampler-style quilt. Each layout provides a unique arrangement of seven 8" blocks and includes a table that provides the information of how many of each block you'll need to make for each size. Think of it like a painting by numbers exercise (or a cross-stitch chart) where the "paint color" is a block and the "numbers" are the letters!

Once you've decided on a size and layout, use the *Fabric Planner Worksheet* to fill in the details before moving on to the next step of looking up yardage requirements (*Yardage Planner Worksheet*) and cutting instructions (*Cutting Planner Worksheet*).

Don't forget that these quantities might change if you decide to shake things up and customize your corners (or center or anywhere else).

> NOTE: Don't forget to check out the Appendix for a QR code to all the printable hard copies and downloadable soft copies of the blocks and quilt top layout charts!

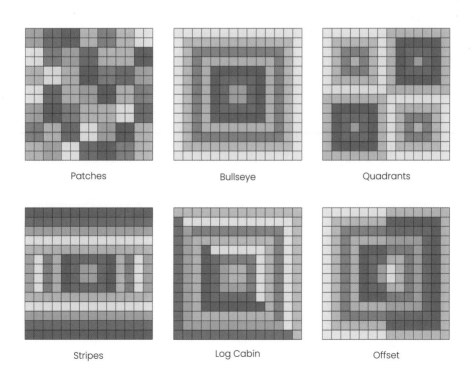

| Patches | Bullseye | Quadrants |
| Stripes | Log Cabin | Offset |

Patches

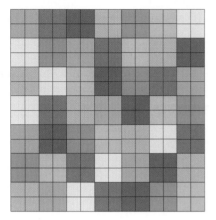

King size quilt shown in this example

The Patches layout provides multiple small canvases to explore how the blocks look with simple repetition to see how quickly they transform into something new! I especially enjoy seeing how many different star-like blocks I can create from these blocks. Don't feel obligated to have all the blocks point toward the center of each four-patch: with a simple rotation of one or two blocks, you can transform the four-patch into something totally new and different.

Baby	Square Crib	Throw	Square Throw	Twin	Full/Queen

BLOCK REQUIREMENTS

	(W)	(H)	A	B	C	D	E	F	G
BABY	32"	48"	4	4	4	4	4	4	–
SQ. CRIB	48"	48"	4	4	8	4	8	4	4
THROW	48"	64"	4	4	8	8	8	8	8
SQ. THROW	64"	64"	8	8	8	8	8	12	12
TWIN	80"	96"	16	16	20	16	16	16	20
FULL/QUEEN	96"	112"	24	24	24	24	24	24	24
KING	112"	112"	28	28	28	28	28	28	28

Bullseye

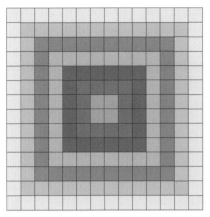

King size quilt shown in this example

The Bullseye layout is like a starburst and I love watching it grow as I add each new ring layer. This layout plays particularly well with the blocks that aren't symmetrical as they naturally point outward (or inward, depending on how you rotate them). While I love using only two colors to really showcase the patchwork patterns, this would be a very cool quilt to create in an ombre color palette, starting with the darks in the center, with the blocks getting lighter as they get toward the edges, or vice versa.

| Baby | Crib | Throw | Square Throw | Twin | Full/Queen |

BLOCK REQUIREMENTS

	(W)	(H)	A	B	C	D	E	F	G
BABY	32"	48"	–	–	–	–	8	12	4
CRIB	40"	48"	–	–	–	–	18	10	2
THROW	48"	64"	–	–	–	12	20	12	4
SQ. THROW	64"	64"	–	–	–	28	20	12	4
TWIN	80"	96"	–	20	36	28	20	12	4
FULL/QUEEN	96"	112"	24	44	36	28	20	12	4
KING	112"	112"	52	44	36	28	20	12	4

Quadrants

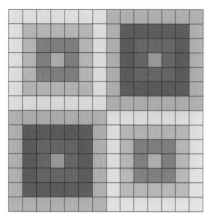

King size quilt shown in this example

Quadrants is like the Goldilocks of the Patches and the Bullseye layout, as you get to play with a couple different design ideas within one quilt top—plus you can indulge any starburst-creating tendencies you have! It's also a great design to add your own twist to: instead of two repeating quadrants, you could up the ante and make four different layouts.

Baby	Square Crib	Throw	Square Throw	Twin	Full/Queen

BLOCK REQUIREMENTS

	(W)	(H)	A	B	C	D	E	F	G
BABY	32"	48"	–	–	–	–	8	12	4
SQ. CRIB	48"	48"	–	–	16	2	–	16	2
THROW	48"	64"	12	–	16	2	–	16	2
SQ. THROW	64"	64"	–	–	24	8	–	24	8
TWIN	80"	96"	20	32	16	2	32	16	2
FULL/QUEEN	96"	112"	24	40	24	8	40	24	8
KING	112"	112"	48	32	16	50	32	16	2

Stripes

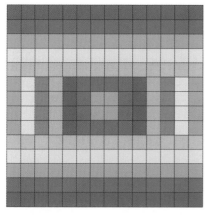

King size quilt shown in this example

The Stripes layout is a great mashup of lines and visual cues—I love playing with the juxtaposition of vertical and horizontal motifs while creating a center medallion. Try coming up with different four-patch center layouts that create larger versions of individual blocks (like how four Block 18s together look like a giant Block 30). Or try finding common visual "themes" within blocks and highlighting them in different parts of the quilt layout, then surrounding them with smaller, repeating pattern motifs (like the small checkerboard of Block 03 or the stripes of Block 01).

Crib	Square Crib	Throw	Square Throw	Twin	Full/Queen

BLOCK REQUIREMENTS

	(W)	(H)	A	B	C	D	E	F	G
CRIB	40"	48"	–	10	–	–	8	10	2
SQ. CRIB	48"	48"	–	12	–	–	8	12	4
THROW	48"	64"	12	12	–	–	8	12	4
SQ. THROW	64"	64"	16	16	–	8	8	12	4
TWIN	80"	96"	20	20	8	8	8	32	24
FULL/QUEEN	96"	112"	32	24	8	8	32	36	28
KING	112"	112"	36	28	8	8	36	40	40

*If you'd like to make a Baby size, follow the instructions for the Bullseye Quilt Top Layout.

Log Cabin

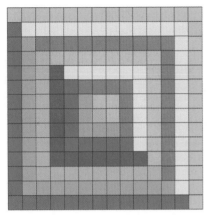

King size quilt shown in this example

For the Log Cabin layout, I often start by making pairs of blocks that don't quite work together—those ones that when placed next to each other create a little visual friction. And then I take those pairs and start to build the quilt using those block pairs in opposite corners. This layout definitely takes a little finessing, but once you get the balance right, the visual dissonance it creates is magic!

Square Baby	Square Crib	Throw	Square Throw	Twin	Full/Queen

BLOCK REQUIREMENTS

	(W)	(H)	A	B	C	D	E	F	G
SQ. BABY	40"	40"	–	3	7	1	–	9	5
SQ. CRIB	48"	48"	11	4	7	1	–	9	4
THROW	48"	64"	12	4	8	4	–	12	8
SQ. THROW	64"	64"	11	18	7	1	13	9	5
TWIN	80"	96"	12	20	28	24	16	12	8
FULL/QUEEN	96"	112"	36	20	28	24	16	12	32
KING	112"	112"	34	45	26	18	13	34	26

Offset

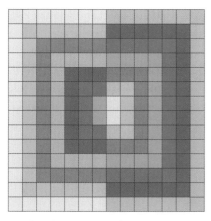

King size quilt shown in this example

The Offset layout is not for the faint of heart, and it may take some extra time playing with layouts to get it just right. As with the Log Cabin layout, I like to start by coming up with pairs of blocks, but instead of searching for ones that create visual disharmony, I look for ones that flow next to each other (like the big squares of Block 02 into the same size HSTs into Block 14). Once I find a pair I love, I'll use that to anchor my design as two of the largest "rings" of the quilt design. From there, it's honestly a lot of trial and error as I audition blocks next to each other.

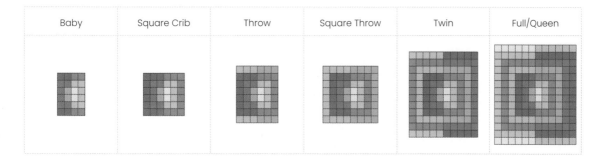

| | Baby | Square Crib | Throw | Square Throw | Twin | Full/Queen |

BLOCK REQUIREMENTS

	(W)	(H)	A	B	C	D	E	F	G
BABY	32"	48"	2	6	4	–	4	6	2
SQ. CRIB	48"	48"	2	6	10	–	10	6	2
THROW	48"	64"	2	6	10	6	10	6	8
SQ. THROW	64"	64"	2	6	10	14	10	6	16
TWIN	80"	96"	2	16	28	14	20	24	16
FULL/QUEEN	96"	112"	14	28	28	26	32	24	16
KING	112"	112"	28	28	28	40	32	24	16

Sampler

King size quilt shown in this example

Sometimes, you don't want to work with an all-over pattern or worry about cohesive designs—you just want to make. For those times, the Sampler layout is my go-to. I love having the opportunity to make one-off blocks, seeing how they look when pieced, taking the time to try them all, discovering what patchwork construction techniques make me happy. Plus, the Sampler is a great opportunity to dive into your scrap bin, and I'll never say no to that.

Note that the Sampler quilt is different from the rest of the Quilt Top layouts: instead of giving you a suggested layout of blocks, I'm providing the numbers of blocks you'll need to make, but the final assortment is up to you! The chart below provides the yardage and math for the sashing and borders, but since there are so many potential combinations of blocks, it'd be impossible to say how many of each block you'll need in the end.

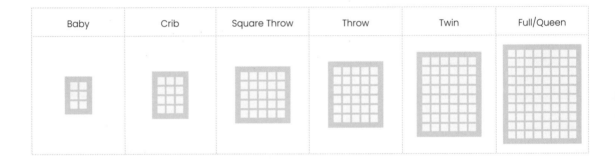

Baby	Crib	Square Throw	Throw	Twin	Full/Queen

SAMPLER QUILT DIMENSIONS, NUMBER OF BLOCKS & YARDAGE REQUIREMENTS

	(W)	(H)	NO. BLOCKS	BORDERS & SASHING YARDAGE
BABY	30"	40"	6	1 yd.
CRIB	40"	50"	12	1⅛ yds.
SQ. THROW	60"	60"	25	2 yds.
THROW	60"	70"	30	2 yds.
TWIN	70"	90"	48	3 yds.
FULL/QUEEN	90"	110"	80	4½
KING	110"	110"	100	5¼ yds.

SASHING CUTTING INSTRUCTIONS

To construct your Sampler Style quilt, first sew your blocks into rows with your vertical sashing (2½" x 8½"). Then sew your rows together with your Horizontal Sashing (please see table below for dimensions). For the Square Throw, Throw, Twin, Full/Queen, and King size quilts, you will first need to assemble your Horizontal Sashing along their 2.5" sides. I like to sew them into one long strip and then trim them to size as I assemble.

	VERTICAL SASHING WOF	VERTICAL SASHING (DIM.)	HORIZONTAL SASHING WOF	HORIZONTAL SASHING (DIM.)
BABY	2½" x WOF (1)	2½" x 8½" (3)	2½" x WOF (1)	2½" x 18½" (2)
CRIB	2½" x WOF (2)	2½" x 8½" (8)	2½" x WOF (3)	2½" x 28½" (3)
SQ. THROW	2½" x WOF (5)	2½" x 8½" (20)	2½" x WOF (5)	2½" x 48½" (4)
THROW	2½" x WOF (6)	2½" x 8½" (24)	2½" x WOF (6)	2½" x 48½" (5)
TWIN	2½" x WOF (10)	2½" x 8½" (40)	2½" x WOF (10)	2½" x 58½" (7)
FULL/QUEEN	2½" x WOF (18)	2½" x 8½" (70)	2½" x WOF (18)	2½" x 78½" (9)
KING	2½" x WOF (23)	2½" x 8½" (90)	2½" x WOF (22)	2½" x 98½" (9)

BORDERS CUTTING INSTRUCTIONS

To finish your Sampler Style quilt top, first sew on your Vertical Borders (see table below for the dimensions). Then sew your Horizontal Sashing (please see table below for dimensions). For the Square Throw, Throw, Twin, Full/Queen, and King size, you will need to assemble your Borders first. Just like with my sashing, I will often create one long strip of fabric before trimming to size.

	VERTICAL BORDERS WOF	VERTICAL BORDERS (DIM.)	HORIZONAL BORDERS WOF	HORIZONTAL BORDERS (DIM.)
BABY	6½" x WOF (2)	6½" x 28½" (2)	6½" x WOF (2)	6½" x 30½" (2)
CRIB	6½" x WOF (2)	6½" x 38½" (2)	6½" x WOF (2)	6½" x 40½" (2)
SQ. THROW	6½" x WOF (3)	6½" x 48½" (2)	6½" x WOF (3)	6½" x 60½" (2)
THROW	6½" x WOF (3)	6½" x 58½" (2)	6½" x WOF (3)	6½" x 60½" (2)
TWIN	6½" x WOF (4)	6½" x 78½" (2)	6½" x WOF (4)	6½" x 70½" (2)
FULL/QUEEN	6½" x WOF (5)	6½" x 98½" (2)	6½" x WOF (5)	6½" x 90½" (2)
KING	6½" x WOF (5)	6½" x 98½" (2)	6½" x WOF (6)	6½" x 110½" (2)

Block Index

On the following pages, you'll find all thirty 8" blocks, as well as a quick overview of Block Construction Tips. Each page includes step-by-step illustrated instructions for how to construct the block, as well as a selection of illustrated examples of how the blocks look repeated, as a four-patch "center" block as well as in a row and corner layout.

Please note that all blocks are made with a ¼" seam allowance and finish at 8" (8½" unfinished before assembling into your quilt top). Width of fabric (WOF) is assumed to be 42".

STRIPES & CHECKERBOARDS

block 01 block 02 block 03 block 04 block 05 block 06

L-SHAPED

block 07 block 08 block 09 block 10 block 11 block 12 block 13

LARGE-HALF SQUARE TRIANGLES

block 14 block 15 block 16 block 17 block 18 block 19 block 20 block 21 block 22

SMALL HALF SQUARE TRIANGLES

block 23

EXTRA-LARGE HALF SQUARE TRIANGLES

block 24

LARGE FLYING GEESE

block 25 block 26 block 27 block 28

SMALL FLYING GEESE

block 29 block 30

Block Construction Tips:
Patchwork Basics

The blocks in this book aren't too terribly difficult to make: it's all flying geese, half square triangles, rectangles, and squares (Blocks 29 and 30 are the trickiest, with their smaller flying geese and bulkier seams). But even though these blocks are fairly elemental, it doesn't mean that there aren't ways to make life easier!

Here's a quick refresher for how to make your half square triangles and flying geese, and how to speed up production (if you so choose).

Please note that all blocks are made with a ¼" seam allowance and finish at 8" (8½" unfinished, before assembling into your quilt top). Width of fabric (WOF) is assumed to be 42".

Step-by-Step Cutting Diagram Key

KEY CUTTING CHART

SOLID LINE: MARK LINE	_____
DOTTED LINE: SEW OR CUT LINE	- - - - - - - - - - - - -
PLUS SIGN: SEW TOGETHER	+

NOTE: Fabric 1 is always represented as the darker color and Fabric 2 is always illustrated as the lighter: please keep this in mind as you decide on your fabrics.

Two-at-a-Time HSTs

We'll be making HSTs two-at-a-time in three different sizes: 2½", 4½", and 8½". Here are the measurements of the pieces to make these:

HST SIZE (UNFINISHED)	STARTING SQUARE SIZE
8½" x 8½"	9" x 9"
4½" x 4½"	5" x 5"
2½" x 2½"	3" x 3"

To make your HSTs two-at-a-time, start with two squares of fabric (one Fabric 1 and one Fabric 2):

1. Draw a diagonal line on the back of one of the squares and place it on top of the second square, right sides together.
2. Sew a ¼" seam on both sides of the line, then cut along the drawn line.
3. Press and trim to size as needed.

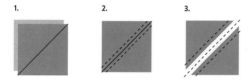

Four-at-a-Time HSTs

The thing to remember with four-at-a-time HSTs is that this method does create bias edges. All this means is that when you press your HSTs you want to truly press, and not iron back and forth (pressing will minimize the pulling of the fabric and keep the HSTs from becoming wonky).

HST SIZE (UNFINISHED)	STARTING SQUARE SIZE
4½" x 4½"	7¼" x 7¼"
2½" x 2½"	4¼" x 4¼"

To make your HSTs, take your two squares of fabric:

1. With your squares right sides together, sew a ¼" seam around the border.
2. Cut corner to corner in both directions.
3. Trim your HSTs to size as needed.

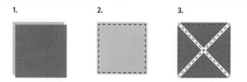

Also, whichever way you make your HSTs, you may have one or two left over (I've tried to minimize this as much as possible). But the good news is that they're perfect for a scrappy pillow or using in a scrappy party-in-the-quilt-back!

Flying Geese

Never made four-at-a-time flying geese? Never fear: it's a breeze! We'll be working with two different sizes of flying geese in these blocks: 4½" x 8½" and 2½" x 4½". Here are the measurements of the pieces to make these:

FLYING GEESE SIZE (UNFINISHED)	"CORNERS" (SMALL TRIANGLES)	"BODY" (LARGE MIDDLE TRIANGLE)
4½" x 8½"	4⅞" x 4⅞" (4)	9¼" x 9¼" (1)
2½" x 4½"	2⅞" x 2⅞" (4)	5¼" x 5¼" (1)

Here's how to make them step-by-step:

1. Draw a diagonal line on the wrong side of the four smaller squares of "Corner" fabric.
2. Place two of these smaller squares in opposite corners of one larger "Body" fabric square (right sides together). Pin and sew ¼" on both sides of the drawn diagonal lines (note that the smaller squares will overlap slightly).
3. Cut the square in half between the two seams.
4. Press one of the halves open.
5. Place another smaller square in the open corner of one of the units from Step 4. Pin and sew ¼" on both sides of the drawn diagonal lines.
6. Cut between the two seams and press open.
7. Repeat Steps 4–6 with the second unit, and presto: four flying geese (honk honk)!

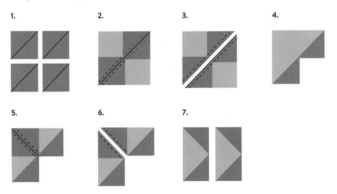

Just like with your HSTs, you may end up with a couple extra flying geese units (I've tried to minimize this as much as possible). But the good news is that they're also great to use in a scrappy pillow or a scrappy party-in-the-quilt-back, just like those extra HSTs!

Strip Piecing

When you're making multiples of the same blocks, it can be tiresome to cut out all your teeny-tiny pieces first and then sew them together, especially when you're working with checkerboard or stripe blocks. For those sorts of blocks, I like to speed things up and strip piece any width of fabric sets that I can (strip piecing can also help with the accuracy of your seam allowance, as it can be hard to keep things perfectly aligned at the start and end of any seam!).

To make the stripes of Block 1, figure out how many width of fabric (WOF) strip pairs you are working with first. Then sew them together in Fabric 1 and Fabric 2 pairs. Press your seams. You can cut them to 8½" and sew them together to make your blocks, OR if you have enough WOF strip pairs so that each has a pair, you can sew pairs of pairs together and THEN cut them down to 8½" blocks. No matter how you sew the two sets of stripes together, try to make sure that middle seam is sewn in the opposite direction of the original seams (if they are all sewn in the same direction your block can start to "lean" in one direction).

For the checkerboard of Block 2, the same method works! Sew your Fabric 1 and 2 WOF pairs together, then cut all the necessary 4½" pieces. Rotate one stripe set to pair with another to create your checkerboard, then sew together and press. Voilà!

Strip piecing will also work for sewing the 2½" Fabric 1 and Fabric 2 square pairs that occur in the L-shaped blocks! And if you don't have a full WOF strip to work with, you can always use a smaller strip set.

> **TIP:** Any time you see small repeating subunits, take a step back and consider whether you want to speed things up with a little strip piecing.

Chain Piecing

This is one of my favorite ways to speed up my patchwork—plus, I love the chain of pieces at the end: it feels like a little celebratory patchwork garland! Instead of lifting the presser foot on your sewing machine at the end of each seam and trimming your threads, you're just going to keep sewing.

I'll chain piece whenever I have a whole stack of the same repeated seams to get through. So, my first step in chain piecing is lining up my seam pairs. If they're larger, I'll pin all the pairs together. If they're smaller/more manageable to sew, sometimes I'll just organize my two piles of fabric at my machine, to grab and line up the pairs as I sew. But, to be fair, I sew A LOT and am very confident in my ability to keep my pieces aligned and my seam allowance even. So, my advice: when in doubt, pin it.

Some folks like to start chain piecing by sewing along a piece of "lead fabric" (any scrap of fabric will do). This makes it so that any knots or tangles or other sewing machine bloopers end up on scrap fabric. It also allows you to start sewing along your seam allowance perfectly as you'll be feeding it in (instead of lowering your presser foot and hoping for the best). To be completely honest, I'm too lazy to do this and just start sewing (hoping for the best), but give it a try!

Once you've sewn along the lead fabric, queue up your first pair of pieces in front of the presser foot. Do not lift your presser foot or cut the thread! Simply feed the pieces through your machine, queuing up the next pair of pieces, and so on and so forth. In order to make it easier to trim, I'll let my machine sew a couple stitches "on air" before I feed in the next pair. Once you've fed all your pairs through, lift your presser foot and trim your thread as you normally would. Then snip the stitches between each pair, and press and trim as normal. How easy was that?

TROUBLESHOOTING: If you're looking for more how-tos or video examples of the above, make sure to head on over to broadclothstudio.com for further information!

Block 01

MATH PAGE 66

PIECES PER BLOCK	
■ Fabric 1: 2½" x 8½" (2)	■ Fabric 2: 2½" x 8½" (2)

PAIRS WELL WITH...

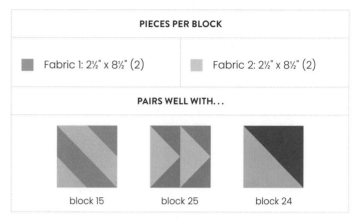

block 15 block 25 block 24

STEP-BY-STEP ASSEMBLY

1.

1. Sew the (4) 2½" x 8½" rectangles together, alternating Fabric 1 and Fabric 2.

CENTER BLOCK EXAMPLE	ROW + CORNER EXAMPLES

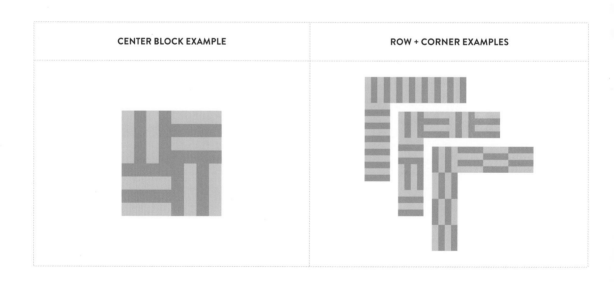

Block 02

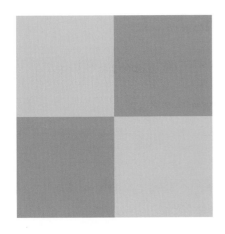

PIECES PER BLOCK	

Fabric 1: 4½" x 4½" (2) Fabric 2: 4½" x 4½" (2)

PAIRS WELL WITH...

block 13 block 05 block 16

STEP-BY-STEP ASSEMBLY

1. **2.**

1. Sew (1) Fabric 1 4½" square to (1) Fabric 2 4½" square. Repeat 1x.

2. Sew the (2) Step 1 units together

CENTER BLOCK EXAMPLE	ROW + CORNER EXAMPLES
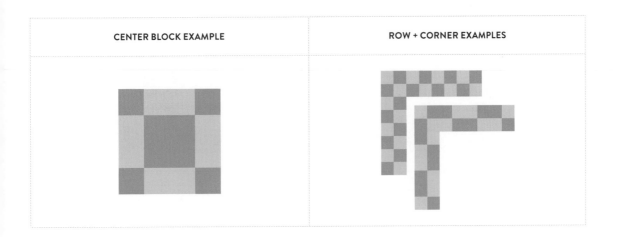	

Block 03

MATH PAGE 70

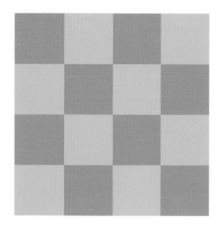

PIECES PER BLOCK	
■ Fabric 1: 2½" x 2½" (8)	■ Fabric 2: 2½" x 2½" (8)

PAIRS WELL WITH...

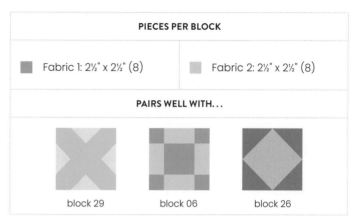

block 29 block 06 block 26

STEP-BY-STEP ASSEMBLY

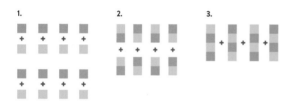

1. Sew (1) Fabric 1 2½" square to (1) Fabric 2 2½" square. Repeat 7x.

2. Sew (2) Step 1 unit together, matching Fabric 1 to Fabric 2. Repeat 3x.

3. Sew the (4) Step 2 units together.

CENTER BLOCK EXAMPLE	ROW + CORNER EXAMPLES

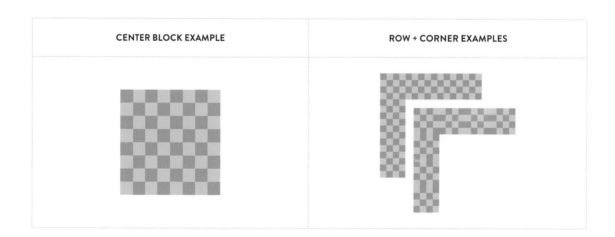

Block 04

PIECES PER BLOCK	
■ Fabric 1: 2½" x 4½" (2); 2½" x 8½" (2)	■ Fabric 2: 4½" x 4½" (1)

PAIRS WELL WITH...

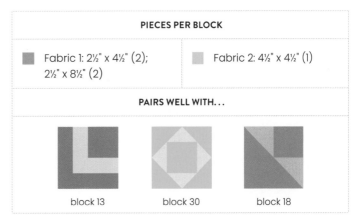

| block 13 | block 30 | block 18 |

STEP-BY-STEP ASSEMBLY

1. Sew (1) Fabric 1 2½" x 4½" rectangle on both sides of (1) Fabric 2 4½" x 4½" square.

2. Sew (1) Fabric 1 2½" x 8½" rectangle on the top and bottom of (1) Step 1 unit.

CENTER BLOCK EXAMPLE	ROW + CORNER EXAMPLES

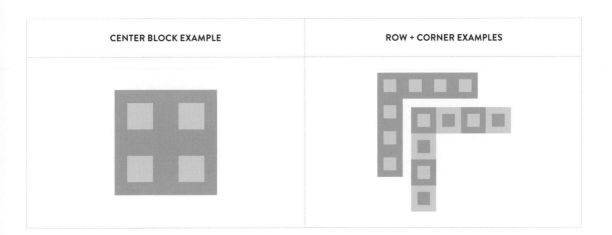

Block 05

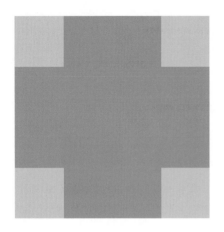

PIECES PER BLOCK	
■ Fabric 1: 4½" x 8½" (1); 4½" x 2½" (2)	■ Fabric 2: 2½" x 2½" (4)

PAIRS WELL WITH...

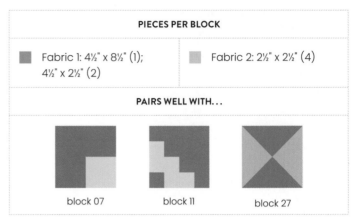

block 07　　　block 11　　　block 27

STEP-BY-STEP ASSEMBLY

1. Sew (1) Fabric 2 2½" x 2½" on either end of (1) Fabric 1 4½" x 2½" piece. Repeat 1x.

2. Sew (1) Step 1 unit to the top and (1) to the bottom of (1) Fabric 1 4½" x 8½" rectangle.

CENTER BLOCK EXAMPLE	ROW + CORNER EXAMPLES

Block 06

MATH PAGE 76

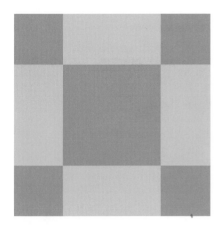

PIECES PER BLOCK	
Fabric 1: 4½" x 4½" (1); 2½" x 2½" (4)	Fabric 2: 2½" x 4½" (4)

PAIRS WELL WITH...

block 08　　　block 02　　　block 13

STEP-BY-STEP ASSEMBLY

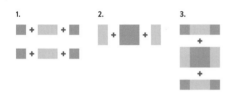

1. Sew (1) Fabric 2 2½" square on either end of (1) Fabric 1 4½" x 2½" rectangle. Repeat 1x.

2. Sew (1) Fabric 2 2½" x 4½" rectangle on both sides of (1) Fabric 1 4½" square.

3. Sew the (3) units from Step 1 and 2 together.

CENTER BLOCK EXAMPLE	ROW + CORNER EXAMPLES
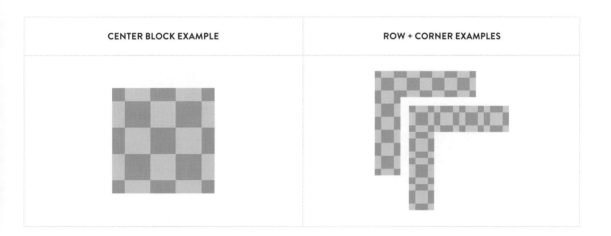	

Block 07

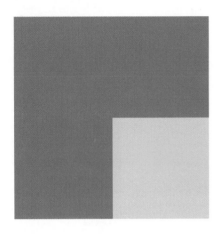

PIECES PER BLOCK	
Fabric 1: 4½" x 4½" (1); 4½" x 8½" (1)	Fabric 2: 4½" x 4½" (1)

PAIRS WELL WITH...

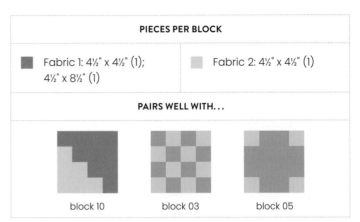

block 10 block 03 block 05

STEP-BY-STEP ASSEMBLY

1. **2.**

1. Sew (1) Fabric 2 4½" square to (1) Fabric 1 4½" square.

2. Sew (1) Step 1 unit to (1) Fabric 1 4½" x 8½" rectangle.

CENTER BLOCK EXAMPLE	ROW + CORNER EXAMPLES

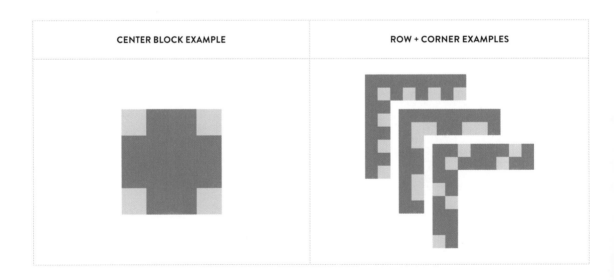

Block 08

PIECES PER BLOCK	
Fabric 1: 4½" x 4½" (2); 2½" x 2½" (2); 2½" x 4½" (2)	Fabric 2: 2½" x 2½" (2)

PAIRS WELL WITH...

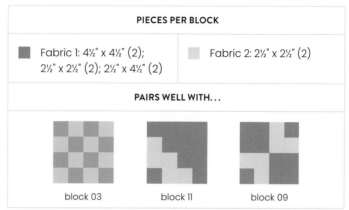

block 03 block 11 block 09

STEP-BY-STEP ASSEMBLY

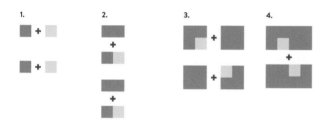

1. Sew (1) Fabric 1 2½" square to (1) Fabric 2 2½" square. Repeat 1x.

2. Sew (1) Step 1 unit to (1) Fabric 1 2½" x 4½" rectangle. Repeat 1x.

3. Sew (1) Step 2 unit to (1) Fabric 1 4½" square. Repeat 1x.

4. Sew the (2) Step 3 units together.

CENTER BLOCK EXAMPLE	ROW + CORNER EXAMPLES

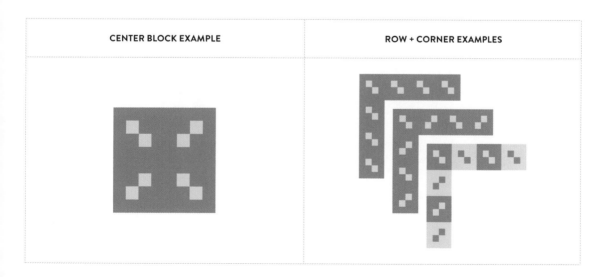

Block 09

MATH PAGE 84

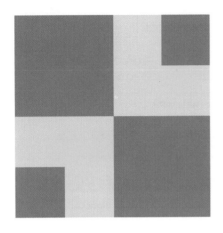

PIECES PER BLOCK	
■ Fabric 1: 4½" x 4½" (2); 2½" x 2½" (2)	■ Fabric 2: 2½" x 4½" (2); 2½" x 2½" (2)

PAIRS WELL WITH...

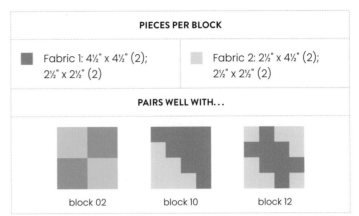

block 02 block 10 block 12

STEP-BY-STEP ASSEMBLY

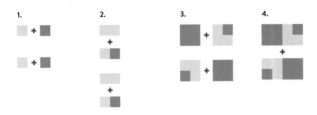

1. Sew (1) Fabric 1 2½" square to (1) Fabric 2 2½" square. Repeat 1x.

2. Sew (1) Step 1 unit (1) Fabric 2 2½" x 4½" rectangle. Repeat 1x.

3. Sew (1) Step 2 unit to (1) Fabric 1 4½" square. Repeat 1x.

4. Sew the (2) Step 3 units together.

CENTER BLOCK EXAMPLE	ROW + CORNER EXAMPLES

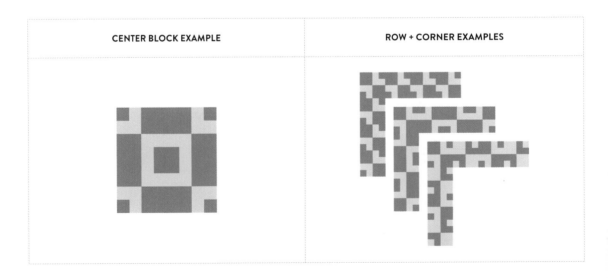

Block 10

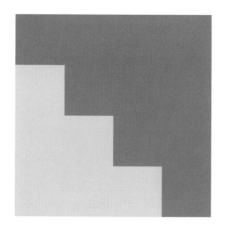

PIECES PER BLOCK	
■ Fabric 1: 4½" x 4½" (1); 4½" x 2½" (2); 2½" x 2½" (2)	▪ Fabric 2: 4½" x 4½" (1); 2½" x 2½" (2)

PAIRS WELL WITH...

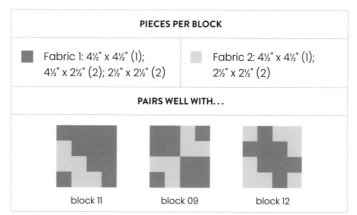

block 11 block 09 block 12

STEP-BY-STEP ASSEMBLY

1. Sew (1) Fabric 1 2½" square to (1) Fabric 2 2½" square. Repeat 1x.

2. Sew (1) Step 1 unit to (1) Fabric 1 2½" x 4½" rectangle. Repeat 1x.

3. Sew (1) Step 2 unit to (1) Fabric 1 4½" square, and sew (1) Step 2 unit to (1) Fabric 2 4½" square.

4. Sew the (2) Step 3 units together.

CENTER BLOCK EXAMPLE	ROW + CORNER EXAMPLES

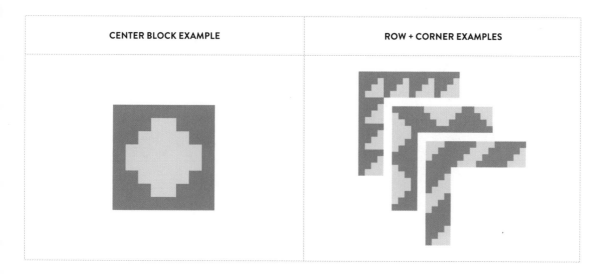

Block 11

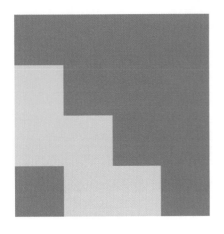

PIECES PER BLOCK

Fabric 1: 4½" x 4½" (1); 4½" x 2½" (2); 2½" x 2½" (3)

Fabric 2: 4½" x 2½" (1); 2½" x 2½" (3)

PAIRS WELL WITH...

block 05 block 08 block 06

STEP-BY-STEP ASSEMBLY

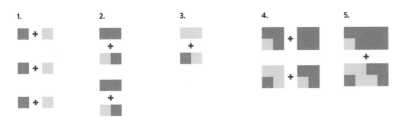

1. Sew (1) Fabric 1 2½" square to (1) Fabric 2 2½" square. Repeat 2x.

2. Sew (1) Step 1 unit to (1) Fabric 1 2½" x 4½" rectangle. Repeat 1x.

3. Sew (1) Step 1 unit to (1) Fabric 2 2½" x 4½" rectangle.

4. Sew (1) Step 2 unit to (1) Fabric 1 4½" square. Sew (1) Step 2 unit to (1) Step 3 unit.

5. Sew the (2) Step 4 units together.

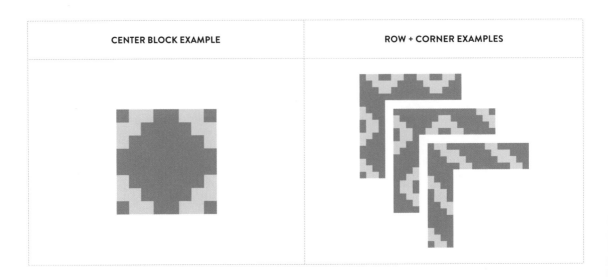

CENTER BLOCK EXAMPLE	ROW + CORNER EXAMPLES

Block 12

PIECES PER BLOCK	
■ Fabric 1: 2½" x 4½" (2); 2½" x 2½" (4)	■ Fabric 2: 2½" x 4½" (2); 2½" x 2½" (4)

PAIRS WELL WITH...

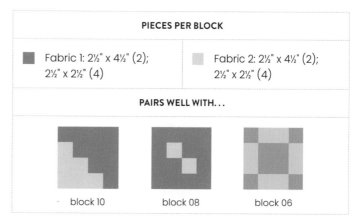

block 10 block 08 block 06

STEP-BY-STEP ASSEMBLY

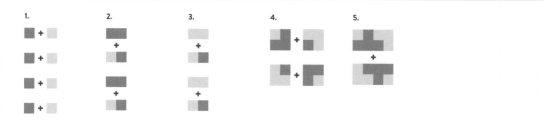

1. Sew (1) Fabric 1 2½" square to (1) Fabric 2 2½" square. Repeat 3x.

2. Sew (1) Step 1 unit to (1) Fabric 1 2½" x 4½" rectangle. Repeat 1x.

3. Sew (1) Step 1 unit to (1) Fabric 2 2½" x 4½" rectangle. Repeat 1x.

4. Sew (1) Step 2 unit to (1) Step 3 unit. Repeat 1x.

5. Sew the (2) Step 4 units together.

CENTER BLOCK EXAMPLE	ROW + CORNER EXAMPLES

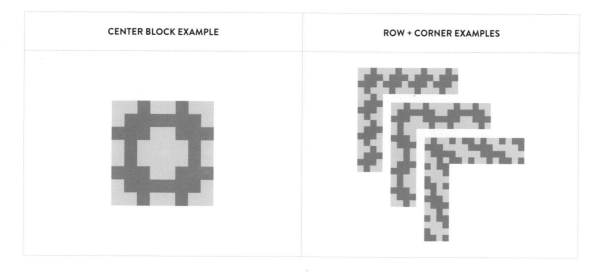

Block 13

PIECES PER BLOCK	
■ Fabric 1: 4½" x 4½" (1); 6½" x 2½" (1); 8½" x 2½" (1)	▢ Fabric 2: 2½" x 6½" (1); 2½" x 4½" (1)

PAIRS WELL WITH...

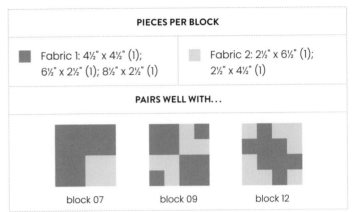

block 07 block 09 block 12

STEP-BY-STEP ASSEMBLY

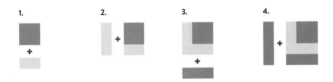

1. 2. 3. 4.

1. Sew (1) Fabric 2 2½" x 4½" rectangle to the bottom of (1) Fabric 1 4½" square.

2. Sew (1) Fabric 2 2½" x 6½" rectangle to the left of the Step 1 unit.

3. Sew (1) Fabric 1 6½" x 2½" rectangle to the bottom of the Step 2 unit.

4. Sew (1) Fabric 1 8½" x 2½" rectangle to the left of the Step 3 unit.

CENTER BLOCK EXAMPLE	ROW + CORNER EXAMPLES

Block 14

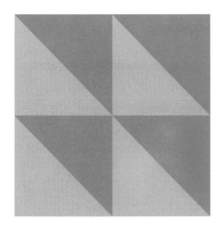

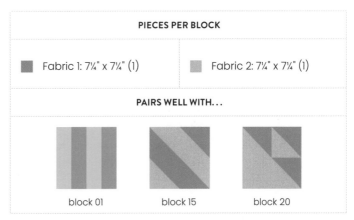

PIECES PER BLOCK

■ Fabric 1: 7¼" x 7¼" (1) ■ Fabric 2: 7¼" x 7¼" (1)

PAIRS WELL WITH...

block 01 block 15 block 20

STEP-BY-STEP ASSEMBLY

1. Pin (1) Fabric 1 7¼" square to (1) Fabric 2 7¼" square, right sides together.

2. Sew a ¼" seam around the border.

3. Cut corner to corner and press your HSTs open. Trim to 4½" square, as needed.

4. Sew (1) HST to (1) HST. Repeat 1x.

5. Sew the (2) Step 4 units together.

CENTER BLOCK EXAMPLE	ROW + CORNER EXAMPLES

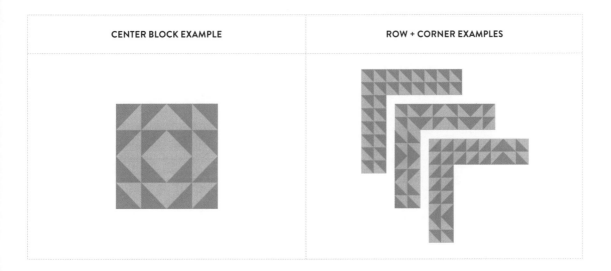

Block 15

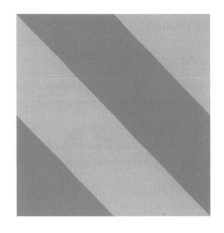

PIECES PER BLOCK	
■ Fabric 1: 7¼" x 7¼" (1)	■ Fabric 2: 7¼" x 7¼" (1)

PAIRS WELL WITH...

block 25 block 01 block 29

STEP-BY-STEP ASSEMBLY

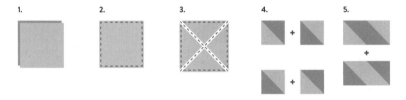

1. Pin (1) Fabric 1 7¼" square to (1) Fabric 2 7¼" square, right sides together.

2. Sew a ¼" seam around the border.

3. Cut corner to corner and press your HSTs open. Trim to 4½" square, as needed.

4. Sew (1) HST to (1) HST. Repeat 1x.

5. Sew the (2) Step 4 units together.

CENTER BLOCK EXAMPLE	ROW + CORNER EXAMPLES

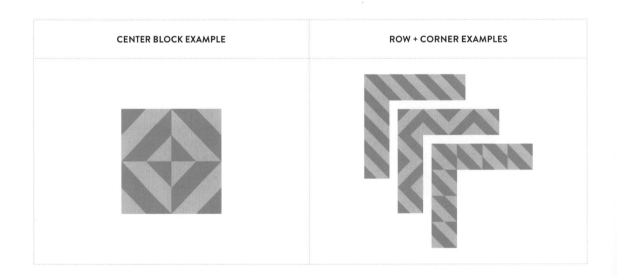

Block 16

PIECES PER BLOCK

■ Fabric 1: 5" x 5" (1); 4½" x 4½" (2)	■ Fabric 2: 5" x 5" (1)

PAIRS WELL WITH...

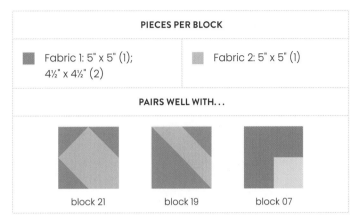

block 21 block 19 block 07

STEP-BY-STEP ASSEMBLY

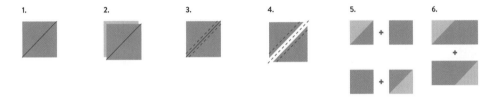

1. 2. 3. 4. 5. 6.

1. Draw a diagonal line on the wrong side of (1) Fabric 1 5" square.

2. Pair (1) Fabric 1 5" square with (1) Fabric 2 5" square, right sides together.

3. Sew a ¼" seam on both sides of the line.

4. Cut along the drawn line and press your HSTs open. Trim to 4½" square, as needed.

5. Sew (1) HST to (1) Fabric 1 4½" square. Repeat 1x.

6. Sew the (2) Step 5 units together.

CENTER BLOCK EXAMPLE	ROW + CORNER EXAMPLES

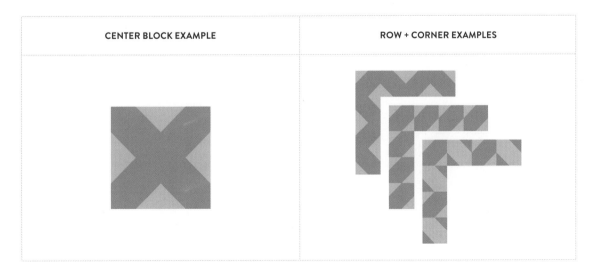

Block 17

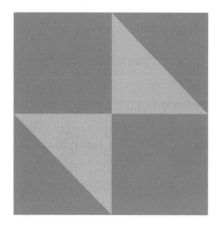

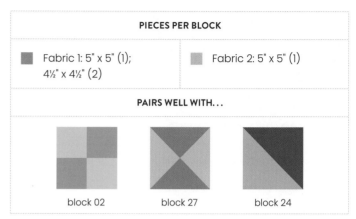

PIECES PER BLOCK	
■ Fabric 1: 5" x 5" (1); 4½" x 4½" (2)	■ Fabric 2: 5" x 5" (1)

PAIRS WELL WITH. . .

block 02 block 27 block 24

STEP-BY-STEP ASSEMBLY

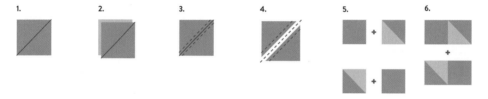

1. Draw a diagonal line on the wrong side of (1) Fabric 1 5" square.

2. Pair (1) Fabric 1 5" square with (1) Fabric 2 5" square, right sides together.

3. Sew a ¼" seam on both sides of the line.

4. Cut along the drawn line and press your HSTs open. Trim to 4½" square, as needed.

5. Sew (1) HST to (1) Fabric 1 4½" square. Repeat 1x.

6. Sew the (2) Step 5 units together.

CENTER BLOCK EXAMPLE	ROW + CORNER EXAMPLES
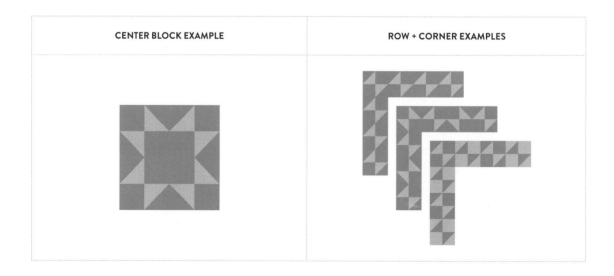	

Block 18

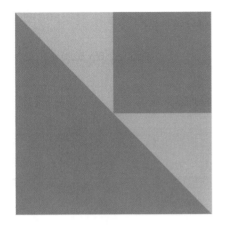

PIECES PER BLOCK	
Fabric 1: 5" x 5" (1); 4½" x 4½" (2)	Fabric 2: 5" x 5" (1)

PAIRS WELL WITH...

block 30 block 26 block 23

STEP-BY-STEP ASSEMBLY

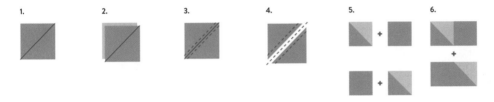

1. Draw a diagonal line on the wrong side of (1) Fabric 1 5" square.

2. Pair (1) Fabric 1 5" square with (1) Fabric 2 5" square, right sides together.

3. Sew a ¼" seam on both sides of the line.

4. Cut along the drawn line and press your HSTs open. Trim to 4½" square, as needed.

5. Sew (1) HST to (1) Fabric 1 4½" square. Repeat 1x.

6. Sew the (2) Step 5 units together.

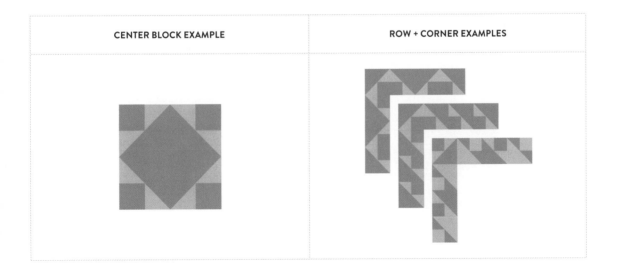

CENTER BLOCK EXAMPLE	ROW + CORNER EXAMPLES

Block 19

MATH PAGE 105

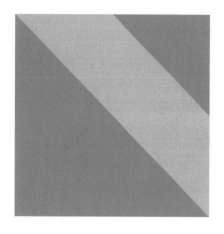

PIECES PER BLOCK	
Fabric 1: 5" x 5" (2); 4½" x 4½" (1)	Fabric 2: 5" x 5" (2)

PAIRS WELL WITH...

block 20 block 04 block 15

STEP-BY-STEP ASSEMBLY

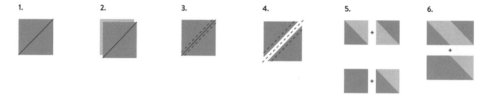

1. 2. 3. 4. 5. 6.

1. Draw a diagonal line on the wrong side of (2) Fabric 1 5" squares.

2. Pair (1) Fabric 1 5" square with (1) Fabric 2 5" square, right sides together. Repeat 1x.

3. Sew a ¼" seam on both sides of the line for the (2) Step 2 units.

4. Cut along the drawn line of the (2) Step 2 units and press your HSTs open. Trim to 4½" square, as needed.

5. Sew (2) HSTs together and sew (1) HST to (1) Fabric 1 4½" square.

6. Sew the (2) Step 5 units together.

Note: This block may have leftover HSTs.

CENTER BLOCK EXAMPLE	ROW + CORNER EXAMPLES

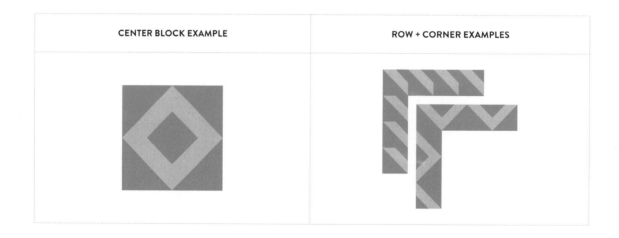

Block 20

MATH PAGE 108

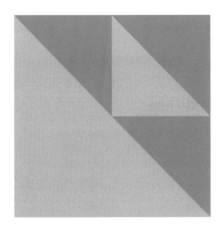

PIECES PER BLOCK	
■ Fabric 1: 5" x 5" (2)	■ Fabric 2: 5" x 5" (2); 4½" x 4½" (1)

PAIRS WELL WITH...

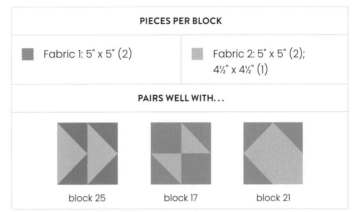

block 25 block 17 block 21

STEP-BY-STEP ASSEMBLY

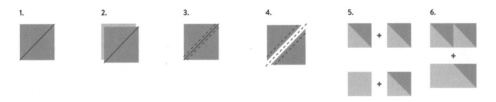

1. 2. 3. 4. 5. 6.

1. Draw a diagonal line on the wrong side of (2) Fabric 1 5" squares.

2. Pair (1) Fabric 1 5" square with (1) Fabric 2 5" square, right sides together. Repeat 1x.

3. Sew a ¼" seam on both sides of the line for the (2) Step 2 units.

4. Cut along the drawn line of the (2) Step 2 units and press your HSTs open. Trim to 4½" square, as needed.

5. Sew (2) HSTs together and sew (1) HST to (1) Fabric 2 4½" square.

6. Sew the (2) Step 5 units together.

Note: This block may have leftover HSTs.

CENTER BLOCK EXAMPLE	ROW + CORNER EXAMPLES

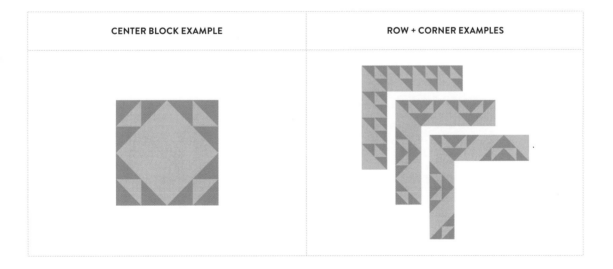

Block 21

PIECES PER BLOCK	
■ Fabric 1: 5" x 5" (2)	■ Fabric 2: 5" x 5" (2); 4½" x 4½" (1)

PAIRS WELL WITH...

block 19 block 29 block 14

STEP-BY-STEP ASSEMBLY

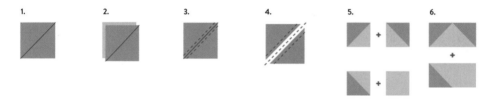

1. Draw a diagonal line on the wrong side of (2) Fabric 1 5" squares.

2. Pair (1) Fabric 1 5" square with (1) Fabric 2 5" square, right sides together. Repeat 1x.

3. Sew a ¼" seam on both sides of the line for the (2) Step 2 units.

4. Cut along the drawn line of the (2) Step 2 units and press your HSTs open. Trim to 4½" square, as needed.

5. Sew (2) HSTs together and sew (1) HST to (1) Fabric 2 4½" square.

6. Sew the (2) Step 5 units together.

Note: This block may have leftover HSTs.

CENTER BLOCK EXAMPLE	ROW + CORNER EXAMPLES
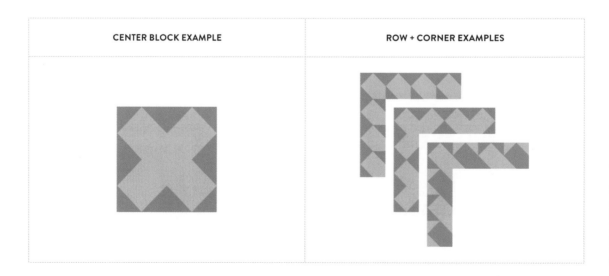	

Block 22

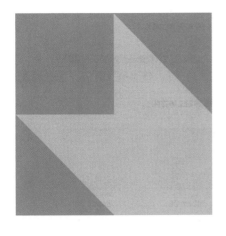

PIECES PER BLOCK	
Fabric 1: 5" x 5" (1); 4½" x 4½" (1)	Fabric 2: 5" x 5" (1); 4½" x 4½" (1)

PAIRS WELL WITH...

block 23 block 18 block 21

STEP-BY-STEP ASSEMBLY

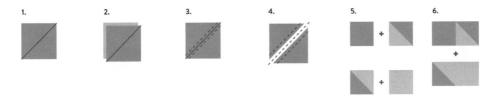

1. Draw a diagonal line on the wrong side of (1) Fabric 1 5" square.

2. Pair (1) Fabric 1 5" square with (1) Fabric 2 5" square, right sides together.

3. Sew a ¼" seam on both sides of the line.

4. Cut along the drawn line of the (2) Step 2 units and press your HSTs open. Trim to 4½" square, as needed.

5. Sew (1) HST to (1) Fabric 2 4½" square and sew (1) HST to (1) Fabric 1 4½" square.

6. Sew the (2) Step 5 units together.

CENTER BLOCK EXAMPLE	ROW + CORNER EXAMPLES

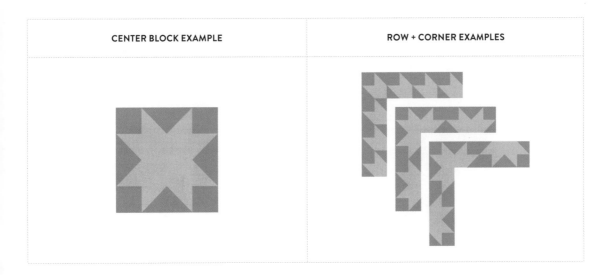

Block 23

MATH PAGE 114

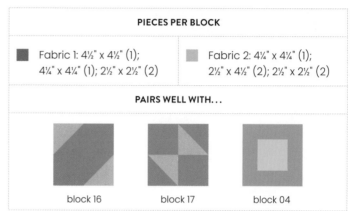

PIECES PER BLOCK

■ Fabric 1: 4½" x 4½" (1);
4¼" x 4¼" (1); 2½" x 2½" (2)

■ Fabric 2: 4¼" x 4¼" (1);
2½" x 4½" (2); 2½" x 2½" (2)

PAIRS WELL WITH...

block 16 block 17 block 04

STEP-BY-STEP ASSEMBLY

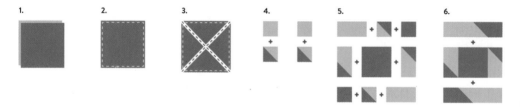

1. Pin (1) Fabric 1 4¼" square to (1) Fabric 2 4¼" square, right sides together.

2. Sew a ¼" seam around the border.

3. Cut corner to corner, press your HSTs open, and trim to 2½" square, as needed.

4. Sew (1) HST to (1) Fabric 2 2½" square. Repeat 1x.

5. Sew your rows:
 i. (1) Fabric 2 2½" x 4½" + (1) 2½" HST + (1) Fabric 1 2½" x 2½"
 ii. (1) Step 4 Unit + (1) Fabric 1 4½" x 4½" + (1) Step 4 Unit
 iii. (1) Fabric 1 2½" x 2½" + (1) 2½" HST + (1) Fabric 2 2½" x 4½"

6. Sew your (3) Step 5 rows together.

CENTER BLOCK EXAMPLE	ROW + CORNER EXAMPLES

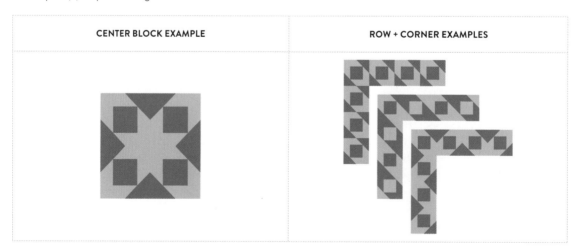

Block 24

PIECES PER BLOCK	
■ Fabric 1: 9" x 9" (1)	■ Fabric 2: 9" x 9" (1)

PAIRS WELL WITH...

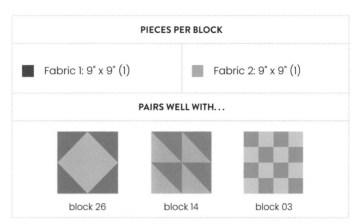

block 26 block 14 block 03

STEP-BY-STEP ASSEMBLY

1. **1.** 2. **2.** 3. **3.** 4. **4.**

1. Draw a diagonal line on the wrong side of (1) Fabric 1 9" square.

2. Pair (1) Fabric 1 9" square with (1) Fabric 2 9" square, right sides together.

3. Sew a ¼" seam on both sides of the line.

4. Cut along the drawn line and press. Trim to an 8½" square, as needed.

Note: This block can also be made with smaller HSTs by following the instructions from Block 22 and rotating the HSTs accordingly.

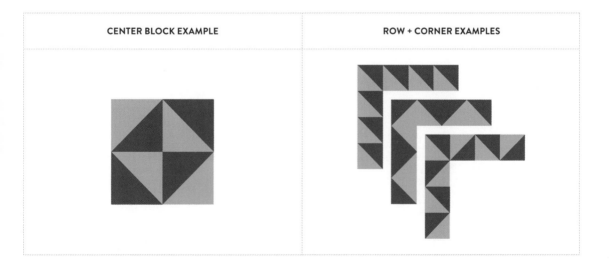

CENTER BLOCK EXAMPLE	ROW + CORNER EXAMPLES

Block 25

MATH PAGE 120

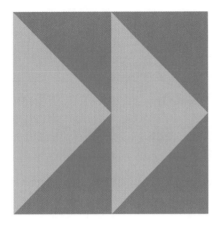

PIECES PER BLOCK	
◼ Fabric 1: 4⅞" x 4⅞" (4)	◻ Fabric 2: 9¼" x 9¼" (1)

PAIRS WELL WITH...

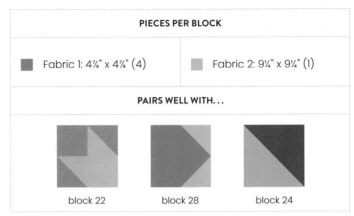

block 22 block 28 block 24

STEP-BY-STEP ASSEMBLY

1. 2. 3. 4. 5. 6. 7.

1. Draw a diagonal line on the wrong side of the (4) Fabric 1 4⅞" squares.

2. Place (2) Fabric 1 4⅞" squares in opposite corners of (1) Fabric 2 9¼" square, right sides together. Pin and sew ¼" on both sides of the drawn diagonal lines (note that the smaller squares will overlap slightly).

3. Cut the square in half between the two seams. Press (1) of the units open.

4. Place (1) Fabric 1 4⅞" square in the open corner of your Step 4 unit. Pin and sew ¼" on both sides of the drawn diagonal lines.

5. Cut between the two seams and press open. If you are making two blocks or more, repeat Steps 4–6 with the second Step 3 unit to make (4) flying geese.

6. Sew (2) flying geese together.

Note: This block can also be made with smaller HSTs by following the instructions from Block 14 and rotating the HSTs accordingly.

CENTER BLOCK EXAMPLE	ROW + CORNER EXAMPLES

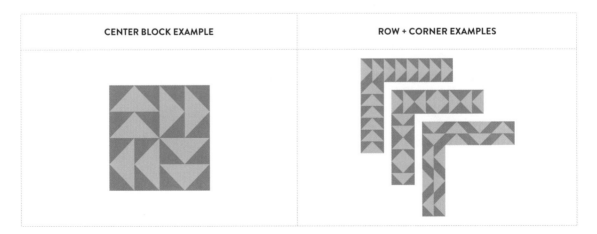

Block 26

PIECES PER BLOCK	
Fabric 1: 4⅞" x 4⅞" (4)	Fabric 2: 9¼" x 9¼" (1)

PAIRS WELL WITH...

block 27 block 19 block 04

STEP-BY-STEP ASSEMBLY

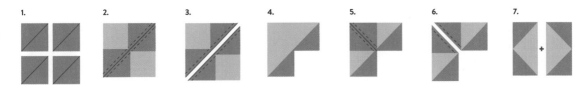

1. Draw a diagonal line on the wrong side of the (4) Fabric 1 4⅞" squares.

2. Place (2) Fabric 1 4⅞" squares in opposite corners of (1) Fabric 2 9¼" square, right sides together. Pin and sew ¼" on both sides of the drawn diagonal lines (note that the smaller squares will overlap slightly).

3. Cut the square in half between the two seams. Press (1) of the units open.

4. Place (1) Fabric 1 4⅞" square in the open corner of your Step 4 unit. Pin and sew ¼" on both sides of the drawn diagonal lines.

5. Cut between the two seams and press open. If you are making two blocks or more, repeat Steps 4–6 with the second Step 3 unit to make (4) flying geese.

6. Sew (2) flying geese together.

Note: This block can also be made with smaller HSTs by following the instructions from Block 14 and rotating the HSTs accordingly.

CENTER BLOCK EXAMPLE	ROW + CORNER EXAMPLES

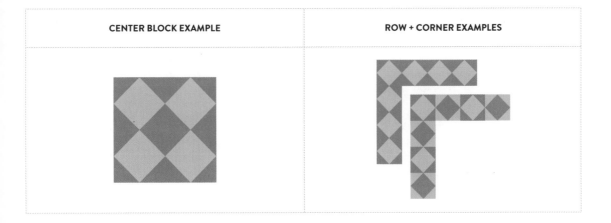

Block 27

MATH PAGE 120

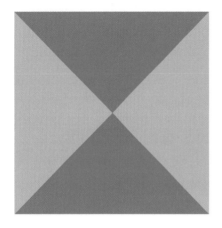

PIECES PER BLOCK	
■ Fabric 1: 4⅞" x 4⅞" (4)	■ Fabric 2: 9¼" x 9¼" (1)

PAIRS WELL WITH...

block 28 block 30 block 01

STEP-BY-STEP ASSEMBLY

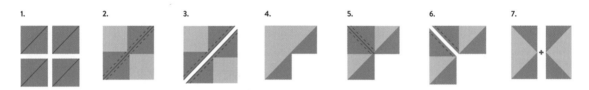

1. 2. 3. 4. 5. 6. 7.

1. Draw a diagonal line on the wrong side of the (4) Fabric 1 4⅞" squares.

2. Place (2) Fabric 1 4⅞" squares in opposite corners of (1) Fabric 2 9¼" square, right sides together. Pin and sew ¼" on both sides of the drawn diagonal lines (note that the smaller squares will overlap slightly).

3. Cut the square in half between the two seams. Press (1) of the units open.

4. Place (1) Fabric 1 4⅞" square in the open corner of your Step 4 unit. Pin and sew ¼" on both sides of the drawn diagonal lines.

5. Cut between the two seams and press open. If you are making two blocks or more, repeat Steps 4–6 with the second Step 3 unit to make (4) flying geese.

6. Sew (2) flying geese together.

Note: This block can also be made with smaller HSTs by following the instructions from Block 14 and rotating the HSTs accordingly.

CENTER BLOCK EXAMPLE	ROW + CORNER EXAMPLES

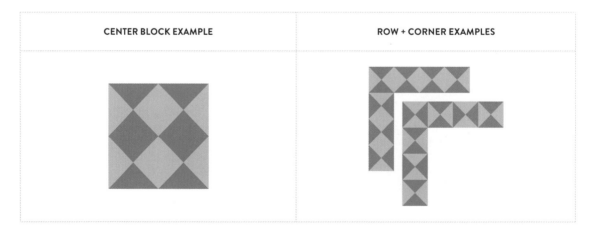

Block 28

MATH PAGE 122

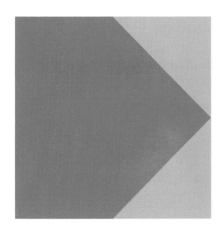

PIECES PER BLOCK	
■ Fabric 1: 9¼" x 9¼" (1); 8½" x 4½" (1)	■ Fabric 2: 4⅞" x 4⅞" (4)

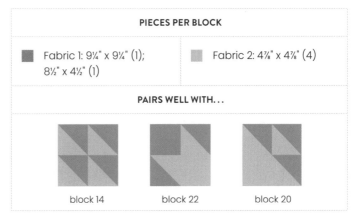

PAIRS WELL WITH...

block 14 block 22 block 20

STEP-BY-STEP ASSEMBLY

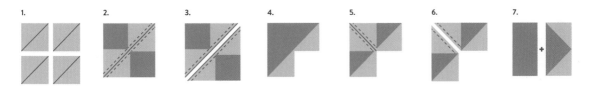

1. Draw a diagonal line on the wrong side of the (4) Fabric 2 4⅞" squares.

2. Place (2) Fabric 2 4⅞" squares in opposite corners of (1) Fabric 1 9¼" square, right sides together. Pin and sew ¼" on both sides of the drawn diagonal lines (note that the smaller squares will overlap slightly).

3. Cut the square in half between the two seams. Press (1) of the units open.

4. Place (1) Fabric 2 4⅞" square in the open corner of your Step 4 unit. Pin and sew ¼" on both sides of the drawn diagonal lines.

5. Cut between the two seams and press open. If you are making three blocks or more, repeat Steps 4–6 with the second Step 3 unit to make (4) flying geese.

6. Sew (1) flying geese to (1) Fabric 1 8½" x 4½" rectangle.

Note: This block can also be made with smaller HSTs by following the instructions from Block 16 and rotating the HSTs accordingly.

CENTER BLOCK EXAMPLE	ROW + CORNER EXAMPLES

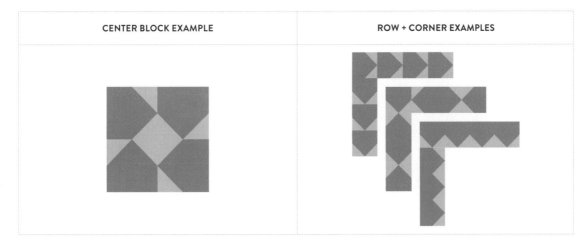

Block 29

PIECES PER BLOCK

■ Fabric 1: 4½" x 4½" (1); 2½" x 2½" (4); 2⅞" x 2⅞" (4)	■ Fabric 2: 5¼" x 5¼" (1)

PAIRS WELL WITH...

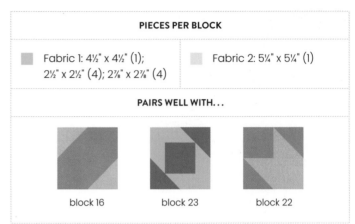

block 16 block 23 block 22

STEP-BY-STEP ASSEMBLY

1. Draw a diagonal line on the wrong side of the (4) Fabric 1 2⅞" squares.

2. Place (2) Fabric 1 2⅞" squares in opposite corners of (1) Fabric 2 5¼" square, right sides together. Pin and sew ¼" on both sides of the drawn diagonal lines (note that the smaller squares will overlap slightly).

3. Cut the square in half between the two seams.

4. Press (1) of the Step 3 units open.

5. Place (1) Fabric 1 2⅞" square in the open corner of your Step 4 unit. Pin and sew ¼" on both sides of the drawn diagonal lines.

6. Cut between the two seams and press open. Repeat Steps 4–6 with the second Step 3 unit to make (4) flying geese.

7. Sew your rows:
 i. (1) Fabric 1 2½" x 2½" + (1) Flying Geese + (1) Fabric 1 2½" x 2½"
 ii. (1) Flying Geese + (1) Fabric 1 4½" x 4½" + (1) Flying Geese
 iii. (1) Fabric 1 2½" x 2½" + (1) Flying Geese + (1) Fabric 1 2½" x 2½"

8. Sew your rows together.

CENTER BLOCK EXAMPLE	ROW + CORNER EXAMPLES

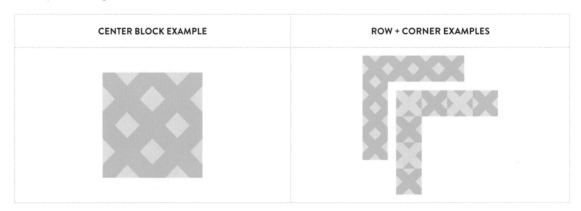

Block 30

PIECES PER BLOCK	
Fabric 1: 4½" x 4½" (1); 2⅞" x 2⅞" (4); 2½" x 2½" (4)	Fabric 2: 5¼" x 5¼" (1)

PAIRS WELL WITH...

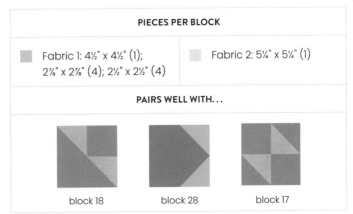

block 18 block 28 block 17

STEP-BY-STEP ASSEMBLY

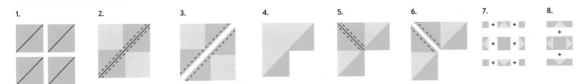

1. Draw a diagonal line on the wrong side of the (4) Fabric 1 2⅞" squares.

2. Place (2) Fabric 1 2⅞" squares in opposite corners of (1) Fabric 2 5¼" square, right sides together. Pin and sew ¼" on both sides of the drawn diagonal lines (note that the smaller squares will overlap slightly).

3. Cut the square in half between the two seams.

4. Press (1) of the Step 3 units open.

5. Place (1) Fabric 1 2⅞" square in the open corner of your Step 4 unit. Pin and sew ¼" on both sides of the drawn diagonal lines.

6. Cut between the two seams and press open. Repeat Steps 4–6 with the second Step 3 unit to make (4) flying geese.

7. Sew your rows:
 i. (1) Fabric 1 2½" x 2½" + (1) Flying Geese + (1) Fabric 1 2½" x 2½"
 ii. (1) Flying Geese + (1) Fabric 1 4½" x 4½" + (1) Flying Geese
 iii. (1) Fabric 1 2½" x 2½" + (1) Flying Geese + (1) Fabric 1 2½" x 2½"

8. Sew your rows together.

CENTER BLOCK EXAMPLE	ROW + CORNER EXAMPLES

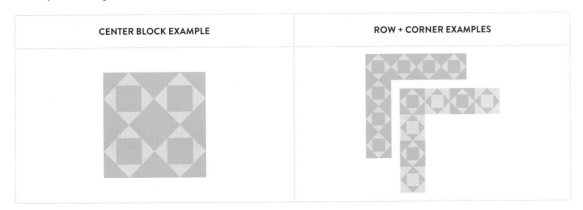

The Math

On the following pages is the math to make all the possible permutations of all the Quilt Top Layouts with any seven blocks from the Block Index.

Once you've finalized your quilt top layout and filled in your *Fabric Planner Worksheet* (page 166), navigate to each block's math pages to find the inches of yardage you'll need, as well as the cutting instructions for the block (everything is based on an assumed 42" width of fabric [WOF]). Then use the *Yardage Planner Worksheet* (page 165) to ensure you purchase enough fabric. (Don't forget to factor in the fabric you'll need to finish your quilt—you can find Backing & Binding Requirements in the Appendix.)

> **NOTE:** Fabric 1 is always represented as the darker color and Fabric 2 is always illustrated as the lighter; please keep this in mind as you decide what your fabrics will be!

As you look up the required yardage and cutting instructions for each block, I'd suggest filling in the *Cutting Planner Worksheet* (page 166) as you go to minimize how much flipping back and forth you have to do.

One last thing: All blocks are made with a ¼" seam allowance and finish at 8" (8½" unfinished before assembling into your quilt top). Width of fabric (WOF) is assumed to be 42". Perhaps it goes without saying, but this is 42" of usable fabric; make sure to double check your yardage, especially on fabrics with fun decorative selvages! If you are planning on using fabrics with directional prints and if you want those prints to all point in the same direction, you may need to update the cutting instructions to make this happen, depending on the block.

Block 01

DESIGN PAGE 34

#		FABRIC 1			FABRIC 2
	IN.	CUTTING REQUIREMENTS		IN.	CUTTING REQUIREMENTS
1	2½"	2½" x WOF (1): 2½" x 8½" (2)		2½"	2½" x WOF (1): 2½" x 8½" (2)
2	2½"	2½" x WOF (1): 2½" x 8½" (4)		2½"	2½" x WOF (1): 2½" x 8½" (4)
3	5"	2½" x WOF (1): 2½" x 8½" (4) 2½" x WOF (1): 2½" x 8½" (2)		5"	2½" x WOF (1): 2½" x 8½" (4) 2½" x WOF (1): 2½" x 8½" (2)
4	5"	2½" x WOF (2): 2½" x 8½" (4)		5"	2½" x WOF (2): 2½" x 8½" (4)
5	7½"	2½" x WOF (2): 2½" x 8½" (4) 2½" x WOF (1): 2½" x 8½" (2)		7½"	2½" x WOF (2): 2½" x 8½" (4) 2½" x WOF (1): 2½" x 8½" (2)
6	7½"	2½" x WOF (3): 2½" x 8½" (4)		7½"	2½" x WOF (3): 2½" x 8½" (4)
7	10"	2½" x WOF (3): 2½" x 8½" (4) 2½" x WOF (1): 2½" x 8½" (2)		10"	2½" x WOF (3): 2½" x 8½" (4) 2½" x WOF (1): 2½" x 8½" (2)
8	10"	2½" x WOF (4): 2½" x 8½" (4)		10"	2½" x WOF (4): 2½" x 8½" (4)
9	12½"	2½" x WOF (4): 2½" x 8½" (4) 2½" x WOF (1): 2½" x 8½" (2)		12½"	2½" x WOF (4): 2½" x 8½" (4) 2½" x WOF (1): 2½" x 8½" (2)
10	12½"	2½" x WOF (5): 2½" x 8½" (4)		12½"	2½" x WOF (5): 2½" x 8½" (4)
11	15"	2½" x WOF (5): 2½" x 8½" (4) 2½" x WOF (1): 2½" x 8½" (2)		15"	2½" x WOF (5): 2½" x 8½" (4) 2½" x WOF (1): 2½" x 8½" (2)
12	15"	2½" x WOF (6): 2½" x 8½" (4)		15"	2½" x WOF (6): 2½" x 8½" (4)
13	17½"	2½" x WOF (6): 2½" x 8½" (4) 2½" x WOF (1): 2½" x 8½" (2)		17½"	2½" x WOF (6): 2½" x 8½" (4) 2½" x WOF (1): 2½" x 8½" (2)
14	17½"	2½" x WOF (7): 2½" x 8½" (4)		17½"	2½" x WOF (7): 2½" x 8½" (4)
15	20"	2½" x WOF (7): 2½" x 8½" (4) 2½" x WOF (1): 2½" x 8½" (2)		20"	2½" x WOF (7): 2½" x 8½" (4) 2½" x WOF (1): 2½" x 8½" (2)
16	20"	2½" x WOF (8): 2½" x 8½" (4)		20"	2½" x WOF (8): 2½" x 8½" (4)
17	22½"	2½" x WOF (8): 2½" x 8½" (4) 2½" x WOF (1): 2½" x 8½" (2)		22½"	2½" x WOF (8): 2½" x 8½" (4) 2½" x WOF (1): 2½" x 8½" (2)
18	22½"	2½" x WOF (9): 2½" x 8½" (4)		22½"	2½" x WOF (9): 2½" x 8½" (4)
20	25"	2½" x WOF (10): 2½" x 8½" (4)		25"	2½" x WOF (10): 2½" x 8½" (4)
21	27½"	2½" x WOF (10): 2½" x 8½" (4) 2½" x WOF (1): 2½" x 8½" (2)		27½"	2½" x WOF (10): 2½" x 8½" (4) 2½" x WOF (1): 2½" x 8½" (2)
22	27½"	2½" x WOF (11): 2½" x 8½" (4)		27½"	2½" x WOF (11): 2½" x 8½" (4)
24	30"	2½" x WOF (12): 2½" x 8½" (4)		30"	2½" x WOF (12): 2½" x 8½" (4)
26	32½"	2½" x WOF (13): 2½" x 8½" (4)		32½"	2½" x WOF (13): 2½" x 8½" (4)
28	35"	2½" x WOF (14): 2½" x 8½" (4)		35"	2½" x WOF (14): 2½" x 8½" (4)
32	40"	2½" x WOF (16): 2½" x 8½" (4)		40"	2½" x WOF (16): 2½" x 8½" (4)
34	42½"	2½" x WOF (17): 2½" x 8½" (4)		42½"	2½" x WOF (17): 2½" x 8½" (4)

	FABRIC 1		FABRIC 2	
#	IN.	CUTTING REQUIREMENTS	IN.	CUTTING REQUIREMENTS
36	45"	2½ x WOF (18): 2½" x 8½" (4)	45"	2½ x WOF (18): 2½" x 8½" (4)
40	50"	2½ x WOF (20): 2½" x 8½" (4)	50"	2½" x WOF (20): 2½" x 8½" (4)
44	55"	2½" x WOF (22): 2½" x 8½" (4)	55"	2½" x WOF (22): 2½" x 8½" (4)
45	57½"	2½" x WOF (22): 2½" x 8½" (4) 2½" x WOF (1): 2½" x 8½" (2)	57½"	2½" x WOF (22): 2½" x 8½" (4) 2½" x WOF (1): 2½" x 8½" (2)
48	60"	2½" x WOF (24): 2½" x 8½" (4)	60"	2½" x WOF (24): 2½" x 8½" (4)
50	62½"	2½" x WOF (25): 2½" x 8½" (4)	62½"	2½" x WOF (25): 2½" x 8½" (4)
52	65"	2½" x WOF (26): 2½" x 8½" (4)	65"	2½" x WOF (26): 2½" x 8½" (4)
56	70"	2½" x WOF (28): 2½" x 8½" (4)	70"	2½" x WOF (28): 2½" x 8½" (4)

Block 02

DESIGN PAGE 35

#	IN.	CUTTING REQUIREMENTS	IN.	CUTTING REQUIREMENTS
	FABRIC 1		**FABRIC 2**	
1	4½"	4½" x WOF (1): 4½" x 4½" (2)	4½"	4½" x WOF (1): 4½" x 4½" (2)
2	4½"	4½" x WOF (1): 4½" x 4½" (4)	4½"	4½" x WOF (1): 4½" x 4½" (4)
3	4½"	4½" x WOF (1): 4½" x 4½" (6)	4½"	4½" x WOF (1): 4½" x 4½" (6)
4	4½"	4½" x WOF (1): 4½" x 4½" (8)	4½"	4½" x WOF (1): 4½" x 4½" (8)
5	9"	4½" x WOF (1): 4½" x 4½" (9) 4½" x WOF (1): 4½" x 4½" (1)	9"	4½" x WOF (1): 4½" x 4½" (9) 4½" x WOF (1): 4½" x 4½" (1)
6	9"	4½" x WOF (1): 4½" x 4½" (9) 4½" x WOF (1): 4½" x 4½" (3)	9"	4½" x WOF (1): 4½" x 4½" (9) 4½" x WOF (1): 4½" x 4½" (3)
7	9"	4½" x WOF (1): 4½" x 4½" (9) 4½" x WOF (1): 4½" x 4½" (5)	9"	4½" x WOF (1): 4½" x 4½" (9) 4½" x WOF (1): 4½" x 4½" (5)
8	9"	4½" x WOF (1): 4½" x 4½" (9) 4½" x WOF (1): 4½" x 4½" (7)	9"	4½" x WOF (1): 4½" x 4½" (9) 4½" x WOF (1): 4½" x 4½" (7)
9	9"	4½" x WOF (2): 4½" x 4½" (9)	9"	4½" x WOF (2): 4½" x 4½" (9)
10	13½"	4½" x WOF (2): 4½" x 4½" (9) 4½" x WOF (1): 4½" x 4½" (2)	13½"	4½" x WOF (2): 4½" x 4½" (9) 4½" x WOF (1): 4½" x 4½" (2)
11	13½"	4½" x WOF (2): 4½" x 4½" (9) 4½" x WOF (1): 4½" x 4½" (4)	13½"	4½" x WOF (2): 4½" x 4½" (9) 4½" x WOF (1): 4½" x 4½" (4)
12	13½"	4½" x WOF (2): 4½" x 4½" (9) 4½" x WOF (1): 4½" x 4½" (6)	13½"	4½" x WOF (2): 4½" x 4½" (9) 4½" x WOF (1): 4½" x 4½" (6)
13	13½"	4½" x WOF (2): 4½" x 4½" (9) 4½" x WOF (1): 4½" x 4½" (8)	13½"	4½" x WOF (2): 4½" x 4½" (9) 4½" x WOF (1): 4½" x 4½" (8)
14	18"	4½" x WOF (3): 4½" x 4½" (9) 4½" x WOF (1): 4½" x 4½" (1)	18"	4½" x WOF (3): 4½" x 4½" (9) 4½" x WOF (1): 4½" x 4½" (1)
15	18"	4½" x WOF (3): 4½" x 4½" (9) 4½" x WOF (1): 4½" x 4½" (3)	18"	4½" x WOF (3): 4½" x 4½" (9) 4½" x WOF (1): 4½" x 4½" (3)
16	18"	4½" x WOF (3): 4½" x 4½" (9) 4½" x WOF (1): 4½" x 4½" (5)	18"	4½" x WOF (3): 4½" x 4½" (9) 4½" x WOF (1): 4½" x 4½" (5)
17	18"	4½" x WOF (3): 4½" x 4½" (9) 4½" x WOF (1): 4½" x 4½" (7)	18"	4½" x WOF (3): 4½" x 4½" (9) 4½" x WOF (1): 4½" x 4½" (7)
18	18"	4½" x WOF (4): 4½" x 4½" (9)	18"	4½" x WOF (4): 4½" x 4½" (9)
20	22½"	4½" x WOF (4): 4½" x 4½" (9) 4½" x WOF (1): 4½" x 4½" (4)	22½"	4½" x WOF (4): 4½" x 4½" (9) 4½" x WOF (1): 4½" x 4½" (4)
21	22½"	4½" x WOF (4): 4½" x 4½" (9) 4½" x WOF (1): 4½" x 4½" (6)	22½"	4½" x WOF (4): 4½" x 4½" (9) 4½" x WOF (1): 4½" x 4½" (6)
22	22½"	4½" x WOF (4): 4½" x 4½" (9) 4½" x WOF (1): 4½" x 4½" (8)	22½"	4½" x WOF (4): 4½" x 4½" (9) 4½" x WOF (1): 4½" x 4½" (8)
24	27"	4½" x WOF (5): 4½" x 4½" (9) 4½" x WOF (1): 4½" x 4½" (3)	27"	4½" x WOF (5): 4½" x 4½" (9) 4½" x WOF (1): 4½" x 4½" (3)

	FABRIC 1		**FABRIC 2**	
#	IN.	CUTTING REQUIREMENTS	IN.	CUTTING REQUIREMENTS
26	27"	4½ x WOF (5): 4½" x 4½" (9) 4½ x WOF (1): 4½" x 4½" (7)	27"	4½ x WOF (5): 4½" x 4½" (9) 4½" x WOF (1): 4½" x 4½" (7)
28	31½"	4½" x WOF (6): 4½" x 4½" (9) 4½" x WOF (1): 4½" x 4½" (2)	31½"	4½" x WOF (6): 4½" x 4½" (9) 4½" x WOF (1): 4½" x 4½" (2)
32	36"	4½" x WOF (7): 4½" x 4½" (9) 4½" x WOF (1): 4½" x 4½" (1)	36"	4½" x WOF (7): 4½" x 4½" (9) 4½" x WOF (1): 4½" x 4½" (1)
34	36"	4½" x WOF (7): 4½" x 4½" (9) 4½" x WOF (1): 4½" x 4½" (5)	36"	4½" x WOF (7): 4½" x 4½" (9) 4½" x WOF (1): 4½" x 4½" (5)
36	36"	4½" x WOF (8): 4½" x 4½" (9)	36"	4½" x WOF (8): 4½" x 4½" (9)
40	40½"	4½" x WOF (8): 4½" x 4½" (9) 4½" x WOF (1): 4½" x 4½" (8)	40½"	4½" x WOF (8): 4½" x 4½" (9) 4½" x WOF (1): 4½" x 4½" (8)
44	45"	4½" x WOF (9): 4½" x 4½" (9) 4½" x WOF (1): 4½" x 4½" (7)	45"	4½" x WOF (9): 4½" x 4½" (9) 4½" x WOF (1): 4½" x 4½" (7)
45	45"	4½" x WOF (10): 4½" x 4½" (9)	45"	4½" x WOF (10): 4½" x 4½" (9)
48	49½"	4½" x WOF (10): 4½" x 4½" (9) 4½" x WOF (1): 4½" x 4½" (6)	49½"	4½" x WOF (10): 4½" x 4½" (9) 4½" x WOF (1): 4½" x 4½" (6)
50	54"	4½" x WOF (11): 4½" x 4½" (9) 4½" x WOF (1): 4½" x 4½" (1)	54"	4½" x WOF (11): 4½" x 4½" (9) 4½" x WOF (1): 4½" x 4½" (1)
52	54"	4½" x WOF (11): 4½" x 4½" (9) 4½" x WOF (1): 4½" x 4½" (5)	54"	4½" x WOF (11): 4½" x 4½" (9) 4½" x WOF (1): 4½" x 4½" (5)
56	58½"	4½" x WOF (12): 4½" x 4½" (9) 4½" x WOF (1): 4½" x 4½" (4)	58½"	4½" x WOF (12): 4½" x 4½" (9) 4½" x WOF (1): 4½" x 4½" (4)

Block 03

#	IN.	FABRIC 1 CUTTING REQUIREMENTS	IN.	FABRIC 2 CUTTING REQUIREMENTS
1	2½"	2½" x WOF (1): 2½" x 2½" (8)	2½"	2½" x WOF (1): 2½" x 2½" (8)
2	2½"	2½" x WOF (1): 2½" x 2½" (16)	2½"	2½" x WOF (1): 2½" x 2½" (16)
3	5"	2½" x WOF (1): 2½" x 2½" (16) 2½" x WOF (1): 2½" x 2½" (8)	5"	2½" x WOF (1): 2½" x 2½" (16) 2½" x WOF (1): 2½" x 2½" (8)
4	5"	2½" x WOF (2): 2½" x 2½" (16)	5"	2½" x WOF (2): 2½" x 2½" (16)
5	7½"	2½" x WOF (2): 2½" x 2½" (16) 2½" x WOF (1): 2½" x 2½" (8)	7½"	2½" x WOF (2): 2½" x 2½" (16) 2½" x WOF (1): 2½" x 2½" (8)
6	7½"	2½" x WOF (3): 2½" x 2½" (16)	7½"	2½" x WOF (3): 2½" x 2½" (16)
7	10"	2½" x WOF (3): 2½" x 2½" (16) 2½" x WOF (1): 2½" x 2½" (8)	10"	2½" x WOF (3): 2½" x 2½" (16) 2½" x WOF (1): 2½" x 2½" (8)
8	10"	2½" x WOF (4): 2½" x 2½" (16)	10"	2½" x WOF (4): 2½" x 2½" (16)
9	12½"	2½" x WOF (4): 2½" x 2½" (16) 2½" x WOF (1): 2½" x 2½" (8)	12½"	2½" x WOF (4): 2½" x 2½" (16) 2½" x WOF (1): 2½" x 2½" (8)
10	12½"	2½" x WOF (5): 2½" x 2½" (16)	12½"	2½" x WOF (5): 2½" x 2½" (16)
11	15"	2½" x WOF (5): 2½" x 2½" (16) 2½" x WOF (1): 2½" x 2½" (8)	15"	2½" x WOF (5): 2½" x 2½" (16) 2½" x WOF (1): 2½" x 2½" (8)
12	15"	2½" x WOF (6): 2½" x 2½" (16)	15"	2½" x WOF (6): 2½" x 2½" (16)
13	17½"	2½" x WOF (6): 2½" x 2½" (16) 2½" x WOF (1): 2½" x 2½" (8)	17½"	2½" x WOF (6): 2½" x 2½" (16) 2½" x WOF (1): 2½" x 2½" (8)
14	17½"	2½" x WOF (7): 2½" x 2½" (16)	17½"	2½" x WOF (7): 2½" x 2½" (16)
15	20"	2½" x WOF (7): 2½" x 2½" (16) 2½" x WOF (1): 2½" x 2½" (8)	20"	2½" x WOF (7): 2½" x 2½" (16) 2½" x WOF (1): 2½" x 2½" (8)
16	20"	2½" x WOF (8): 2½" x 2½" (16)	20"	2½" x WOF (8): 2½" x 2½" (16)
17	22½"	2½" x WOF (8): 2½" x 2½" (16) 2½" x WOF (1): 2½" x 2½" (8)	22½"	2½" x WOF (8): 2½" x 2½" (16) 2½" x WOF (1): 2½" x 2½" (8)
18	22½"	2½" x WOF (9): 2½" x 2½" (16)	22½"	2½" x WOF (9): 2½" x 2½" (16)
20	25"	2½" x WOF (10): 2½" x 2½" (16)	25"	2½" x WOF (10): 2½" x 2½" (16)
21	27½"	2½" x WOF (10): 2½" x 2½" (16) 2½" x WOF (1): 2½" x 2½" (8)	27½"	2½" x WOF (10): 2½" x 2½" (16) 2½" x WOF (1): 2½" x 2½" (8)
22	27½"	2½" x WOF (11): 2½" x 2½" (16)	27½"	2½" x WOF (11): 2½" x 2½" (16)
24	30"	2½" x WOF (12): 2½" x 2½" (16)	30"	2½" x WOF (12): 2½" x 2½" (16)
26	32½"	2½" x WOF (13): 2½" x 2½" (16)	32½"	2½" x WOF (13): 2½" x 2½" (16)
28	35"	2½" x WOF (14): 2½" x 2½" (16)	35"	2½" x WOF (14): 2½" x 2½" (16)
32	40"	2½" x WOF (16): 2½" x 2½" (16)	40"	2½" x WOF (16): 2½" x 2½" (16)

	FABRIC 1		FABRIC 2	
#	IN.	CUTTING REQUIREMENTS	IN.	CUTTING REQUIREMENTS
34	42½"	2½" x WOF (17): 2½" x 2½" (16)	42½"	2½" x WOF (17): 2½" x 2½" (16)
36	45"	2½" x WOF (18): 2½" x 2½" (16)	45"	2½" x WOF (18): 2½" x 2½" (16)
40	50"	2½" x WOF (20): 2½" x 2½" (16)	50"	2½" x WOF (20): 2½" x 2½" (16)
44	55"	2½" x WOF (22): 2½" x 2½" (16)	55"	2½" x WOF (22): 2½" x 2½" (16)
45	57½"	2½" x WOF (22): 2½" x 2½" (16) 2½" x WOF (1): 2½" x 2½" (8)	57½"	2½" x WOF (22): 2½" x 2½" (16) 2½" x WOF (1): 2½" x 2½" (8)
48	60"	2½" x WOF (24): 2½" x 2½" (16)	60"	2½" x WOF (24): 2½" x 2½" (16)
50	62½"	2½" x WOF (25): 2½" x 2½" (16)	62½"	2½" x WOF (25): 2½" x 2½" (16)
52	65"	2½" x WOF (26): 2½" x 2½" (16)	65"	2½" x WOF (26): 2½" x 2½" (16)
56	70"	2½" x WOF (28): 2½" x 2½" (16)	70"	2½" x WOF (28): 2½" x 2½" (16)

#	IN.	FABRIC 1 CUTTING REQUIREMENTS	IN.	FABRIC 2 CUTTING REQUIREMENTS
1	2½"	2½" x WOF (1): 2½" x 4½" (2); 2½" x 8½" (2)	4½"	4½" x WOF (1): 4½" x 4½" (1)
2	5"	2½" x WOF (1): 2½" x 4½" (3); 2½" x 8½" (3) 2½" x WOF (1): 2½" x 4½" (1); 2½" x 8½" (1)	4½"	4½" x WOF (1): 4½" x 4½" (2)
3	5"	2½" x WOF (2): 2½" x 4½" (3); 2½" x 8½" (3)	4½"	4½" x WOF (1): 4½" x 4½" (3)
4	7½"	2½" x WOF (2): 2½" x 4½" (3); 2½" x 8½" (3) 2½" x WOF (1): 2½" x 4½" (2); 2½" x 8½" (2)	4½"	4½" x WOF (1): 4½" x 4½" (4)
5	10"	2½" x WOF (3): 2½" x 4½" (3); 2½" x 8½" (3) 2½" x WOF (1): 2½" x 4½" (1); 2½" x 8½" (1)	4½"	4½" x WOF (1): 4½" x 4½" (5)
6	10"	2½" x WOF (4): 2½" x 4½" (3); 2½" x 8½" (3)	4½"	4½" x WOF (1): 4½" x 4½" (6)
7	12½"	2½" x WOF (4): 2½" x 4½" (3); 2½" x 8½" (3) 2½" x WOF (1): 2½" x 4½" (2); 2½" x 8½" (2)	4½"	4½" x WOF (1): 4½" x 4½" (7)
8	15"	2½" x WOF (5): 2½" x 4½" (3); 2½" x 8½" (3) 2½" x WOF (1): 2½" x 4½" (1); 2½" x 8½" (1)	4½"	4½" x WOF (1): 4½" x 4½" (8)
9	15"	2½" x WOF (6): 2½" x 4½" (3); 2½" x 8½" (3)	4½"	4½" x WOF (1): 4½" x 4½" (9)
10	17½"	2½" x WOF (6): 2½" x 4½" (3); 2½" x 8½" (3) 2½" x WOF (1): 2½" x 4½" (2); 2½" x 8½" (2)	9"	4½" x WOF (1): 4½" x 4½" (9) 4½" x WOF (1): 4½" x 4½" (1)
11	20"	2½" x WOF (7): 2½" x 4½" (3); 2½" x 8½" (3) 2½" x WOF (1): 2½" x 4½" (1); 2½" x 8½" (1)	9"	4½" x WOF (1): 4½" x 4½" (9) 4½" x WOF (1): 4½" x 4½" (2)
12	20"	2½" x WOF (8): 2½" x 4½" (3); 2½" x 8½" (3)	9"	4½" x WOF (1): 4½" x 4½" (9) 4½" x WOF (1): 4½" x 4½" (3)
13	22½"	2½" x WOF (8): 2½" x 4½" (3); 2½" x 8½" (3) 2½" x WOF (1): 2½" x 4½" (2); 2½" x 8½" (2)	9"	4½" x WOF (1): 4½" x 4½" (9) 4½" x WOF (1): 4½" x 4½" (4)
14	25"	2½" x WOF (9): 2½" x 4½" (3); 2½" x 8½" (3) 2½" x WOF (1): 2½" x 4½" (1); 2½" x 8½" (1)	9"	4½" x WOF (1): 4½" x 4½" (9) 4½" x WOF (1): 4½" x 4½" (5)
15	25"	2½" x WOF (10): 2½" x 4½" (3); 2½" x 8½" (3)	9"	4½" x WOF (1): 4½" x 4½" (9) 4½" x WOF (1): 4½" x 4½" (6)
16	27½"	2½" x WOF (10): 2½" x 4½" (3); 2½" x 8½" (3) 2½" x WOF (1): 2½" x 4½" (2); 2½" x 8½" (2)	9"	4½" x WOF (1): 4½" x 4½" (9) 4½" x WOF (1): 4½" x 4½" (7)
17	30"	2½" x WOF (11): 2½" x 4½" (3); 2½" x 8½" (3) 2½" x WOF (1): 2½" x 4½" (1); 2½" x 8½" (1)	9"	4½" x WOF (1): 4½" x 4½" (9) 4½" x WOF (1): 4½" x 4½" (8)
18	30"	2½" x WOF (12): 2½" x 4½" (3); 2½" x 8½" (3)	9"	4½" x WOF (2): 4½" x 4½" (9)
20	35"	2½" x WOF (13): 2½" x 4½" (3); 2½" x 8½" (3) 2½" x WOF (1): 2½" x 4½" (1); 2½" x 8½" (1)	13½"	4½" x WOF (2): 4½" x 4½" (9) 4½" x WOF (1): 4½" x 4½" (2)
21	35"	2½" x WOF (14): 2½" x 4½" (3); 2½" x 8½" (3)	13½"	4½" x WOF (2): 4½" x 4½" (9) 4½" x WOF (1): 4½" x 4½" (3)

| | FABRIC 1 | | FABRIC 2 | |
#	IN.	CUTTING REQUIREMENTS	IN.	CUTTING REQUIREMENTS
22	37½"	2½" x WOF (14): 2½" x 4½" (3); 2½" x 8½" (3) 2½" x WOF (1): 2½" x 4½" (2); 2½" x 8½" (2)	13½"	4½" x WOF (2): 4½" x 4½" (9) 4½" x WOF (1): 4½" x 4½" (4)
24	40"	2½" x WOF (16): 2½" x 4½" (3); 2½" x 8½" (3)	13½"	4½" x WOF (2): 4½" x 4½" (9) 4½" x WOF (1): 4½" x 4½" (6)
26	45"	2½" x WOF (17): 2½" x 4½" (3); 2½" x 8½" (3) 2½" x WOF (1): 2½" x 4½" (1); 2½" x 8½" (1)	13½"	4½" x WOF (2): 4½" x 4½" (9) 4½" x WOF (1): 4½" x 4½" (8)
28	47½"	2½" x WOF (18): 2½" x 4½" (3); 2½" x 8½" (3) 2½" x WOF (1): 2½" x 4½" (2); 2½" x 8½" (2)	18"	4½" x WOF (3): 4½" x 4½" (9) 4½" x WOF (1): 4½" x 4½" (1)
32	55"	2½" x WOF (21): 2½" x 4½" (3); 2½" x 8½" (3) 2½" x WOF (1): 2½" x 4½" (1); 2½" x 8½" (1)	18"	4½" x WOF (3): 4½" x 4½" (9) 4½" x WOF (1): 4½" x 4½" (5)
34	57½"	2½" x WOF (22): 2½" x 4½" (3); 2½" x 8½" (3) 2½" x WOF (1): 2½" x 4½" (2); 2½" x 8½" (2)	18"	4½" x WOF (3): 4½" x 4½" (9) 4½" x WOF (1): 4½" x 4½" (7)
36	60"	2½" x WOF (24): 2½" x 4½" (3); 2½" x 8½" (3)	18"	4½" x WOF (4): 4½" x 4½" (9)
40	67½"	2½" x WOF (26): 2½" x 4½" (3); 2½" x 8½" (3) 2½" x WOF (1): 2½" x 4½" (2); 2½" x 8½" (2)	22½"	4½" x WOF (4): 4½" x 4½" (9) 4½" x WOF (1): 4½" x 4½" (4)
44	75"	2½" x WOF (29): 2½" x 4½" (3); 2½" x 8½" (3) 2½" x WOF (1): 2½" x 4½" (1); 2½" x 8½" (1)	22½"	4½" x WOF (4): 4½" x 4½" (9) 4½" x WOF (1): 4½" x 4½" (8)
45	75"	2½" x WOF (30): 2½" x 4½" (3); 2½" x 8½" (3)	22½"	4½" x WOF (5): 4½" x 4½" (9)
48	80"	2½" x WOF (32): 2½" x 4½" (3); 2½" x 8½" (3)	27"	4½" x WOF (5): 4½" x 4½" (9) 4½" x WOF (1): 4½" x 4½" (3)
50	85"	2½" x WOF (33): 2½" x 4½" (3); 2½" x 8½" (3) 2½" x WOF (1): 2½" x 4½" (1); 2½" x 8½" (1)	27"	4½" x WOF (5): 4½" x 4½" (9) 4½" x WOF (1): 4½" x 4½" (5)
52	87½"	2½" x WOF (34): 2½" x 4½" (3); 2½" x 8½" (3) 2½" x WOF (1): 2½" x 4½" (2); 2½" x 8½" (2)	27"	4½" x WOF (5): 4½" x 4½" (9) 4½" x WOF (1): 4½" x 4½" (7)
56	95"	2½" x WOF (37): 2½" x 4½" (3); 2½" x 8½" (3) 2½" x WOF (1): 2½" x 4½" (1); 2½" x 8½" (1)	31½"	4½" x WOF (6): 4½" x 4½" (9) 4½" x WOF (1): 4½" x 4½" (2)

Block 05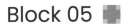

DESIGN PAGE 38

#	FABRIC 1		FABRIC 2	
	IN.	CUTTING REQUIREMENTS	IN.	CUTTING REQUIREMENTS
1	4½"	4½" x WOF (1): 4½" x 2½" (2); 4½" x 8½" (1)	2½"	2½" x WOF (1): 2½" x 2½" (4)
2	4½"	4½" x WOF (1): 4½" x 2½" (4); 4½" x 8½" (2)	2½"	2½" x WOF (1): 2½" x 2½" (8)
3	4½"	4½" x WOF (1): 4½" x 2½" (6); 4½" x 8½" (3)	2½"	2½" x WOF (1): 2½" x 2½" (12)
4	9"	4½" x WOF (1): 4½" x 2½" (6); 4½" x 8½" (3) 4½" x WOF (1): 4½" x 2½" (2); 4½" x 8½" (1)	2½"	2½" x WOF (1): 2½" x 2½" (16)
5	9"	4½" x WOF (1): 4½" x 2½" (6); 4½" x 8½" (3) 4½" x WOF (1): 4½" x 2½" (4); 4½" x 8½" (2)	5"	2½" x WOF (1): 2½" x 2½" (16) 2½" x WOF (1): 2½" x 2½" (4)
6	9"	4½" x WOF (2): 4½" x 2½" (6); 4½" x 8½" (3)	5"	2½" x WOF (1): 2½" x 2½" (16) 2½" x WOF (1): 2½" x 2½" (8)
7	13½"	4½" x WOF (2): 4½" x 2½" (6); 4½" x 8½" (3) 4½" x WOF (1): 4½" x 2½" (2); 4½" x 8½" (1)	5"	2½" x WOF (1): 2½" x 2½" (16) 2½" x WOF (1): 2½" x 2½" (12)
8	13½"	4½" x WOF (2): 4½" x 2½" (6); 4½" x 8½" (3) 4½" x WOF (1): 4½" x 2½" (4); 4½" x 8½" (2)	5"	2½" x WOF (2): 2½" x 2½" (16)
9	13½"	4½" x WOF (3): 4½" x 2½" (6); 4½" x 8½" (3)	7½"	2½" x WOF (2): 2½" x 2½" (16) 2½" x WOF (1): 2½" x 2½" (4)
10	18"	4½" x WOF (3): 4½" x 2½" (6); 4½" x 8½" (3) 4½" x WOF (1): 4½" x 2½" (2); 4½" x 8½" (1)	7½"	2½" x WOF (2): 2½" x 2½" (16) 2½" x WOF (1): 2½" x 2½" (8)
11	18"	4½" x WOF (3): 4½" x 2½" (6); 4½" x 8½" (3) 4½" x WOF (1): 4½" x 2½" (4); 4½" x 8½" (2)	7½"	2½" x WOF (2): 2½" x 2½" (16) 2½" x WOF (1): 2½" x 2½" (12)
12	18"	4½" x WOF (4): 4½" x 2½" (6); 4½" x 8½" (3)	7½"	2½" x WOF (3): 2½" x 2½" (16)
13	22½"	4½" x WOF (4): 4½" x 2½" (6); 4½" x 8½" (3) 4½" x WOF (1): 4½" x 2½" (2); 4½" x 8½" (1)	10"	2½" x WOF (3): 2½" x 2½" (16) 2½" x WOF (1): 2½" x 2½" (4)
14	22½"	4½" x WOF (4): 4½" x 2½" (6); 4½" x 8½" (3) 4½" x WOF (1): 4½" x 2½" (4); 4½" x 8½" (2)	10"	2½" x WOF (3): 2½" x 2½" (16) 2½" x WOF (1): 2½" x 2½" (8)
15	22½"	4½" x WOF (5): 4½" x 2½" (6); 4½" x 8½" (3)	10"	2½" x WOF (3): 2½" x 2½" (16) 2½" x WOF (1): 2½" x 2½" (12)
16	27"	4½" x WOF (5): 4½" x 2½" (6); 4½" x 8½" (3) 4½" x WOF (1): 4½" x 2½" (2); 4½" x 8½" (1)	10"	2½" x WOF (4): 2½" x 2½" (16)
17	27"	4½" x WOF (5): 4½" x 2½" (6); 4½" x 8½" (3) 4½" x WOF (1): 4½" x 2½" (4); 4½" x 8½" (2)	12½"	2½" x WOF (4): 2½" x 2½" (16) 2½" x WOF (1): 2½" x 2½" (4)
18	27"	4½" x WOF (6): 4½" x 2½" (6); 4½" x 8½" (3)	12½"	2½" x WOF (4): 2½" x 2½" (16) 2½" x WOF (1): 2½" x 2½" (8)
20	31½"	4½" x WOF (6): 4½" x 2½" (6); 4½" x 8½" (3) 4½" x WOF (1): 4½" x 2½" (4); 4½" x 8½" (2)	12½"	2½" x WOF (5): 2½" x 2½" (16)
21	31½"	4½" x WOF (7): 4½" x 2½" (6); 4½" x 8½" (3)	15"	2½" x WOF (5): 2½" x 2½" (16) 2½" x WOF (1): 2½" x 2½" (4)

| | FABRIC 1 | | FABRIC 2 | |
#	IN.	CUTTING REQUIREMENTS	IN.	CUTTING REQUIREMENTS
22	36"	4½" x WOF (7): 4½" x 2½" (6); 4½" x 8½" (3) 4½" x WOF (1): 4½" x 2½" (2); 4½" x 8½" (1)	15"	2½" x WOF (5): 2½" x 2½" (16) 2½" x WOF (1): 2½" x 2½" (8)
24	36"	4½" x WOF (8): 4½" x 2½" (6); 4½" x 8½" (3)	15"	2½" x WOF (6): 2½" x 2½" (16)
26	40½"	4½" x WOF (8): 4½" x 2½" (6); 4½" x 8½" (3) 4½" x WOF (1): 4½" x 2½" (4); 4½" x 8½" (2)	17½"	2½" x WOF (6): 2½" x 2½" (16) 2½" x WOF (1): 2½" x 2½" (8)
28	45"	4½" x WOF (9): 4½" x 2½" (6); 4½" x 8½" (3) 4½" x WOF (1): 4½" x 2½" (2); 4½" x 8½" (1)	17½"	2½" x WOF (7): 2½" x 2½" (16)
32	49½"	4½" x WOF (10): 4½" x 2½" (6); 4½" x 8½" (3) 4½" x WOF (1): 4½" x 2½" (4); 4½" x 8½" (2)	20"	2½" x WOF (8): 2½" x 2½" (16)
34	54"	4½" x WOF (11): 4½" x 2½" (6); 4½" x 8½" (3) 4½" x WOF (1): 4½" x 2½" (2); 4½" x 8½" (1)	22½"	2½" x WOF (8): 2½" x 2½" (16) 2½" x WOF (1): 2½" x 2½" (8)
36	54"	4½" x WOF (12): 4½" x 2½" (6); 4½" x 8½" (3)	22½"	2½" x WOF (9): 2½" x 2½" (16)
40	63"	4½" x WOF (13): 4½" x 2½" (6); 4½" x 8½" (3) 4½" x WOF (1): 4½" x 2½" (2); 4½" x 8½" (1)	25"	2½" x WOF (10): 2½" x 2½" (16)
44	67½"	4½" x WOF (14): 4½" x 2½" (6); 4½" x 8½" (3) 4½" x WOF (1): 4½" x 2½" (4); 4½" x 8½" (2)	27½"	2½" x WOF (11): 2½" x 2½" (16)
45	67½"	4½" x WOF (15): 4½" x 2½" (6); 4½" x 8½" (3)	30"	2½" x WOF (11): 2½" x 2½" (16) 2½" x WOF (1): 2½" x 2½" (4)
48	72"	4½" x WOF (16): 4½" x 2½" (6); 4½" x 8½" (3)	30"	2½" x WOF (12): 2½" x 2½" (16)
50	76½"	4½" x WOF (16): 4½" x 2½" (6); 4½" x 8½" (3) 4½" x WOF (1): 4½" x 2½" (4); 4½" x 8½" (2)	32½"	2½" x WOF (12): 2½" x 2½" (16) 2½" x WOF (1): 2½" x 2½" (8)
52	81"	4½" x WOF (17): 4½" x 2½" (6); 4½" x 8½" (3) 4½" x WOF (1): 4½" x 2½" (2); 4½" x 8½" (1)	32½"	2½" x WOF (13): 2½" x 2½" (16)
56	85½"	4½" x WOF (18): 4½" x 2½" (6); 4½" x 8½" (3) 4½" x WOF (1): 4½" x 2½" (4); 4½" x 8½" (2)	35"	2½" x WOF (14): 2½" x 2½" (16)

Block 06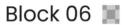

#	IN.	FABRIC 1 CUTTING REQUIREMENTS	IN.	FABRIC 2 CUTTING REQUIREMENTS
1	4½"	4½" x WOF (1): 4½" x 4½" (1); 2½" x 2½" (4)	2½"	2½" x WOF (1): 2½" x 4½" (4)
2	4½"	4½" x WOF (1): 4½" x 4½" (2); 2½" x 2½" (8)	2½"	2½" x WOF (1): 2½" x 4½" (8)
3	7"	4½" x WOF (1): 4½" x 4½" (3) 2½" x WOF (1): 2½" x 2½" (12)	5"	2½" x WOF (1): 2½" x 4½" (9) 2½" x WOF (1): 2½" x 4½" (3)
4	7"	4½" x WOF (1): 4½" x 4½" (4) 2½" x WOF (1): 2½" x 2½" (16)	5"	2½" x WOF (1): 2½" x 4½" (9) 2½" x WOF (1): 2½" x 4½" (7)
5	7"	4½" x WOF (1): 4½" x 4½" (5); 2½" x 2½" (4) 2½" x WOF (1): 2½" x 2½" (16)	7½"	2½" x WOF (2): 2½" x 4½" (9) 2½" x WOF (1): 2½" x 4½" (2)
6	9½"	4½" x WOF (1): 4½" x 4½" (6) 2½" x WOF (1): 2½" x 2½" (16) 2½" x WOF (1): 2½" x 2½" (8)	7½"	2½" x WOF (2): 2½" x 4½" (9) 2½" x WOF (1): 2½" x 4½" (6)
7	9½"	4½" x WOF (1): 4½" x 4½" (7) 2½" x WOF (1): 2½" x 2½" (16) 2½" x WOF (1): 2½" x 2½" (12)	10"	2½" x WOF (3): 2½" x 4½" (9) 2½" x WOF (1): 2½" x 4½" (1)
8	9½"	4½" x WOF (1): 4½" x 4½" (8) 2½" x WOF (2): 2½" x 2½" (16)	10"	2½" x WOF (3): 2½" x 4½" (9) 2½" x WOF (1): 2½" x 4½" (5)
9	12"	4½" x WOF (1): 4½" x 4½" (9) 2½" x WOF (2): 2½" x 2½" (16) 2½" x WOF (1): 2½" x 2½" (4)	10"	2½" x WOF (4): 2½" x 4½" (9)
10	14"	4½" x WOF (1): 4½" x 4½" (9) 4½" x WOF (1): 4½" x 4½" (1); 2½" x 2½" (8) 2½" x WOF (2): 2½" x 2½" (16)	12½"	2½" x WOF (4): 2½" x 4½" (9) 2½" x WOF (1): 2½" x 4½" (4)
11	14"	4½" x WOF (1): 4½" x 4½" (9) 4½" x WOF (1): 4½" x 4½" (2); 2½" x 2½" (12) 2½" x WOF (2): 2½" x 2½" (16)	12½"	2½" x WOF (4): 2½" x 4½" (9) 2½" x WOF (1): 2½" x 4½" (8)
12	16½"	4½" x WOF (1): 4½" x 4½" (9) 4½" x WOF (1): 4½" x 4½" (3) 2½" x WOF (3): 2½" x 2½" (16)	15"	2½" x WOF (5): 2½" x 4½" (9) 2½" x WOF (1): 2½" x 4½" (3)
13	16½"	4½" x WOF (1): 4½" x 4½" (9) 4½" x WOF (1): 4½" x 4½" (4); 2½" x 2½" (4) 2½" x WOF (3): 2½" x 2½" (16)	15"	2½" x WOF (5): 2½" x 4½" (9) 2½" x WOF (1): 2½" x 4½" (7)
14	19"	4½" x WOF (1): 4½" x 4½" (9) 4½" x WOF (1): 4½" x 4½" (5) 2½" x WOF (3): 2½" x 2½" (16) 2½" x WOF (1): 2½" x 2½" (8)	17½"	2½" x WOF (6): 2½" x 4½" (9) 2½" x WOF (1): 2½" x 4½" (2)
15	19"	4½" x WOF (1): 4½" x 4½" (9) 4½" x WOF (1): 4½" x 4½" (6) 2½" x WOF (3): 2½" x 2½" (16) 2½" x WOF (1): 2½" x 2½" (12)	17½"	2½" x WOF (6): 2½" x 4½" (9) 2½" x WOF (1): 2½" x 4½" (6)
16	19"	4½" x WOF (1): 4½" x 4½" (9) 4½" x WOF (1): 4½" x 4½" (7) 2½" x WOF (4): 2½" x 2½" (16)	20"	2½" x WOF (7): 2½" x 4½" (9) 2½" x WOF (1): 2½" x 4½" (1)

#	FABRIC 1		FABRIC 2	
	IN.	CUTTING REQUIREMENTS	IN.	CUTTING REQUIREMENTS
17	21½"	4½" x WOF (1): 4½" x 4½" (9) 4½" x WOF (1): 4½" x 4½" (8) 2½" x WOF (4): 2½" x 2½" (16) 2½" x WOF (1): 2½" x 2½" (4)	20"	2½" x WOF (7): 2½" x 4½" (9) 2½" x WOF (1): 2½" x 4½" (5)
18	21½"	4½" x WOF (2): 4½" x 4½" (9) 2½" x WOF (4): 2½" x 2½" (16) 2½" x WOF (1): 2½" x 2½" (8)	20"	2½" x WOF (8): 2½" x 4½" (9)
20	26"	4½" x WOF (2): 4½" x 4½" (9) 4½" x WOF (1): 4½" x 4½" (2) 2½" x WOF (5): 2½" x 2½" (16)	22½"	2½" x WOF (8): 2½" x 4½" (9) 2½" x WOF (1): 2½" x 4½" (8)
21	26"	4½" x WOF (2): 4½" x 4½" (9) 4½" x WOF (1): 4½" x 4½" (3); 2½" x 2½" (4) 2½" x WOF (5): 2½" x 2½" (16)	25"	2½" x WOF (9): 2½" x 4½" (9) 2½" x WOF (1): 2½" x 4½" (3)
22	26"	4½" x WOF (2): 4½" x 4½" (9) 4½" x WOF (1): 4½" x 4½" (4); 2½" x 2½" (8) 2½" x WOF (5): 2½" x 2½" (16)	25"	2½" x WOF (9): 2½" x 4½" (9) 2½" x WOF (1): 2½" x 4½" (7)
24	28½"	4½" x WOF (2): 4½" x 4½" (9) 4½" x WOF (1): 4½" x 4½" (6) 2½" x WOF (6): 2½" x 2½" (16)	27½"	2½" x WOF (10): 2½" x 4½" (9) 2½" x WOF (1): 2½" x 4½" (6)
26	31"	4½" x WOF (2): 4½" x 4½" (9) 4½" x WOF (1): 4½" x 4½" (8) 2½" x WOF (6): 2½" x 2½" (16) 2½" x WOF (1): 2½" x 2½" (8)	30"	2½" x WOF (11): 2½" x 4½" (9) 2½" x WOF (1): 2½" x 4½" (5)
28	35½"	4½" x WOF (3): 4½" x 4½" (9) 4½" x WOF (1): 4½" x 4½" (1) 2½" x WOF (7): 2½" x 2½" (16)	32½"	2½" x WOF (12): 2½" x 4½" (9) 2½" x WOF (1): 2½" x 4½" (4)
32	38"	4½" x WOF (3): 4½" x 4½" (9) 4½" x WOF (1): 4½" x 4½" (5) 2½" x WOF (8): 2½" x 2½" (16)	37½"	2½" x WOF (14): 2½" x 4½" (9) 2½" x WOF (1): 2½" x 4½" (2)
34	40½"	4½" x WOF (3): 4½" x 4½" (9) 4½" x WOF (1): 4½" x 4½" (7) 2½" x WOF (8): 2½" x 2½" (16) 2½" x WOF (1): 2½" x 2½" (8)	40"	2½" x WOF (15): 2½" x 4½" (9) 2½" x WOF (1): 2½" x 4½" (1)
36	40½"	4½" x WOF (4): 4½" x 4½" (9) 2½" x WOF (9): 2½" x 2½" (16)	40"	2½" x WOF (16): 2½" x 4½" (9)
40	47½"	4½" x WOF (4): 4½" x 4½" (9) 4½" x WOF (1): 4½" x 4½" (4) 2½" x WOF (10): 2½" x 2½" (16)	45"	2½" x WOF (17): 2½" x 4½" (9) 2½" x WOF (1): 2½" x 4½" (7)
44	50"	4½" x WOF (4): 4½" x 4½" (9) 4½" x WOF (1): 4½" x 4½" (8) 2½" x WOF (11): 2½" x 2½" (16)	50"	2½" x WOF (19): 2½" x 4½" (9) 2½" x WOF (1): 2½" x 4½" (5)

continues on next page

Block 06 continued

#	\multicolumn{2}{c}{FABRIC 1}		\multicolumn{2}{c}{FABRIC 2}	
	IN.	CUTTING REQUIREMENTS	IN.	CUTTING REQUIREMENTS
45	52½"	4½" x WOF (5): 4½" x 4½" (9) 2½" x WOF (11): 2½" x 2½" (16) 2½" x WOF (1): 2½" x 2½" (4)	50"	2½" x WOF (20): 2½" x 4½" (9)
48	57"	4½" x WOF (5): 4½" x 4½" (9) 4½" x WOF (1): 4½" x 4½" (3) 2½" x WOF (12): 2½" x 2½" (16)	55"	2½" x WOF (21): 2½" x 4½" (9) 2½" x WOF (1): 2½" x 4½" (3)
50	59½"	4½" x WOF (5): 4½" x 4½" (9) 4½" x WOF (1): 4½" x 4½" (5) 2½" x WOF (12): 2½" x 2½" (16) 2½" x WOF (1): 2½" x 2½" (8)	57½"	2½" x WOF (22): 2½" x 4½" (9) 2½" x WOF (1): 2½" x 4½" (2)
52	59½"	4½" x WOF (5): 4½" x 4½" (9) 4½" x WOF (1): 4½" x 4½" (7) 2½" x WOF (13): 2½" x 2½" (16)	60"	2½" x WOF (23): 2½" x 4½" (9) 2½" x WOF (1): 2½" x 4½" (1)
56	66½"	4½" x WOF (6): 4½" x 4½" (9) 4½" x WOF (1): 4½" x 4½" (2) 2½" x WOF (14): 2½" x 2½" (16)	62½"	2½" x WOF (24): 2½" x 4½" (9) 2½" x WOF (1): 2½" x 4½" (8)

Block 07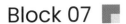

DESIGN PAGE 40

#	IN.	FABRIC 1 CUTTING REQUIREMENTS	IN.	FABRIC 2 CUTTING REQUIREMENTS
1	4½"	4½" x WOF (1): 4½" x 4½" (1); 4½" x 8½" (1)	4½"	4½" x WOF (1): 4½" x 4½" (1)
2	4½"	4½" x WOF (1): 4½" x 4½" (2); 4½" x 8½" (2)	4½"	4½" x WOF (1): 4½" x 4½" (2)
3	4½"	4½" x WOF (1): 4½" x 4½" (3); 4½" x 8½" (3)	4½"	4½" x WOF (1): 4½" x 4½" (3)
4	9"	4½" x WOF (1): 4½" x 4½" (3); 4½" x 8½" (3) 4½" x WOF (1): 4½" x 4½" (1); 4½" x 8½" (1)	4½"	4½" x WOF (1): 4½" x 4½" (4)
5	9"	4½" x WOF (1): 4½" x 4½" (3); 4½" x 8½" (3) 4½" x WOF (1): 4½" x 4½" (2); 4½" x 8½" (2)	4½"	4½" x WOF (1): 4½" x 4½" (5)
6	9"	4½" x WOF (2): 4½" x 4½" (3); 4½" x 8½" (3)	4½"	4½" x WOF (1): 4½" x 4½" (6)
7	13½"	4½" x WOF (2): 4½" x 4½" (3); 4½" x 8½" (3) 4½" x WOF (1): 4½" x 4½" (1); 4½" x 8½" (1)	4½"	4½" x WOF (1): 4½" x 4½" (7)
8	13½"	4½" x WOF (2): 4½" x 4½" (3); 4½" x 8½" (3) 4½" x WOF (1): 4½" x 4½" (2); 4½" x 8½" (2)	4½"	4½" x WOF (1): 4½" x 4½" (8)
9	13½"	4½" x WOF (3): 4½" x 4½" (3); 4½" x 8½" (3)	4½"	4½" x WOF (1): 4½" x 4½" (9)
10	18"	4½" x WOF (3): 4½" x 4½" (3); 4½" x 8½" (3) 4½" x WOF (1): 4½" x 4½" (1); 4½" x 8½" (1)	9"	4½" x WOF (1): 4½" x 4½" (9) 4½" x WOF (1): 4½" x 4½" (1)
11	18"	4½" x WOF (3): 4½" x 4½" (3); 4½" x 8½" (3) 4½" x WOF (1): 4½" x 4½" (2); 4½" x 8½" (2)	9"	4½" x WOF (1): 4½" x 4½" (9) 4½" x WOF (1): 4½" x 4½" (2)
12	18"	4½" x WOF (4): 4½" x 4½" (3); 4½" x 8½" (3)	9"	4½" x WOF (1): 4½" x 4½" (9) 4½" x WOF (1): 4½" x 4½" (3)
13	22½"	4½" x WOF (4): 4½" x 4½" (3); 4½" x 8½" (3) 4½" x WOF (1): 4½" x 4½" (1); 4½" x 8½" (1)	9"	4½" x WOF (1): 4½" x 4½" (9) 4½" x WOF (1): 4½" x 4½" (4)
14	22½"	4½" x WOF (4): 4½" x 4½" (3); 4½" x 8½" (3) 4½" x WOF (1): 4½" x 4½" (2); 4½" x 8½" (2)	9"	4½" x WOF (1): 4½" x 4½" (9) 4½" x WOF (1): 4½" x 4½" (5)
15	22½"	4½" x WOF (5): 4½" x 4½" (3); 4½" x 8½" (3)	9"	4½" x WOF (1): 4½" x 4½" (9) 4½" x WOF (1): 4½" x 4½" (6)
16	27"	4½" x WOF (5): 4½" x 4½" (3); 4½" x 8½" (3) 4½" x WOF (1): 4½" x 4½" (1); 4½" x 8½" (1)	9"	4½" x WOF (1): 4½" x 4½" (9) 4½" x WOF (1): 4½" x 4½" (7)
17	27"	4½" x WOF (5): 4½" x 4½" (3); 4½" x 8½" (3) 4½" x WOF (1): 4½" x 4½" (2); 4½" x 8½" (2)	9"	4½" x WOF (1): 4½" x 4½" (9) 4½" x WOF (1): 4½" x 4½" (8)
18	27"	4½" x WOF (6): 4½" x 4½" (3); 4½" x 8½" (3)	9"	4½" x WOF (2): 4½" x 4½" (9)
20	31½"	4½" x WOF (6): 4½" x 4½" (3); 4½" x 8½" (3) 4½" x WOF (1): 4½" x 4½" (2); 4½" x 8½" (2)	13½"	4½" x WOF (2): 4½" x 4½" (9) 4½" x WOF (1): 4½" x 4½" (2)
21	31½"	4½" x WOF (7): 4½" x 4½" (3); 4½" x 8½" (3)	13½"	4½" x WOF (2): 4½" x 4½" (9) 4½" x WOF (1): 4½" x 4½" (3)
22	36"	4½" x WOF (7): 4½" x 4½" (3); 4½" x 8½" (3) 4½" x WOF (1): 4½" x 4½" (1); 4½" x 8½" (1)	13½"	4½" x WOF (2): 4½" x 4½" (9) 4½" x WOF (1): 4½" x 4½" (4)

continues on next page

#	FABRIC 1		FABRIC 2	
	IN.	CUTTING REQUIREMENTS	IN.	CUTTING REQUIREMENTS
24	36"	4½" x WOF (8): 4½" x 4½" (3); 4½" x 8½" (3)	13½"	4½" x WOF (2): 4½" x 4½" (9) 4½" x WOF (1): 4½" x 4½" (6)
26	40½"	4½" x WOF (8): 4½" x 4½" (3); 4½" x 8½" (3) 4½" x WOF (1): 4½" x 4½" (2); 4½" x 8½" (2)	13½"	4½" x WOF (2): 4½" x 4½" (9) 4½" x WOF (1): 4½" x 4½" (8)
28	45"	4½" x WOF (9): 4½" x 4½" (3); 4½" x 8½" (3) 4½" x WOF (1): 4½" x 4½" (1); 4½" x 8½" (1)	18"	4½" x WOF (3): 4½" x 4½" (9) 4½" x WOF (1): 4½" x 4½" (1)
32	49½"	4½" x WOF (10): 4½" x 4½" (3); 4½" x 8½" (3) 4½" x WOF (1): 4½" x 4½" (2); 4½" x 8½" (2)	18"	4½" x WOF (3): 4½" x 4½" (9) 4½" x WOF (1): 4½" x 4½" (5)
34	54"	4½" x WOF (11): 4½" x 4½" (3); 4½" x 8½" (3) 4½" x WOF (1): 4½" x 4½" (1); 4½" x 8½" (1)	18"	4½" x WOF (3): 4½" x 4½" (9) 4½" x WOF (1): 4½" x 4½" (7)
36	54"	4½" x WOF (12): 4½" x 4½" (3); 4½" x 8½" (3)	18"	4½" x WOF (4): 4½" x 4½" (9)
40	63"	4½" x WOF (13): 4½" x 4½" (3); 4½" x 8½" (3) 4½" x WOF (1): 4½" x 4½" (1); 4½" x 8½" (1)	22½"	4½" x WOF (4): 4½" x 4½" (9) 4½" x WOF (1): 4½" x 4½" (4)
44	67½"	4½" x WOF (14): 4½" x 4½" (3); 4½" x 8½" (3) 4½" x WOF (1): 4½" x 4½" (2); 4½" x 8½" (2)	22½"	4½" x WOF (4): 4½" x 4½" (9) 4½" x WOF (1): 4½" x 4½" (8)
45	67½"	4½" x WOF (15): 4½" x 4½" (3); 4½" x 8½" (3)	22½"	4½" x WOF (5): 4½" x 4½" (9)
48	72"	4½" x WOF (16): 4½" x 4½" (3); 4½" x 8½" (3)	27"	4½" x WOF (5): 4½" x 4½" (9) 4½" x WOF (1): 4½" x 4½" (3)
50	76½"	4½" x WOF (16): 4½" x 4½" (3); 4½" x 8½" (3) 4½" x WOF (1): 4½" x 4½" (2); 4½" x 8½" (2)	27"	4½" x WOF (5): 4½" x 4½" (9) 4½" x WOF (1): 4½" x 4½" (5)
52	81"	4½" x WOF (17): 4½" x 4½" (3); 4½" x 8½" (3) 4½" x WOF (1): 4½" x 4½" (1); 4½" x 8½" (1)	27"	4½" x WOF (5): 4½" x 4½" (9) 4½" x WOF (1): 4½" x 4½" (7)
56	85½"	4½" x WOF (18): 4½" x 4½" (3); 4½" x 8½" (3) 4½" x WOF (1): 4½" x 4½" (2); 4½" x 8½" (2)	31½"	4½" x WOF (6): 4½" x 4½" (9) 4½" x WOF (1): 4½" x 4½" (2)

Block 08 ▪

#	IN.	FABRIC 1 CUTTING REQUIREMENTS	IN.	FABRIC 2 CUTTING REQUIREMENTS
1	4½"	4½" x WOF (1): 4½" x 4½" (2); 4½" x 2½" (2); 2½" x 2½" (2)	2½"	2½" x WOF (1): 2½" x 2½" (2)
2	4½"	4½" x WOF (1): 4½" x 4½" (4); 4½" x 2½" (4); 2½" x 2½" (4)	2½"	2½" x WOF (1): 2½" x 2½" (4)
3	7"	4½" x WOF (1): 4½" x 4½" (6); 4½" x 2½" (6) 2½" x WOF (1): 2½" x 2½" (6)	2½"	2½" x WOF (1): 2½" x 2½" (6)
4	9"	4½" x WOF (1): 4½" x 4½" (8) 4½" x WOF (1): 4½" x 2½" (8); 2½" x 2½" (8)	2½"	2½" x WOF (1): 2½" x 2½" (8)
5	11½"	4½" x WOF (1): 4½" x 4½" (9) 4½" x WOF (1): 4½" x 4½" (1); 4½" x 2½" (10) 2½" x WOF (1): 2½" x 2½" (10)	2½"	2½" x WOF (1): 2½" x 2½" (10)
6	13½"	4½" x WOF (1): 4½" x 4½" (9) 4½" x WOF (1): 4½" x 4½" (3); 2½" x 2½" (11) 4½" x WOF (1): 4½" x 2½" (12); 2½" x 2½" (1)	2½"	2½" x WOF (1): 2½" x 2½" (12)
7	16"	4½" x WOF (1): 4½" x 4½" (9) 4½" x WOF (1): 4½" x 4½" (5) 4½" x WOF (1): 4½" x 2½" (14) 2½" x WOF (1): 2½" x 2½" (14)	2½"	2½" x WOF (1): 2½" x 2½" (14)
8	16"	4½" x WOF (1): 4½" x 4½" (9) 4½" x WOF (1): 4½" x 4½" (7) 4½" x WOF (1): 4½" x 2½" (16) 2½" x WOF (1): 2½" x 2½" (16)	2½"	2½" x WOF (1): 2½" x 2½" (16)
9	18½"	4½" x WOF (2): 4½" x 4½" (9) 4½" x WOF (1): 4½" x 2½" (16) 2½" x WOF (1): 2½" x 2½" (16) 2½" x WOF (1): 2½" x 4½" (2); 2½" x 2½" (2)	5"	2½" x WOF (1): 2½" x 2½" (16) 2½" x WOF (1): 2½" x 2½" (2)
10	20½"	4½" x WOF (2): 4½" x 4½" (9) 4½" x WOF (1): 4½" x 4½" (2); 4½" x 2½" (4); 2½" x 2½" (4) 4½" x WOF (1): 4½" x 2½" (16) 2½" x WOF (1): 2½" x 2½" (16)	5"	2½" x WOF (1): 2½" x 2½" (16) 2½" x WOF (1): 2½" x 2½" (4)
11	23"	4½" x WOF (2): 4½" x 4½" (9) 4½" x WOF (1): 4½" x 4½" (4); 4½" x 2½" (6) 4½" x WOF (1): 4½" x 2½" (16) 2½" x WOF (1): 2½" x 2½" (16) 2½" x WOF (1): 2½" x 2½" (6)	5"	2½" x WOF (1): 2½" x 2½" (16) 2½" x WOF (1): 2½" x 2½" (6)
12	25"	4½" x WOF (2): 4½" x 4½" (9) 4½" x WOF (1): 4½" x 4½" (6) 4½" x WOF (1): 4½" x 2½" (16) 4½" x WOF (1): 4½" x 2½" (8); 2½" x 2½" (8) 2½" x WOF (1): 2½" x 2½" (16)	5"	2½" x WOF (1): 2½" x 2½" (16) 2½" x WOF (1): 2½" x 2½" (8)
13	27½"	4½" x WOF (2): 4½" x 4½" (9) 4½" x WOF (1): 4½" x 4½" (8) 4½" x WOF (1): 4½" x 2½" (16) 4½" x WOF (1): 4½" x 2½" (10) 2½" x WOF (1): 2½" x 2½" (16) 2½" x WOF (1): 2½" x 2½" (10)	5"	2½" x WOF (1): 2½" x 2½" (16) 2½" x WOF (1): 2½" x 2½" (10)

continues on next page

Block 08 continued

#	IN.	FABRIC 1 CUTTING REQUIREMENTS	IN.	FABRIC 2 CUTTING REQUIREMENTS
14	27½"	4½" x WOF (3): 4½" x 4½" (9) 4½" x WOF (1): 4½" x 4½" (1); 4½" x 2½" (12) 4½" x WOF (1): 4½" x 2½" (16) 2½" x WOF (1): 2½" x 2½" (16) 2½" x WOF (1): 2½" x 2½" (12)	5"	2½" x WOF (1): 2½" x 2½" (16) 2½" x WOF (1): 2½" x 2½" (12)
15	32"	4½" x WOF (3): 4½" x 4½" (9) 4½" x WOF (1): 4½" x 4½" (3) 4½" x WOF (1): 4½" x 2½" (16) 4½" x WOF (1): 4½" x 2½" (14) 2½" x WOF (1): 2½" x 2½" (16) 2½" x WOF (1): 2½" x 2½" (14)	5"	2½" x WOF (1): 2½" x 2½" (16) 2½" x WOF (1): 2½" x 2½" (14)
16	32"	4½" x WOF (3): 4½" x 4½" (9) 4½" x WOF (1): 4½" x 4½" (5) 4½" x WOF (2): 4½" x 2½" (16) 2½" x WOF (2): 2½" x 2½" (16)	5"	2½" x WOF (2): 2½" x 2½" (16)
17	32"	4½" x WOF (3): 4½" x 4½" (9) 4½" x WOF (1): 4½" x 4½" (7); 4½" x 2½" (2); 2½" x 2½" (2) 4½" x WOF (2): 4½" x 2½" (16) 2½" x WOF (2): 2½" x 2½" (16)	7½"	2½" x WOF (2): 2½" x 2½" (16) 2½" x WOF (1): 2½" x 2½" (2)
18	36½"	4½" x WOF (4): 4½" x 4½" (9) 4½" x WOF (2): 4½" x 2½" (16) 4½" x WOF (1): 4½" x 2½" (4); 2½" x 2½" (4) 2½" x WOF (2): 2½" x 2½" (16)	7½"	2½" x WOF (2): 2½" x 2½" (16) 2½" x WOF (1): 2½" x 2½" (4)
20	39"	4½" x WOF (4): 4½" x 4½" (9) 4½" x WOF (1): 4½" x 4½" (4); 4½" x 2½" (8) 4½" x WOF (2): 4½" x 2½" (16) 2½" x WOF (2): 2½" x 2½" (16) 2½" x WOF (1): 2½" x 2½" (8)	7½"	2½" x WOF (2): 2½" x 2½" (16) 2½" x WOF (1): 2½" x 2½" (8)
21	41"	4½" x WOF (4): 4½" x 4½" (9) 4½" x WOF (1): 4½" x 4½" (6); 4½" x 2½" (6) 4½" x WOF (2): 4½" x 2½" (16) 4½" x WOF (1): 4½" x 2½" (4); 2½" x 2½" (10) 2½" x WOF (2): 2½" x 2½" (16)	7½"	2½" x WOF (2): 2½" x 2½" (16) 2½" x WOF (1): 2½" x 2½" (10)
22	43½"	4½" x WOF (4): 4½" x 4½" (9) 4½" x WOF (1): 4½" x 4½" (8) 4½" x WOF (2): 4½" x 2½" (16) 4½" x WOF (1): 4½" x 2½" (12) 2½" x WOF (2): 2½" x 2½" (16) 2½" x WOF (1): 2½" x 2½" (12)	7½"	2½" x WOF (2): 2½" x 2½" (16) 2½" x WOF (1): 2½" x 2½" (12)
24	48"	4½" x WOF (5): 4½" x 4½" (9) 4½" x WOF (1): 4½" x 4½" (3) 4½" x WOF (3): 4½" x 2½" (16) 2½" x WOF (3): 2½" x 2½" (16)	7½"	2½" x WOF (3): 2½" x 2½" (16)
26	50½"	4½" x WOF (5): 4½" x 4½" (9) 4½" x WOF (1): 4½" x 4½" (7); 4½" x 2½" (4) 4½" x WOF (3): 4½" x 2½" (16) 2½" x WOF (3): 2½" x 2½" (16) 2½" x WOF (1): 2½" x 2½" (4)	10"	2½" x WOF (3): 2½" x 2½" (16) 2½" x WOF (1): 2½" x 2½" (4)

QUILT YOUR OWN ADVENTURE

		FABRIC 1		FABRIC 2	
#	IN.	CUTTING REQUIREMENTS	IN.	CUTTING REQUIREMENTS	
28	55"	4½" x WOF (6): 4½" x 4½" (9) 4½" x WOF (1): 4½" x 4½" (2); 4½" x 2½" (8) 4½" x WOF (3): 4½" x 2½" (16) 2½" x WOF (3): 2½" x 2½" (16) 2½" x WOF (1): 2½" x 2½" (8)	10"	2½" x WOF (3): 2½" x 2½" (16) 2½" x WOF (1): 2½" x 2½" (8)	
32	64"	4½" x WOF (7): 4½" x 4½" (9) 4½" x WOF (1): 4½" x 4½" (1) 4½" x WOF (4): 4½" x 2½" (16) 2½" x WOF (4): 2½" x 2½" (16)	10"	2½" x WOF (4): 2½" x 2½" (16)	
34	66½"	4½" x WOF (7): 4½" x 4½" (9) 4½" x WOF (1): 4½" x 4½" (5); 4½" x 2½" (4) 4½" x WOF (4): 4½" x 2½" (16) 2½" x WOF (4): 2½" x 2½" (16) 2½" x WOF (1): 2½" x 2½" (4)	12½"	2½" x WOF (4): 2½" x 2½" (16) 2½" x WOF (1): 2½" x 2½" (4)	
36	68½"	4½" x WOF (8): 4½" x 4½" (9) 4½" x WOF (4): 4½" x 2½" (16) 4½" x WOF (1): 4½" x 2½" (8); 2½" x 2½" (8) 2½" x WOF (4): 2½" x 2½" (16)	12½"	2½" x WOF (4): 2½" x 2½" (16) 2½" x WOF (1): 2½" x 2½" (8)	
40	75½"	4½" x WOF (8): 4½" x 4½" (9) 4½" x WOF (1): 4½" x 4½" (8) 4½" x WOF (5): 4½" x 2½" (16) 2½" x WOF (5): 2½" x 2½" (16)	12½"	2½" x WOF (5): 2½" x 2½" (16)	
44	84½"	4½" x WOF (9): 4½" x 4½" (9) 4½" x WOF (1): 4½" x 4½" (7) 4½" x WOF (5): 4½" x 2½" (16) 4½" x WOF (1): 4½" x 2½" (8); 2½" x 2½" (8) 2½" x WOF (5): 2½" x 2½" (16)	15"	2½" x WOF (5): 2½" x 2½" (16) 2½" x WOF (1): 2½" x 2½" (8)	
45	87"	4½" x WOF (10): 4½" x 4½" (9) 4½" x WOF (5): 4½" x 2½" (16) 4½" x WOF (1): 4½" x 4½" (10) 2½" x WOF (5): 2½" x 2½" (16) 2½" x WOF (1): 2½" x 2½" (10)	15"	2½" x WOF (5): 2½" x 2½" (16) 2½" x WOF (1): 2½" x 2½" (10)	
48	91½"	4½" x WOF (10): 4½" x 4½" (9) 4½" x WOF (1): 4½" x 4½" (6) 4½" x WOF (6): 4½" x 2½" (16) 2½" x WOF (6): 2½" x 2½" (16)	15"	2½" x WOF (6): 2½" x 2½" (16)	
50	96"	4½" x WOF (11): 4½" x 4½" (9) 4½" x WOF (1): 4½" x 4½" (1); 4½" x 2½" (4); 2½" x 2½" (4) 4½" x WOF (6): 4½" x 2½" (16) 2½" x WOF (6): 2½" x 2½" (16)	17½"	2½" x WOF (6): 2½" x 2½" (16) 2½" x WOF (1): 2½" x 2½" (4)	
52	100½"	4½" x WOF (11): 4½" x 4½" (9) 4½" x WOF (1): 4½" x 4½" (5) 4½" x WOF (6): 4½" x 2½" (16) 4½" x WOF (1): 4½" x 2½" (8); 2½" x 2½" (8) 2½" x WOF (6): 2½" x 2½" (16)	17½"	2½" x WOF (6): 2½" x 2½" (16) 2½" x WOF (1): 2½" x 2½" (8)	
56	107½"	4½" x WOF (12): 4½" x 4½" (9) 4½" x WOF (1): 4½" x 4½" (4) 4½" x WOF (7): 4½" x 2½" (16) 2½" x WOF (7): 2½" x 2½" (16)	17½"	2½" x WOF (7): 2½" x 2½" (16)	

Block 09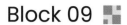

DESIGN PAGE 42

#	FABRIC 1 IN.	FABRIC 1 CUTTING REQUIREMENTS	FABRIC 2 IN.	FABRIC 2 CUTTING REQUIREMENTS
1	4½"	4½" x WOF (1): 4½" x 4½" (2); 2½" x 2½" (2)	2½"	2½" x WOF (1): 2½" x 4½" (2); 2½" x 2½" (2)
2	4½"	4½" x WOF (1): 4½" x 4½" (4); 2½" x 2½" (4)	2½"	2½" x WOF (1): 2½" x 4½" (4); 2½" x 2½" (4)
3	4½"	4½" x WOF (1): 4½" x 4½" (6); 2½" x 2½" (6)	2½"	2½" x WOF (1): 2½" x 4½" (6); 2½" x 2½" (6)
4	7"	4½" x WOF (1): 4½" x 4½" (8) 2½" x WOF (1): 2½" x 2½" (8)	5"	2½" x WOF (1): 2½" x 4½" (6); 2½" x 2½" (6) 2½" x WOF (1): 2½" x 4½" (2); 2½" x 2½" (2)
5	9"	4½" x WOF (1): 4½" x 4½" (9) 4½" x WOF (1): 4½" x 4½" (1); 2½" x 2½" (10)	5"	2½" x WOF (1): 2½" x 4½" (6); 2½" x 2½" (6) 2½" x WOF (1): 2½" x 4½" (4); 2½" x 2½" (4)
6	11½"	4½" x WOF (1): 4½" x 4½" (9) 4½" x WOF (1): 4½" x 4½" (3) 2½" x WOF (1): 2½" x 2½" (12)	5"	2½" x WOF (2): 2½" x 4½" (6); 2½" x 2½" (6)
7	11½"	4½" x WOF (1): 4½" x 4½" (9) 4½" x WOF (1): 4½" x 4½" (5) 2½" x WOF (1): 2½" x 2½" (14)	7½"	2½" x WOF (2): 2½" x 4½" (6); 2½" x 2½" (6) 2½" x WOF (1): 2½" x 4½" (2); 2½" x 2½" (2)
8	11½"	4½" x WOF (1): 4½" x 4½" (9) 4½" x WOF (1): 4½" x 4½" (7) 2½" x WOF (1): 2½" x 2½" (16)	7½"	2½" x WOF (2): 2½" x 4½" (6); 2½" x 2½" (6) 2½" x WOF (1): 2½" x 4½" (4); 2½" x 2½" (4)
9	14"	4½" x WOF (2): 4½" x 4½" (9) 2½" x WOF (1): 2½" x 2½" (16) 2½" x WOF (1): 2½" x 2½" (2)	7½"	2½" x WOF (3): 2½" x 4½" (6); 2½" x 2½" (6)
10	16"	4½" x WOF (2): 4½" x 4½" (9) 4½" x WOF (1): 4½" x 4½" (2); 2½" x 2½" (4) 2½" x WOF (1): 2½" x 2½" (16)	10"	2½" x WOF (3): 2½" x 4½" (6); 2½" x 2½" (6) 2½" x WOF (1): 2½" x 4½" (2); 2½" x 2½" (2)
11	16"	4½" x WOF (2): 4½" x 4½" (9) 4½" x WOF (1): 4½" x 4½" (4); 2½" x 2½" (6) 2½" x WOF (1): 2½" x 2½" (16)	10"	2½" x WOF (3): 2½" x 4½" (6); 2½" x 2½" (6) 2½" x WOF (1): 2½" x 4½" (4); 2½" x 2½" (4)
12	18½"	4½" x WOF (2): 4½" x 4½" (9) 4½" x WOF (1): 4½" x 4½" (6) 2½" x WOF (1): 2½" x 2½" (16) 2½" x WOF (1): 2½" x 2½" (8)	10"	2½" x WOF (4): 2½" x 4½" (6); 2½" x 2½" (6)
13	18½"	4½" x WOF (2): 4½" x 4½" (9) 4½" x WOF (1): 4½" x 4½" (8) 2½" x WOF (1): 2½" x 2½" (16) 2½" x WOF (1): 2½" x 2½" (10)	12½"	2½" x WOF (4): 2½" x 4½" (6); 2½" x 2½" (6) 2½" x WOF (1): 2½" x 4½" (2); 2½" x 2½" (2)
14	20½"	4½" x WOF (3): 4½" x 4½" (9) 4½" x WOF (1): 4½" x 4½" (1); 2½" x 2½" (12) 2½" x WOF (1): 2½" x 2½" (16)	12½"	2½" x WOF (4): 2½" x 4½" (6); 2½" x 2½" (6) 2½" x WOF (1): 2½" x 4½" (4); 2½" x 2½" (4)
15	23"	4½" x WOF (3): 4½" x 4½" (9) 4½" x WOF (1): 4½" x 4½" (3) 2½" x WOF (1): 2½" x 2½" (16) 2½" x WOF (1): 2½" x 2½" (14)	12½"	2½" x WOF (5): 2½" x 4½" (6); 2½" x 2½" (6)
16	23"	4½" x WOF (3): 4½" x 4½" (9) 4½" x WOF (1): 4½" x 4½" (5) 2½" x WOF (2): 2½" x 2½" (16)	15"	2½" x WOF (5): 2½" x 4½" (6); 2½" x 2½" (6) 2½" x WOF (1): 2½" x 4½" (2); 2½" x 2½" (2)

#	\multicolumn FABRIC 1		FABRIC 2	

<table>
<tr><th>#</th><th colspan="2">FABRIC 1</th><th colspan="2">FABRIC 2</th></tr>
<tr><th></th><th>IN.</th><th>CUTTING REQUIREMENTS</th><th>IN.</th><th>CUTTING REQUIREMENTS</th></tr>
<tr>
<td>17</td>
<td>23"</td>
<td>4½in x WOF (3): 4½" x 4½" (9)
4½in x WOF (1): 4½" x 4½" (7); 2½" x 2½" (2)
2½" x WOF (2): 2½" x 2½" (16)</td>
<td>15"</td>
<td>2½" x WOF (5): 2½" x 4½" (6); 2½" x 2½" (6)
2½" x WOF (1): 2½" x 4½" (4); 2½" x 2½" (4)</td>
</tr>
<tr>
<td>18</td>
<td>25½"</td>
<td>4½" x WOF (4): 4½" x 4½" (9)
2½" x WOF (2): 2½" x 2½" (16)
2½" x WOF (1): 2½" x 2½" (4)</td>
<td>15"</td>
<td>2½" x WOF (6): 2½" x 4½" (6); 2½" x 2½" (6)</td>
</tr>
<tr>
<td>20</td>
<td>27½"</td>
<td>4½" x WOF (4): 4½" x 4½" (9)
4½" x WOF (1): 4½" x 4½" (4); 2½" x 2½" (8)
2½" x WOF (2): 2½" x 2½" (16)</td>
<td>17½"</td>
<td>2½" x WOF (6): 2½" x 4½" (6); 2½" x 2½" (6)
2½" x WOF (1): 2½" x 4½" (4); 2½" x 2½" (4)</td>
</tr>
<tr>
<td>21</td>
<td>30"</td>
<td>4½" x WOF (4): 4½" x 4½" (9)
4½" x WOF (1): 4½" x 4½" (6)
2½" x WOF (2): 2½" x 2½" (16)
2½" x WOF (1) 2½" x 2½" (10)</td>
<td>17½"</td>
<td>2½" x WOF (7): 2½" x 4½" (6); 2½" x 2½" (6)</td>
</tr>
<tr>
<td>22</td>
<td>30"</td>
<td>4½" x WOF (4): 4½" x 4½" (9)
4½" x WOF (1): 4½" x 4½" (8)
2½" x WOF (2): 2½" x 2½" (16)
2½" x WOF (1): 2½" x 2½" (12)</td>
<td>20"</td>
<td>2½" x WOF (7): 2½" x 4½" (6); 2½" x 2½" (6)
2½" x WOF (1): 2½" x 4½" (2); 2½" x 2½" (2)</td>
</tr>
<tr>
<td>24</td>
<td>34½"</td>
<td>4½" x WOF (5): 4½" x 4½" (9)
4½" x WOF (1): 4½" x 4½" (3)
2½" x WOF (3): 2½" x 2½" (16)</td>
<td>20"</td>
<td>2½" x WOF (8): 2½" x 4½" (6); 2½" x 2½" (6)</td>
</tr>
<tr>
<td>26</td>
<td>34½"</td>
<td>4½" x WOF (5): 4½" x 4½" (9)
4½" x WOF (1): 4½" x 4½" (7); 2½" x 2½" (4)
2½" x WOF (3): 2½" x 2½" (16)</td>
<td>22½"</td>
<td>2½" x WOF (8): 2½" x 4½" (6); 2½" x 2½" (6)
2½" x WOF (1): 2½" x 4½" (4); 2½" x 2½" (4)</td>
</tr>
<tr>
<td>28</td>
<td>39"</td>
<td>4½" x WOF (6): 4½" x 4½" (9)
4½" x WOF (1): 4½" x 4½" (2); 2½" x 2½" (8)
2½" x WOF (3): 2½" x 2½" (16)</td>
<td>25"</td>
<td>2½" x WOF (9): 2½" x 4½" (6); 2½" x 2½" (6)
2½" x WOF (1): 2½" x 4½" (2); 2½" x 2½" (2)</td>
</tr>
<tr>
<td>32</td>
<td>46"</td>
<td>4½" x WOF (7): 4½" x 4½" (9)
4½" x WOF (1): 4½" x 4½" (1)
2½" x WOF (4): 2½" x 2½" (16)</td>
<td>27½"</td>
<td>2½" x WOF (10): 2½" x 4½" (6); 2½" x 2½" (6)
2½" x WOF (1): 2½" x 4½" (4); 2½" x 2½" (4)</td>
</tr>
<tr>
<td>34</td>
<td>46"</td>
<td>4½" x WOF (7): 4½" x 4½" (9)
4½" x WOF (1): 4½" x 4½" (5); 2½" x 2½" (4)
2½" x WOF (4): 2½" x 2½" (16)</td>
<td>30"</td>
<td>2½" x WOF (11): 2½" x 4½" (6); 2½" x 2½" (6)
2½" x WOF (1): 2½" x 4½" (2); 2½" x 2½" (2)</td>
</tr>
<tr>
<td>36</td>
<td>48½"</td>
<td>4½" x WOF (8): 4½" x 4½" (9)
2½" x WOF (4): 2½" x 2½" (16)
2½" x WOF (1): 2½" x 2½" (8)</td>
<td>30"</td>
<td>2½" x WOF (12): 2½" x 4½" (6); 2½" x 2½" (6)</td>
</tr>
<tr>
<td>40</td>
<td>53"</td>
<td>4½" x WOF (8): 4½" x 4½" (9)
4½" x WOF (1): 4½" x 4½" (8)
2½" x WOF (5): 2½" x 2½" (16)</td>
<td>35"</td>
<td>2½" x WOF (13): 2½" x 4½" (6); 2½" x 2½" (6)
2½" x WOF (1): 2½" x 4½" (2); 2½" x 2½" (2)</td>
</tr>
<tr>
<td>44</td>
<td>60"</td>
<td>4½" x WOF (9): 4½" x 4½" (9)
4½" x WOF (1): 4½" x 4½" (7)
2½" x WOF (5): 2½" x 2½" (16)
2½" x WOF (1): 2½" x 2½" (8)</td>
<td>37½"</td>
<td>2½" x WOF (14): 2½" x 4½" (6); 2½" x 2½" (6)
2½" x WOF (1): 2½" x 4½" (4); 2½" x 2½" (4)</td>
</tr>
</table>

continues on next page

Block 09 continued

#	IN.	FABRIC 1 CUTTING REQUIREMENTS	IN.	FABRIC 2 CUTTING REQUIREMENTS
45	60"	4½" x WOF (10): 4½" x 4½" (9) 2½" x WOF (5): 2½" x 2½" (16) 2½" x WOF (1): 2½" x 2½" (10)	37½"	2½" x WOF (15): 2½" x 4½" (6); 2½" x 2½" (6)
48	64½"	4½" x WOF (10): 4½" x 4½" (9) 4½" x WOF (1): 4½" x 4½" (6) 2½" x WOF (6): 2½" x 2½" (16)	40"	2½" x WOF (16): 2½" x 4½" (6); 2½" x 2½" (6)
50	69"	4½" x WOF (11): 4½" x 4½" (9) 4½" x WOF (1): 4½" x 4½" (1); 2½" x 2½" (4) 2½" x WOF (6): 2½" x 2½" (16)	42½"	2½" x WOF (16): 2½" x 4½" (6); 2½" x 2½" (6) 2½" x WOF (1): 2½" x 4½" (4); 2½" x 2½" (4)
52	71½"	4½" x WOF (11): 4½" x 4½" (9) 4½" x WOF (1): 4½" x 4½" (5) 2½" x WOF (6): 2½" x 2½" (16) 2½" x WOF (1): 2½" x 2½" (8)	45"	2½" x WOF (17): 2½" x 4½" (6); 2½" x 2½" (6) 2½" x WOF (1): 2½" x 4½" (2); 2½" x 2½" (2)
56	76"	4½" x WOF (12): 4½" x 4½" (9) 4½" x WOF (1): 4½" x 4½" (4) 2½" x WOF (7): 2½" x 2½" (16)	47½"	2½" x WOF (18): 2½" x 4½" (6); 2½" x 2½" (6) 2½" x WOF (1): 2½" x 4½" (4); 2½" x 2½" (4)

Block 10

DESIGN PAGE 43

#	FABRIC 1 IN.	FABRIC 1 CUTTING REQUIREMENTS	FABRIC 2 IN.	FABRIC 2 CUTTING REQUIREMENTS
1	4½"	4½" x WOF (1): 4½" x 4½" (1); 4½" x 2½" (2); 2½" x 2½" (2)	4½"	4½" x WOF (1): 4½" x 4½" (1); 2½" x 2½" (2)
2	4½"	4½" x WOF (1): 4½" x 4½" (2); 4½" x 2½" (4); 2½" x 2½" (4)	4½"	4½" x WOF (1): 4½" x 4½" (2); 2½" x 2½" (4)
3	7"	4½" x WOF (1): 4½" x 4½" (3); 4½" x 2½" (6) 2½" x WOF (1): 2½" x 2½" (6)	4½"	4½" x WOF (1): 4½" x 4½" (3); 2½" x 2½" (6)
4	7"	4½" x WOF (1): 4½" x 4½" (4); 4½" x 2½" (8) 2½" x WOF (1): 2½" x 2½" (8)	4½"	4½" x WOF (1): 4½" x 4½" (4); 2½" x 2½" (8)
5	7"	4½" x WOF (1): 4½" x 4½" (5); 4½" x 2½" (7) 2½" x WOF (1): 2½" x 2½" (10); 2½" x 4½" (3)	7"	4½" x WOF (1): 4½" x 4½" (5) 2½" x WOF (1): 2½" x 2½" (10)
6	11½"	4½" x WOF (1): 4½" x 4½" (6) 4½" x WOF (1): 4½" x 2½" (12) 2½" x WOF (1): 2½" x 2½" (12)	7"	4½" x WOF (1): 4½" x 4½" (6) 2½" x WOF (1): 2½" x 2½" (12)
7	11½"	4½" x WOF (1): 4½" x 4½" (7) 4½" x WOF (1): 4½" x 2½" (14) 2½" x WOF (1): 2½" x 2½" (14)	7"	4½" x WOF (1): 4½" x 4½" (7) 2½" x WOF (1): 2½" x 2½" (14)
8	11½"	4½" x WOF (1): 4½" x 4½" (8) 4½" x WOF (1): 4½" x 2½" (16) 2½" x WOF (1): 2½" x 2½" (16)	7"	4½" x WOF (1): 4½" x 4½" (8) 2½" x WOF (1): 2½" x 2½" (16)
9	14"	4½" x WOF (1): 4½" x 4½" (9) 4½" x WOF (1): 4½" x 2½" (16) 2½" x WOF (1): 2½" x 2½" (16) 2½" x WOF (1): 2½" x 2½" (2); 2½" x 4½" (2)	9½"	4½" x WOF (1): 4½" x 4½" (9) 2½" x WOF (1): 2½" x 2½" (16) 2½" x WOF (1): 2½" x 2½" (2)
10	16"	4½" x WOF (1): 4½" x 4½" (9) 4½" x WOF (1): 4½" x 4½" (1); 4½" x 2½" (4); 2½" x 2½" (4) 4½" x WOF (1): 4½" x 2½" (16) 2½" x WOF (1): 2½" x 2½" (16)	11½"	4½" x WOF (1): 4½" x 4½" (9) 4½" x WOF (1): 4½" x 4½" (1); 2½" x 2½" (4) 2½" x WOF (1): 2½" x 2½" (16)
11	16"	4½" x WOF (1): 4½" x 4½" (9) 4½" x WOF (1): 4½" x 4½" (2); 4½" x 2½" (6); 2½" x 2½" (6) 4½" x WOF (1): 4½" x 2½" (16) 2½" x WOF (1): 2½" x 2½" (16)	11½"	4½" x WOF (1): 4½" x 4½" (9) 4½" x WOF (1): 4½" x 4½" (2); 2½" x 2½" (6) 2½" x WOF (1): 2½" x 2½" (16)
12	18½"	4½" x WOF (1): 4½" x 4½" (9) 4½" x WOF (1): 4½" x 4½" (3); 4½" x 2½" (8) 4½" x WOF (1): 4½" x 2½" (16) 2½" x WOF (1): 2½" x 2½" (16) 2½" x WOF (1): 2½" x 2½" (8)	11½"	4½" x WOF (1): 4½" x 4½" (9) 4½" x WOF (1): 4½" x 4½" (3); 2½" x 2½" (8) 2½" x WOF (1): 2½" x 2½" (16)
13	18½"	4½" x WOF (1): 4½" x 4½" (9) 4½" x WOF (1): 4½" x 4½" (4); 4½" x 2½" (9) 4½" x WOF (1): 4½" x 2½" (16) 2½" x WOF (1): 2½" x 2½" (16) 2½" x WOF (1): 2½" x 2½" (10); 2½" x 4½" (1)	14"	4½" x WOF (1): 4½" x 4½" (9) 4½" x WOF (1): 4½" x 4½" (4) 2½" x WOF (1): 2½" x 2½" (16) 2½" x WOF (1): 2½" x 2½" (10)
14	23"	4½" x WOF (1): 4½" x 4½" (9) 4½" x WOF (1): 4½" x 4½" (5) 4½" x WOF (1): 4½" x 2½" (16) 4½" x WOF (1): 4½" x 2½" (12) 2½" x WOF (1): 2½" x 2½" (16) 2½" x WOF (1): 2½" x 2½" (12)	14"	4½" x WOF (1): 4½" x 4½" (9) 4½" x WOF (1): 4½" x 4½" (5) 2½" x WOF (1): 2½" x 2½" (16) 2½" x WOF (1): 2½" x 2½" (12)

continues on next page

Block 10 continued

	FABRIC 1		FABRIC 2	
#	IN.	CUTTING REQUIREMENTS	IN.	CUTTING REQUIREMENTS
15	23"	4½" x WOF (1): 4½" x 4½" (9) 4½" x WOF (1): 4½" x 4½" (6) 4½" x WOF (1): 4½" x 2½" (16) 4½" x WOF (1): 4½" x 2½" (14) 2½" x WOF (1): 2½" x 2½" (16) 2½" x WOF (1): 2½" x 2½" (14)	14"	4½" x WOF (1): 4½" x 4½" (9) 4½" x WOF (1): 4½" x 4½" (6) 2½" x WOF (1): 2½" x 2½" (16) 2½" x WOF (1): 2½" x 2½" (14)
16	23"	4½" x WOF (1): 4½" x 4½" (9) 4½" x WOF (1): 4½" x 4½" (7) 4½" x WOF (2): 4½" x 2½" (16) 2½" x WOF (2): 2½" x 2½" (16)	14"	4½" x WOF (1): 4½" x 4½" (9) 4½" x WOF (1): 4½" x 4½" (7) 2½" x WOF (2): 2½" x 2½" (16)
17	25½"	4½" x WOF (1): 4½" x 4½" (9) 4½" x WOF (1): 4½" x 4½" (8) 4½" x WOF (2): 4½" x 2½" (16) 2½" x WOF (2): 2½" x 2½" (16) 2½" x WOF (1): 2½" x 2½" (2); 2½" x 4½" (2)	14"	4½" x WOF (1): 4½" x 4½" (9) 4½" x WOF (1): 4½" x 4½" (8); 2½" x 2½" (2) 2½" x WOF (2): 2½" x 2½" (16)
18	25½"	4½" x WOF (2): 4½" x 4½" (9) 4½" x WOF (2): 4½" x 2½" (16) 2½" x WOF (2): 2½" x 2½" (16) 2½" x WOF (1): 2½" x 2½" (4); 2½" x 4½" (4)	16½"	4½" x WOF (2): 4½" x 4½" (9) 2½" x WOF (2): 2½" x 2½" (16) 2½" x WOF (1): 2½" x 2½" (4)
20	30"	4½" x WOF (2): 4½" x 4½" (9) 4½" x WOF (1): 4½" x 4½" (2); 4½" x 2½" (8) 4½" x WOF (2): 4½" x 2½" (16) 2½" x WOF (2): 2½" x 2½" (16) 2½" x WOF (1): 2½" x 2½" (8)	18½"	4½" x WOF (2): 4½" x 4½" (9) 4½" x WOF (1): 4½" x 4½" (2); 2½" x 2½" (8) 2½" x WOF (2): 2½" x 2½" (16)
21	30"	4½" x WOF (2): 4½" x 4½" (9) 4½" x WOF (1): 4½" x 4½" (3); 4½" x 2½" (10) 4½" x WOF (2): 4½" x 2½" (16) 2½" x WOF (2): 2½" x 2½" (16) 2½" x WOF (1): 2½" x 2½" (10)	18½"	4½" x WOF (2): 4½" x 4½" (9) 4½" x WOF (1): 4½" x 4½" (3); 2½" x 2½" (10) 2½" x WOF (2): 2½" x 2½" (16)
22	32"	4½" x WOF (2): 4½" x 4½" (9) 4½" x WOF (1): 4½" x 4½" (4); 4½" x 2½" (9) 4½" x WOF (2): 4½" x 2½" (16); 4½" x WOF (1): 4½" x 2½" (3); 2½" x 2½" (12) 2½" x WOF (2): 2½" x 2½" (16)	21"	4½" x WOF (2): 4½" x 4½" (9) 4½" x WOF (1): 4½" x 4½" (4) 2½" x WOF (2): 2½" x 2½" (16) 2½" x WOF (1): 2½" x 2½" (12)
24	34½"	4½" x WOF (2): 4½" x 4½" (9) 4½" x WOF (1): 4½" x 4½" (6) 4½" x WOF (3): 4½" x 2½" (16) 2½" x WOF (3): 2½" x 2½" (16)	21"	4½" x WOF (2): 4½" x 4½" (9) 4½" x WOF (1): 4½" x 4½" (6) 2½" x WOF (3): 2½" x 2½" (16)
26	37"	4½" x WOF (2): 4½" x 4½" (9) 4½" x WOF (1): 4½" x 4½" (8) 4½" x WOF (3): 4½" x 2½" (16) 2½" x WOF (3): 2½" x 2½" (16) 2½" x WOF (1): 2½" x 2½" (4); 2½" x 4½" (4)	23½"	4½" x WOF (2): 4½" x 4½" (9) 4½" x WOF (1): 4½" x 4½" (8) 2½" x WOF (3): 2½" x 2½" (16) 2½" x WOF (1): 2½" x 2½" (4)
28	41½"	4½" x WOF (3): 4½" x 4½" (9) 4½" x WOF (1): 4½" x 4½" (1); 4½" x 2½" (8) 4½" x WOF (3): 4½" x 2½" (16) 2½" x WOF (3): 2½" x 2½" (16) 2½" x WOF (1): 2½" x 2½" (8)	25½"	4½" x WOF (3): 4½" x 4½" (9) 4½" x WOF (1): 4½" x 4½" (1); 2½" x 2½" (8) 2½" x WOF (3): 2½" x 2½" (16)

#	IN.	CUTTING REQUIREMENTS	IN.	CUTTING REQUIREMENTS
		FABRIC 1		**FABRIC 2**
32	46"	4½" x WOF (3): 4½" x 4½" (9) 4½" x WOF (1): 4½" x 4½" (5) 4½" x WOF (4): 4½" x 2½" (16) 2½" x WOF (4): 2½" x 2½" (16)	28"	4½" x WOF (3): 4½" x 4½" (9) 4½" x WOF (1): 4½" x 4½" (5) 2½" x WOF (4): 2½" x 2½" (16)
34	48½"	4½" x WOF (3): 4½" x 4½" (9) 4½" x WOF (1): 4½" x 4½" (7); 4½" x 2½" (4) 4½" x WOF (4): 4½" x 2½" (16) 2½" x WOF (4): 2½" x 2½" (16) 2½" x WOF (1): 2½" x 2½" (4)	28"	4½" x WOF (3): 4½" x 4½" (9) 4½" x WOF (1): 4½" x 4½" (7); 2½" x 2½" (4) 2½" x WOF (4): 2½" x 2½" (16)
36	50½"	4½" x WOF (4): 4½" x 4½" (9) 4½" x WOF (4): 4½" x 2½" (16) 4½" x WOF (1): 4½" x 2½" (8); 2½" x 2½" (8) 2½" x WOF (4): 2½" x 2½" (16)	30½"	4½" x WOF (4): 4½" x 4½" (9) 2½" x WOF (4): 2½" x 2½" (16) 2½" x WOF (1): 2½" x 2½" (8)
40	57½"	4½" x WOF (4): 4½" x 4½" (9) 4½" x WOF (1): 4½" x 4½" (4) 4½" x WOF (5): 4½" x 2½" (16) 2½" x WOF (5): 2½" x 2½" (16)	35"	4½" x WOF (4): 4½" x 4½" (9) 4½" x WOF (1): 4½" x 4½" (4) 2½" x WOF (5): 2½" x 2½" (16)
44	62"	4½" x WOF (4): 4½" x 4½" (9) 4½" x WOF (1): 4½" x 4½" (8) 4½" x WOF (5): 4½" x 2½" (16) 4½" x WOF (1): 4½" x 2½" (8); 2½" x 2½" (8) 2½" x WOF (5): 2½" x 2½" (16)	37½"	4½" x WOF (4): 4½" x 4½" (9) 4½" x WOF (1): 4½" x 4½" (8) 2½" x WOF (5): 2½" x 2½" (16) 2½" x WOF (1): 2½" x 2½" (8)
45	64½"	4½" x WOF (5): 4½" x 4½" (9) 4½" x WOF (5): 4½" x 2½" (16) 4½" x WOF (1): 4½" x 2½" (10) 2½" x WOF (5): 2½" x 2½" (16) 2½" x WOF (1): 2½" x 2½" (10)	37½"	4½" x WOF (5): 4½" x 4½" (9) 2½" x WOF (5): 2½" x 2½" (16) 2½" x WOF (1): 2½" x 2½" (10)
48	69"	4½" x WOF (5): 4½" x 4½" (9) 4½" x WOF (1): 4½" x 4½" (3) 4½" x WOF (6): 4½" x 2½" (16) 2½" x WOF (6): 2½" x 2½" (16)	42"	4½" x WOF (5): 4½" x 4½" (9) 4½" x WOF (1): 4½" x 4½" (3) 2½" x WOF (6): 2½" x 2½" (16)
50	71½"	4½" x WOF (5): 4½" x 4½" (9) 4½" x WOF (1): 4½" x 4½" (5); 4½" x 2½" (4) 4½" x WOF (6): 4½" x 2½" (16) 2½" x WOF (6): 2½" x 2½" (16) 2½" x WOF (1): 2½" x 2½" (4)	44½"	4½" x WOF (5): 4½" x 4½" (9) 4½" x WOF (1): 4½" x 4½" (5) 2½" x WOF (6): 2½" x 2½" (16) 2½" x WOF (1): 2½" x 2½" (4)
52	71½"	4½" x WOF (5): 4½" x 4½" (9) 4½" x WOF (1): 4½" x 4½" (7); 4½" x 2½" (4) 4½" x WOF (6): 4½" x 2½" (16) 2½" x WOF (6): 2½" x 2½" (16) 2½" x WOF (1): 2½" x 2½" (8); 2½" x 4½" (4)	44½"	4½" x WOF (5): 4½" x 4½" (9) 4½" x WOF (1): 4½" x 4½" (7) 2½" x WOF (6): 2½" x 2½" (16) 2½" x WOF (1): 2½" x 2½" (8)
56	80½"	4½" x WOF (6): 4½" x 4½" (9) 4½" x WOF (1): 4½" x 4½" (2) 4½" x WOF (7): 4½" x 2½" (16) 2½" x WOF (7): 2½" x 2½" (16)	49"	4½" x WOF (6): 4½" x 4½" (9) 4½" x WOF (1): 4½" x 4½" (2) 2½" x WOF (7): 2½" x 2½" (16)

Block 11

DESIGN PAGE 44

#	IN.	FABRIC 1 CUTTING REQUIREMENTS	IN.	FABRIC 2 CUTTING REQUIREMENTS
1	4½"	4½" x WOF (1): 4½" x 4½" (1); 4½" x 2½" (2); 2½" x 2½" (3)	2½"	2½" x WOF (1): 2½" x 4½" (1); 2½" x 2½" (3)
2	4½"	4½" x WOF (1): 4½" x 4½" (2); 4½" x 2½" (4); 2½" x 2½" (6)	2½"	2½" x WOF (1): 2½" x 4½" (2); 2½" x 2½" (6)
3	7"	4½" x WOF (1): 4½" x 4½" (3); 4½" x 2½" (6) 2½" x WOF (1): 2½" x 2½" (9)	2½"	2½" x WOF (1): 2½" x 4½" (3); 2½" x 2½" (9)
4	7"	4½" x WOF (1): 4½" x 4½" (4); 4½" x 2½" (8) 2½" x WOF (1): 2½" x 2½" (12)	4½"	4½" x WOF (1): 4½" x 2½" (4); 2½" x 2½" (12)
5	9½"	4½" x WOF (1): 4½" x 4½" (5); 4½" x 2½" (7) 2½" x WOF (1): 4½" x 2½" (3) 2½" x WOF (1): 2½" x 2½" (15)	7"	4½" x WOF (1): 4½" x 2½" (5) 2½" x WOF (1): 2½" x 2½" (15)
6	11½"	4½" x WOF (1): 4½" x 4½" (6) 4½" x WOF (1): 4½" x 2½" (12); 2½" x 2½" (2) 2½" x WOF (1): 2½" x 2½" (16)	7"	4½" x WOF (1): 4½" x 2½" (6); 2½" x 2½" (2) 2½" x WOF (1): 2½" x 2½" (16)
7	11½"	4½" x WOF (1): 4½" x 4½" (7); 4½" x 2½" (4) 4½" x WOF (1): 4½" x 2½" (10); 2½" x 2½" (5) 2½" x WOF (1): 2½" x 2½" (16)	7"	4½" x WOF (1): 4½" x 2½" (7); 2½" x 2½" (5) 2½" x WOF (1): 2½" x 2½" (16)
8	14"	4½" x WOF (1): 4½" x 4½" (8) 4½" x WOF (1): 4½" x 2½" (16) 2½" x WOF (1): 2½" x 2½" (16) 2½" x WOF (1): 2½" x 2½" (8)	7"	4½" x WOF (1): 4½" x 2½" (8); 2½" x 2½" (8) 2½" x WOF (1): 2½" x 2½" (16)
9	14"	4½" x WOF (1): 4½" x 4½" (9) 4½" x WOF (1): 4½" x 2½" (16) 2½" x WOF (1): 2½" x 2½" (16) 2½" x WOF (1): 2½" x 2½" (11); 2½" x 4½" (2)	9½"	4½" x WOF (1): 4½" x 2½" (9) 2½" x WOF (1): 2½" x 2½" (16) 2½" x WOF (1): 2½" x 2½" (11)
10	18½"	4½" x WOF (1): 4½" x 4½" (9) 4½" x WOF (1): 4½" x 4½" (1); 4½" x 2½" (4) 4½" x WOF (1): 4½" x 2½" (16) 2½" x WOF (1): 2½" x 2½" (16) 2½" x WOF (1): 2½" x 2½" (14)	9½"	4½" x WOF (1): 4½" x 2½" (10) 2½" x WOF (1): 2½" x 2½" (16) 2½" x WOF (1): 2½" x 2½" (14)
11	18½"	4½" x WOF (1): 4½" x 4½" (9) 4½" x WOF (1): 4½" x 4½" (2); 4½" x 2½" (6); 2½" x 2½" (1) 4½" x WOF (1): 4½" x 2½" (16) 2½" x WOF (2): 2½" x 2½" (16)	9½"	4½" x WOF (1): 4½" x 2½" (11); 2½" x 2½" (1) 2½" x WOF (2): 2½" x 2½" (16)
12	21"	4½" x WOF (1): 4½" x 4½" (9); 4½" x WOF (1): 4½" x 4½" (3); 4½" x 2½" (8) 4½" x WOF (1): 4½" x 2½" (16) 2½" x WOF (2): 2½" x 2½" (16) 2½" x WOF (1): 2½" x 2½" (4)	9½"	4½" x WOF (1): 4½" x 2½" (12); 2½" x 2½" (4) 2½" x WOF (2): 2½" x 2½" (16)

	FABRIC 1		FABRIC 2	
#	IN.	CUTTING REQUIREMENTS	IN.	CUTTING REQUIREMENTS
13	21"	4½" x WOF (1): 4½" x 4½" (9) 4½" x WOF (1): 4½" x 4½" (4); 4½" x 2½" (9) 4½" x WOF (1): 4½" x 2½" (16) 2½" x WOF (2): 2½" x 2½" (16) 2½" x WOF (1): 2½" x 2½" (7); 2½" x 4½" (1)	12"	4½" x WOF (1): 4½" x 2½" (13) 2½" x WOF (2): 2½" x 2½" (16) 2½" x WOF (1): 2½" x 2½" (7)
14	23"	4½" x WOF (1): 4½" x 4½" (9) 4½" x WOF (1): 4½" x 4½" (5); 2½" x 2½" (7) 4½" x WOF (1): 4½" x 2½" (16) 4½" x WOF (1): 4½" x 2½" (12); 2½" x 2½" (3) 2½" x WOF (2): 2½" x 2½" (16)	12"	4½" x WOF (1): 4½" x 2½" (14) 2½" x WOF (2): 2½" x 2½" (16) 2½" x WOF (1): 2½" x 2½" (10)
15	25½"	4½" x WOF (1): 4½" x 4½" (9) 4½" x WOF (1): 4½" x 4½" (6) 4½" x WOF (1): 4½" x 2½" (16) 4½" x WOF (1): 4½" x 2½" (14) 2½" x WOF (2): 2½" x 2½" (16) 2½" x WOF (1): 2½" x 2½" (13)	12"	4½" x WOF (1): 4½" x 2½" (15) 2½" x WOF (2): 2½" x 2½" (16) 2½" x WOF (1): 2½" x 2½" (13)
16	25½"	4½" x WOF (1): 4½" x 4½" (9) 4½" x WOF (1): 4½" x 4½" (7) 4½" x WOF (2): 4½" x 2½" (16) 2½" x WOF (3): 2½" x 2½" (16)	12"	4½" x WOF (1): 4½" x 2½" (16) 2½" x WOF (3): 2½" x 2½" (16)
17	28"	4½" x WOF (1): 4½" x 4½" (9) 4½" x WOF (1): 4½" x 4½" (8) 4½" x WOF (2): 4½" x 2½" (16) 2½" x WOF (3): 2½" x 2½" (16) 2½" x WOF (1): 2½" x 2½" (3); 2½" x 4½" (2)	14½"	4½" x WOF (1): 4½" x 2½" (16) 2½" x WOF (3): 2½" x 2½" (16) 2½" x WOF (1): 2½" x 2½" (3); 2½" x 4½" (1)
18	30"	4½" x WOF (2): 4½" x 4½" (9) 4½" x WOF (2): 4½" x 2½" (16) 4½" x WOF (1): 4½" x 2½" (4); 2½" x 2½" (6) 2½" x WOF (3): 2½" x 2½" (16)	14½"	4½" x WOF (1): 4½" x 2½" (16) 2½" x WOF (3): 2½" x 2½" (16) 2½" x WOF (1): 2½" x 2½" (6); 2½" x 4½" (2)
20	32½"	4½" x WOF (2): 4½" x 4½" (9) 4½" x WOF (1): 4½" x 4½" (2); 4½" x 2½" (8) 4½" x WOF (2): 4½" x 2½" (16) 2½" x WOF (3): 2½" x 2½" (16) 2½" x WOF (1): 2½" x 2½" (12)	16½"	4½" x WOF (1): 4½" x 2½" (16) 4½" x WOF (1): 4½" x 2½" (4); 2½" x 2½" (12) 2½" x WOF (3): 2½" x 2½" (16)
21	32½"	4½" x WOF (2): 4½" x 4½" (9) 4½" x WOF (1): 4½" x 4½" (3); 4½" x 2½" (10) 4½" x WOF (2): 4½" x 2½" (16) 2½" x WOF (3): 2½" x 2½" (16) 2½" x WOF (1): 2½" x 2½" (15)	19"	4½" x WOF (1): 4½" x 2½" (16) 4½" x WOF (1): 4½" x 2½" (5) 2½" x WOF (3): 2½" x 2½" (16) 2½" x WOF (1): 2½" x 2½" (15)
22	37"	4½" x WOF (2): 4½" x 4½" (9) 4½" x WOF (1): 4½" x 4½" (4); 4½" x 2½" (9) 4½" x WOF (2): 4½" x 2½" (16); 4½" x WOF (1): 4½" x 2½" (3); 2½" x 2½" (2) 2½" x WOF (4): 2½" x 2½" (16)	19"	4½" x WOF (1): 4½" x 2½" (16) 4½" x WOF (1): 4½" x 2½" (6); 2½" x 2½" (2) 2½" x WOF (4): 2½" x 2½" (16)

continues on next page

#	FABRIC 1		FABRIC 2	
	IN.	**CUTTING REQUIREMENTS**	**IN.**	**CUTTING REQUIREMENTS**
24	39½"	4½" x WOF (2): 4½" x 4½" (9) 4½" x WOF (1): 4½" x 4½" (6) 4½" x WOF (3): 4½" x 2½" (16) 2½" x WOF (4): 2½" x 2½" (16) 2½" x WOF (1): 2½" x 2½" (8)	19"	4½" x WOF (1): 4½" x 2½" (16) 4½" x WOF (1): 4½" x 2½" (8); 2½" x 2½" (8) 2½" x WOF (4): 2½" x 2½" (16)
26	44"	4½" x WOF (2): 4½" x 4½" (9) 4½" x WOF (1): 4½" x 4½" (8) 4½" x WOF (3): 4½" x 2½" (16) 4½" x WOF (1): 4½" x 2½" (4) 2½" x WOF (4): 2½" x 2½" (16) 2½" x WOF (1): 2½" x 2½" (14)	21½"	4½" x WOF (1): 4½" x 2½" (16) 4½" x WOF (1): 4½" x 2½" (10) 2½" x WOF (4): 2½" x 2½" (16) 2½" x WOF (1): 2½" x 2½" (14)
28	44"	4½" x WOF (3): 4½" x 4½" (9) 4½" x WOF (1): 4½" x 4½" (1); 4½" x 2½" (8); 2½" x 2½" (4) 4½" x WOF (3): 4½" x 2½" (16) 2½" x WOF (5): 2½" x 2½" (16)	21½"	4½" x WOF (1): 4½" x 2½" (16) 4½" x WOF (1): 4½" x 2½" (12); 2½" x 2½" (4) 2½" x WOF (5): 2½" x 2½" (16)
32	51"	4½" x WOF (3): 4½" x 4½" (9) 4½" x WOF (1): 4½" x 4½" (5) 4½" x WOF (4): 4½" x 2½" (16) 2½" x WOF (6): 2½" x 2½" (16)	24"	4½" x WOF (2): 4½" x 2½" (16) 2½" x WOF (6): 2½" x 2½" (16)
34	53½"	4½" x WOF (3): 4½" x 4½" (9) 4½" x WOF (1): 4½" x 4½" (7); 4½" x 2½" (4) 4½" x WOF (4): 4½" x 2½" (16) 2½" x WOF (6): 2½" x 2½" (16) 2½" x WOF (1): 2½" x 2½" (6)	26½"	4½" x WOF (2): 4½" x 2½" (16) 2½" x WOF (6): 2½" x 2½" (16) 2½" x WOF (1): 2½" x 2½" (6); 2½" x 4½" (2)
36	58"	4½" x WOF (4): 4½" x 4½" (9) 4½" x WOF (4): 4½" x 2½" (16) 4½" x WOF (1): 4½" x 2½" (8) 2½" x WOF (6): 2½" x 2½" (16) 2½" x WOF (1): 2½" x 2½" (12)	28½"	4½" x WOF (2): 4½" x 2½" (16) 4½" x WOF (1): 4½" x 2½" (4); 2½" x 2½" (12) 2½" x WOF (6): 2½" x 2½" (16)
40	62½"	4½" x WOF (4): 4½" x 4½" (9) 4½" x WOF (1): 4½" x 4½" (4); 2½" x 2½" (8) 4½" x WOF (5): 4½" x 2½" (16) 2½" x WOF (7): 2½" x 2½" (16)	31"	4½" x WOF (2): 4½" x 2½" (16) 4½" x WOF (1): 4½" x 2½" (8); 2½" x 2½" (8) 2½" x WOF (7): 2½" x 2½" (16)
44	69½"	4½" x WOF (4): 4½" x 4½" (9) 4½" x WOF (1): 4½" x 4½" (8) 4½" x WOF (5): 4½" x 2½" (16) 4½" x WOF (1): 4½" x 2½" (8); 2½" x 2½" (4) 2½" x WOF (8): 2½" x 2½" (16)	33½"	4½" x WOF (2): 4½" x 2½" (16) 4½" x WOF (1): 4½" x 2½" (12); 2½" x 2½" (4) 2½" x WOF (8): 2½" x 2½" (16)
45	72"	4½" x WOF (5): 4½" x 4½" (9) 4½" x WOF (5): 4½" x 2½" (16) 4½" x WOF (1): 4½" x 2½" (10) 2½" x WOF (8): 2½" x 2½" (16) 2½" x WOF (1): 2½" x 2½" (7)	36"	4½" x WOF (2): 4½" x 2½" (16) 4½" x WOF (1): 4½" x 2½" (13) 2½" x WOF (8): 2½" x 2½" (16) 2½" x WOF (1): 2½" x 2½" (7)

#	FABRIC 1		FABRIC 2	
	IN.	**CUTTING REQUIREMENTS**	**IN.**	**CUTTING REQUIREMENTS**
48	76½"	4½" x WOF (5): 4½" x 4½" (9) 4½" x WOF (1): 4½" x 4½" (3) 4½" x WOF (6): 4½" x 2½" (16) 2½" x WOF (9): 2½" x 2½" (16)	36"	4½" x WOF (3): 4½" x 2½" (16) 2½" x WOF (9): 2½" x 2½" (16)
50	79"	4½" x WOF (5): 4½" x 4½" (9) 4½" x WOF (1): 4½" x 4½" (5); 4½" x 2½" (4) 4½" x WOF (6): 4½" x 2½" (16) 2½" x WOF (9): 2½" x 2½" (16) 2½" x WOF (1): 2½" x 2½" (6)	38½"	4½" x WOF (3): 4½" x 2½" (16) 2½" x WOF (9): 2½" x 2½" (16) 2½" x WOF (1): 2½" x 2½" (6); 2½" x 4½" (2)
52	81½"	4½" x WOF (5): 4½" x 4½" (9) 4½" x WOF (1): 4½" x 4½" (7); 4½" x 2½" (4) 4½" x WOF (6): 4½" x 2½" (16) 2½" x WOF (1): 4½" x 2½" (4) 2½" x WOF (9): 2½" x 2½" (16) 2½" x WOF (1): 2½" x 2½" (12)	40½"	4½" x WOF (3): 4½" x 2½" (16) 4½" x WOF (1): 4½" x 2½" (4); 2½" x 2½" (12) 2½" x WOF (9): 2½" x 2½" (16)
56	88"	4½" x WOF (6): 4½" x 4½" (9) 4½" x WOF (1): 4½" x 4½" (2); 2½" x 2½" (8) 4½" x WOF (7): 4½" x 2½" (16) 2½" x WOF (10): 2½" x 2½" (16)	43"	4½" x WOF (3): 4½" x 2½" (16) 4½" x WOF (1): 4½" x 2½" (8); 2½" x 2½" (8) 2½" x WOF (10): 2½" x 2½" (16)

Block 12

#	FABRIC 1 IN.	FABRIC 1 CUTTING REQUIREMENTS	FABRIC 2 IN.	FABRIC 2 CUTTING REQUIREMENTS
1	2½"	2½" x WOF (1): 2½" x 4½" (2); 2½" x 2½" (4)	2½"	2½" x WOF (1): 2½" x 4½" (2); 2½" x 2½" (4)
2	2½"	2½" x WOF (1): 2½" x 4½" (4); 2½" x 2½" (8)	2½"	2½" x WOF (1): 2½" x 4½" (4); 2½" x 2½" (8)
3	5"	2½" x WOF (1): 2½" x 4½" (6) 2½" x WOF (1): 2½" x 2½" (12)	5"	2½" x WOF (1): 2½" x 4½" (6) 2½" x WOF (1): 2½" x 2½" (12)
4	5"	2½" x WOF (1): 2½" x 4½" (8) 2½" x WOF (1): 2½" x 2½" (16)	5"	2½" x WOF (1): 2½" x 4½" (8) 2½" x WOF (1): 2½" x 2½" (16)
5	7½"	2½" x WOF (1): 2½" x 4½" (9) 2½" x WOF (1): 2½" x 4½" (1); 2½" x 2½" (4) 2½" x WOF (1): 2½" x 2½" (16)	7½"	2½" x WOF (1): 2½" x 4½" (9) 2½" x WOF (1): 2½" x 4½" (1); 2½" x 2½" (4) 2½" x WOF (1): 2½" x 2½" (16)
6	7½"	2½" x WOF (1): 2½" x 4½" (9) 2½" x WOF (1): 2½" x 4½" (3); 2½" x 2½" (8) 2½" x WOF (1): 2½" x 2½" (16)	7½"	2½" x WOF (1): 2½" x 4½" (9) 2½" x WOF (1): 2½" x 4½" (3); 2½" x 2½" (8) 2½" x WOF (1): 2½" x 2½" (16)
7	10"	2½" x WOF (1): 2½" x 4½" (9) 2½" x WOF (1): 2½" x 4½" (5) 2½" x WOF (1): 2½" x 2½" (16) 2½" x WOF (1): 2½" x 2½" (12)	10"	2½" x WOF (1): 2½" x 4½" (9) 2½" x WOF (1): 2½" x 4½" (5) 2½" x WOF (1): 2½" x 2½" (16) 2½" x WOF (1): 2½" x 2½" (12)
8	10"	2½" x WOF (1): 2½" x 4½" (9) 2½" x WOF (1): 2½" x 4½" (7) 2½" x WOF (2): 2½" x 2½" (16)	10"	2½" x WOF (1): 2½" x 4½" (9) 2½" x WOF (1): 2½" x 4½" (7) 2½" x WOF (2): 2½" x 2½" (16)
9	12½"	2½" x WOF (2): 2½" x 4½" (9) 2½" x WOF (2): 2½" x 2½" (16) 2½" x WOF (1): 2½" x 2½" (4)	12½"	2½" x WOF (2): 2½" x 4½" (9) 2½" x WOF (2): 2½" x 2½" (16) 2½" x WOF (1): 2½" x 2½" (4)
10	12½"	2½" x WOF (2): 2½" x 4½" (9) 2½" x WOF (1): 2½" x 4½" (2); 2½" x 2½" (8) 2½" x WOF (2): 2½" x 2½" (16)	12½"	2½" x WOF (2): 2½" x 4½" (9) 2½" x WOF (1): 2½" x 4½" (2); 2½" x 2½" (8) 2½" x WOF (2): 2½" x 2½" (16)
11	15"	2½" x WOF (2): 2½" x 4½" (9) 2½" x WOF (1): 2½" x 4½" (4) 2½" x WOF (2): 2½" x 2½" (16) 2½" x WOF (1): 2½" x 2½" (12)	15"	2½" x WOF (2): 2½" x 4½" (9) 2½" x WOF (1): 2½" x 4½" (4) 2½" x WOF (2): 2½" x 2½" (16) 2½" x WOF (1): 2½" x 2½" (12)
12	15"	2½" x WOF (2): 2½" x 4½" (9) 2½" x WOF (1): 2½" x 4½" (6) 2½" x WOF (3): 2½" x 2½" (16)	15"	2½" x WOF (2): 2½" x 4½" (9) 2½" x WOF (1): 2½" x 4½" (6) 2½" x WOF (3): 2½" x 2½" (16)
13	17½"	2½" x WOF (2): 2½" x 4½" (9) 2½" x WOF (1): 2½" x 4½" (8) 2½" x WOF (3): 2½" x 2½" (16) 2½" x WOF (1): 2½" x 2½" (4)	17½"	2½" x WOF (2): 2½" x 4½" (9) 2½" x WOF (1): 2½" x 4½" (8) 2½" x WOF (3): 2½" x 2½" (16) 2½" x WOF (1): 2½" x 2½" (4)
14	17½"	2½" x WOF (3): 2½" x 4½" (9) 2½" x WOF (1): 2½" x 4½" (1); 2½" x 2½" (8) 2½" x WOF (3): 2½" x 2½" (16)	17½"	2½" x WOF (3): 2½" x 4½" (9) 2½" x WOF (1): 2½" x 4½" (1); 2½" x 2½" (8) 2½" x WOF (3): 2½" x 2½" (16)
15	20"	2½" x WOF (3): 2½" x 4½" (9) 2½" x WOF (1): 2½" x 4½" (3) 2½" x WOF (3): 2½" x 2½" (16) 2½" x WOF (1): 2½" x 2½" (12)	20"	2½" x WOF (3): 2½" x 4½" (9) 2½" x WOF (1): 2½" x 4½" (3) 2½" x WOF (3): 2½" x 2½" (16) 2½" x WOF (1): 2½" x 2½" (12)

#	FABRIC 1		FABRIC 2	
	IN.	CUTTING REQUIREMENTS	IN.	CUTTING REQUIREMENTS
16	20"	2½" x WOF (3): 2½" x 4½" (9) 2½" x WOF (1): 2½" x 4½" (5) 2½" x WOF (4): 2½" x 2½" (16)	20"	2½" x WOF (3): 2½" x 4½" (9) 2½" x WOF (1): 2½" x 4½" (5) 2½" x WOF (4): 2½" x 2½" (16)
17	20"	2½" x WOF (3): 2½" x 4½" (9) 2½" x WOF (1) 2½" x 4½" (7); 2½" x 2½" (4) 2½" x WOF (4): 2½" x 2½" (16)	20"	2½" x WOF (3): 2½" x 4½" (9) 2½" x WOF (1) 2½" x 4½" (7); 2½" x 2½" (4) 2½" x WOF (4): 2½" x 2½" (16)
18	22½"	2½" x WOF (4): 2½" x 4½" (9) 2½" x WOF (4): 2½" x 2½" (16) 2½" x WOF (1): 2½" x 2½" (8)	22½"	2½" x WOF (4): 2½" x 4½" (9) 2½" x WOF (4): 2½" x 2½" (16) 2½" x WOF (1): 2½" x 2½" (8)
20	25"	2½" x WOF (4): 2½" x 4½" (9) 2½" x WOF (1): 2½" x 4½" (4) 2½" x WOF (5): 2½" x 2½" (16)	25"	2½" x WOF (4): 2½" x 4½" (9) 2½" x WOF (1): 2½" x 4½" (4) 2½" x WOF (5): 2½" x 2½" (16)
21	25"	2½" x WOF (4): 2½" x 4½" (9) 2½" x WOF (1): 2½" x 4½" (6); 2½" x 2½" (4) 2½" x WOF (5): 2½" x 2½" (16)	25"	2½" x WOF (4): 2½" x 4½" (9) 2½" x WOF (1): 2½" x 4½" (6); 2½" x 2½" (4) 2½" x WOF (5): 2½" x 2½" (16)
22	27½"	2½" x WOF (4): 2½" x 4½" (9) 2½" x WOF (1): 2½" x 4½" (8) 2½" x WOF (5): 2½" x 2½" (16) 2½" x WOF (1): 2½" x 2½" (8)	27½"	2½" x WOF (4): 2½" x 4½" (9) 2½" x WOF (1): 2½" x 4½" (8) 2½" x WOF (5): 2½" x 2½" (16) 2½" x WOF (1): 2½" x 2½" (8)
24	30"	2½" x WOF (5): 2½" x 4½" (9) 2½" x WOF (1): 2½" x 4½" (3) 2½" x WOF (6): 2½" x 2½" (16)	30"	2½" x WOF (5): 2½" x 4½" (9) 2½" x WOF (1): 2½" x 4½" (3) 2½" x WOF (6): 2½" x 2½" (16)
26	32½"	2½" x WOF (5): 2½" x 4½" (9) 2½" x WOF (1): 2½" x 4½" (7) 2½" x WOF (6): 2½" x 2½" (16) 2½" x WOF (1): 2½" x 2½" (8)	32½"	2½" x WOF (5): 2½" x 4½" (9) 2½" x WOF (1): 2½" x 4½" (7) 2½" x WOF (6): 2½" x 2½" (16) 2½" x WOF (1): 2½" x 2½" (8)
28	35"	2½" x WOF (6): 2½" x 4½" (9) 2½" x WOF (1): 2½" x 4½" (2) 2½" x WOF (7): 2½" x 2½" (16)	35"	2½" x WOF (6): 2½" x 4½" (9) 2½" x WOF (1): 2½" x 4½" (2) 2½" x WOF (7): 2½" x 2½" (16)
32	40"	2½" x WOF (7): 2½" x 4½" (9) 2½" x WOF (1): 2½" x 4½" (1) 2½" x WOF (8): 2½" x 2½" (16)	40"	2½" x WOF (7): 2½" x 4½" (9) 2½" x WOF (1): 2½" x 4½" (1) 2½" x WOF (8): 2½" x 2½" (16)
34	42½"	2½" x WOF (7): 2½" x 4½" (9) 2½" x WOF (1): 2½" x 4½" (5) 2½" x WOF (8): 2½" x 2½" (16) 2½" x WOF (1): 2½" x 2½" (8)	42½"	2½" x WOF (7): 2½" x 4½" (9) 2½" x WOF (1): 2½" x 4½" (5) 2½" x WOF (8): 2½" x 2½" (16) 2½" x WOF (1): 2½" x 2½" (8)
36	42½"	2½" x WOF (8): 2½" x 4½" (9) 2½" x WOF (9): 2½" x 2½" (16)	42½"	2½" x WOF (8): 2½" x 4½" (9) 2½" x WOF (9): 2½" x 2½" (16)
40	47½"	2½" x WOF (8): 2½" x 4½" (9) 2½" x WOF (1): 2½" x 4½" (8) 2½" x WOF (10): 2½" x 2½" (16)	47½"	2½" x WOF (8): 2½" x 4½" (9) 2½" x WOF (1): 2½" x 4½" (8) 2½" x WOF (10): 2½" x 2½" (16)

continues on next page

#	FABRIC 1		FABRIC 2	
	IN.	CUTTING REQUIREMENTS	IN.	CUTTING REQUIREMENTS
44	52½"	2½" x WOF (9): 2½" x 4½" (9) 2½" x WOF (1): 2½" x 4½" (7) 2½" x WOF (11): 2½" x 2½" (16)	52½"	2½" x WOF (9): 2½" x 4½" (9) 2½" x WOF (1): 2½" x 4½" (7) 2½" x WOF (11): 2½" x 2½" (16)
45	55"	2½" x WOF (10): 2½" x 4½" (9) 2½" x WOF (11): 2½" x 2½" (16) 2½" x WOF (1): 2½" x 2½" (4)	55"	2½" x WOF (10): 2½" x 4½" (9) 2½" x WOF (11): 2½" x 2½" (16) 2½" x WOF (1): 2½" x 2½" (4)
48	57½"	2½" x WOF (10): 2½" x 4½" (9) 2½" x WOF (1): 2½" x 4½" (6) 2½" x WOF (12): 2½" x 2½" (16)	57½"	2½" x WOF (10): 2½" x 4½" (9) 2½" x WOF (1): 2½" x 4½" (6) 2½" x WOF (12): 2½" x 2½" (16)
50	60"	2½" x WOF (11): 2½" x 4½" (9) 2½" x WOF (1): 2½" x 4½" (1); 2½" x 2½" (8) 2½" x WOF (12): 2½" x 2½" (16)	60"	2½" x WOF (11): 2½" x 4½" (9) 2½" x WOF (1): 2½" x 4½" (1); 2½" x 2½" (8) 2½" x WOF (12): 2½" x 2½" (16)
52	62½"	2½" x WOF (11): 2½" x 4½" (9) 2½" x WOF (1): 2½" x 4½" (5) 2½" x WOF (13): 2½" x 2½" (16)	62½"	2½" x WOF (11): 2½" x 4½" (9) 2½" x WOF (1): 2½" x 4½" (5) 2½" x WOF (13): 2½" x 2½" (16)
56	67½"	2½" x WOF (12): 2½" x 4½" (9) 2½" x WOF (1): 2½" x 4½" (4) 2½" x WOF (14): 2½" x 2½" (16)	67½"	2½" x WOF (12): 2½" x 4½" (9) 2½" x WOF (1): 2½" x 4½" (4) 2½" x WOF (14): 2½" x 2½" (16)

Block 13 ⌐

#	IN.	FABRIC 1 CUTTING REQUIREMENTS	IN.	FABRIC 2 CUTTING REQUIREMENTS
1	4½"	4½" x WOF (1): 4½" x 4½" (1); 6½" x 2½" (1); 8½" x 2½" (1)	2½"	2½" x WOF (1): 2½" x 6½" (1); 2½" x 4½" (1)
2	4½"	4½" x WOF (1): 4½" x 4½" (2); 8½" x 2½" (2); 6½" x 2½" (2)	2½"	2½" x WOF (1): 2½" x 6½" (2); 2½" x 4½" (2)
3	8½"	8½" x WOF (1): 8½" x 2½" (3); 6½" x 2½" (3); 4½" x 4½" (3)	2½"	2½" x WOF (1): 2½" x 6½" (3); 2½" x 4½" (3)
4	8½"	8½" x WOF (1): 8½" x 2½" (4); 6½" x 2½" (4); 4½" x 4½" (4)	6½"	6½" x WOF (1): 6½" x 2½" (4); 4½" x 2½" (4)
5	13"	8½" x WOF (1): 8½" x 2½" (5); 6½" x 2½" (5) 4½" x WOF (1): 4½" x 4½" (5)	6½"	6½" x WOF (1): 6½" x 2½" (5); 4½" x 2½" (5)
6	13"	8½" x WOF (1): 8½" x 2½" (6); 6½" x 2½" (6) 4½" x WOF (1): 4½" x 4½" (6)	6½"	6½" x WOF (1): 6½" x 2½" (6); 4½" x 2½" (6)
7	13"	8½" x WOF (1): 8½" x 2½" (7); 6½" x 2½" (7) 4½" x WOF (1): 4½" x 4½" (7)	6½"	6½" x WOF (1): 6½" x 2½" (7); 4½" x 2½" (7)
8	13"	8½" x WOF (1): 8½" x 2½" (8); 6½" x 2½" (8) 4½" x WOF (1): 4½" x 4½" (8)	6½"	6½" x WOF (1): 6½" x 2½" (8); 4½" x 2½" (8)
9	19½"	8½" x WOF (1): 8½" x 2½" (9) 6½" x WOF (1): 6½" x 2½" (9) 4½" x WOF (1): 4½" x 4½" (9)	9"	6½" x WOF (1): 6½" x 2½" (8); 4½" x 2½" (8) 2½" x WOF (1): 2½" x 6½" (1); 2½" x 4½" (1)
10	19½"	8½" x WOF (1): 8½" x 2½" (10) 6½" x WOF (1): 6½" x 2½" (10); 4½" x 4½" (1) 4½" x WOF (1): 4½" x 4½" (9)	9"	6½" x WOF (1): 6½" x 2½" (8); 4½" x 2½" (8) 2½" x WOF (1): 2½" x 6½" (2); 2½" x 4½" (2)
11	19½"	8½" x WOF (1): 8½" x 2½" (11) 6½" x WOF (1): 6½" x 2½" (11); 4½" x 4½" (2) 4½" x WOF (1): 4½" x 4½" (9)	9"	6½" x WOF (1): 6½" x 2½" (8); 4½" x 2½" (8) 2½" x WOF (1): 2½" x 6½" (3); 2½" x 4½" (3)
12	19½"	8½" x WOF (1): 8½" x 2½" (12); 4½" x 4½" (2) 6½" x WOF (1): 6½" x 2½" (12); 4½" x 4½" (1) 4½" x WOF (1): 4½" x 4½" (9)	11"	6½" x WOF (1): 6½" x 2½" (12) 4½" x WOF (1): 4½" x 2½" (12)
13	19½"	8½" x WOF (1): 8½" x 2½" (13); 4½" x 4½" (2) 6½" x WOF (1): 6½" x 2½" (13); 4½" x 4½" (2) 4½" x WOF (1): 4½" x 4½" (9)	11"	6½" x WOF (1): 6½" x 2½" (13) 4½" x WOF (1): 4½" x 2½" (13)
14	24"	8½" x WOF (1): 8½" x 2½" (14) 6½" x WOF (1): 6½" x 2½" (14) 4½" x WOF (1): 4½" x 4½" (9) 4½" x WOF (1): 4½" x 4½" (5)	11"	6½" x WOF (1): 6½" x 2½" (14) 4½" x WOF (1): 4½" x 2½" (14)
15	24"	8½" x WOF (1): 8½" x 2½" (15) 6½" x WOF (1): 6½" x 2½" (15) 4½" x WOF (1): 4½" x 4½" (9) 4½" x WOF (1): 4½" x 4½" (6)	11"	6½" x WOF (1): 6½" x 2½" (15) 4½" x WOF (1): 4½" x 2½" (15)

continues on next page

THE MATH

#	IN.	FABRIC 1 CUTTING REQUIREMENTS	IN.	FABRIC 2 CUTTING REQUIREMENTS
16	24"	8½" x WOF (1): 8½" x 2½" (16) 6½" x WOF (1): 6½" x 2½" (16) 4½" x WOF (1): 4½" x 4½" (9) 4½" x WOF (1): 4½" x 4½" (7)	11"	6½" x WOF (1): 6½" x 2½" (16) 4½" x WOF (1): 4½" x 2½" (16)
17	26½"	8½" x WOF (1): 8½" x 2½" (16) 6½" x WOF (1): 6½" x 2½" (16) 4½" x WOF (1): 4½" x 4½" (9) 4½" x WOF (1): 4½" x 4½" (8) 2½" X WOF (1): 2½" x 8½" (1); 2½" x 6½" (1)	13½"	6½" x WOF (1): 6½" x 2½" (16) 4½" x WOF (1): 4½" x 2½" (16) 2½" x WOF (1): 2½" x 6½" (1); 2½" x 4½" (1)
18	26½"	8½" x WOF (1): 8½" x 2½" (16) 6½" x WOF (1): 6½" x 2½" (16) 4½" x WOF (2): 4½" x 4½" (9) 2½" X WOF (1): 2½" x 8½" (2); 2½" x 6½" (2)	13½"	6½" x WOF (1): 6½" x 2½" (16) 4½" x WOF (1): 4½" x 2½" (16) 2½" x WOF (1): 2½" x 6½" (2); 2½" x 4½" (2)
20	33½"	8½" x WOF (1): 8½" x 2½" (16) 6½" x WOF (1): 6½" x 2½" (16) 4½" x WOF (2): 4½" x 4½" (9) 4½" x WOF (1): 4½" x 4½" (2) 2½" X WOF (1): 2½" x 8½" (4) 2½" X WOF (1): 2½" x 6½" (4)	16"	6½" x WOF (1): 6½" x 2½" (16) 4½" x WOF (1): 4½" x 2½" (16) 2½" x WOF (1): 2½" x 6½" (4) 2½" x WOF (1): 2½" x 4½" (4)
21	33½"	8½" x WOF (1): 8½" x 2½" (16) 6½" x WOF (1): 6½" x 2½" (16) 4½" x WOF (2): 4½" x 4½" (9) 4½" x WOF (1): 4½" x 4½" (3) 2½" x WOF (1): 2½" x 8½" (4); 2½" x 6½" (1) 2½" x WOF (1): 2½" x 8½" (1); 2½" x 6½" (4)	16"	6½" x WOF (1): 6½" x 2½" (16) 4½" x WOF (1): 4½" x 2½" (16) 2½" x WOF (1): 2½" x 6½" (5) 2½" x WOF (1): 2½" x 4½" (5)
22	37"	8½" x WOF (1): 8½" x 2½" (16) 8½" x WOF (1): 8½" x 2½" (6); 6½" x 2½" (6) 6½" x WOF (1): 6½" x 2½" (16) 4½" x WOF (2): 4½" x 4½" (9) 4½" x WOF (1): 4½" x 4½" (4)	16"	6½" x WOF (1): 6½" x 2½" (16) 4½" x WOF (1): 4½" x 2½" (16) 2½" x WOF (1): 2½" x 6½" (6) 2½" x WOF (1): 2½" x 4½" (6)
24	37"	8½" x WOF (1): 8½" x 2½" (16) 8½" x WOF (1): 8½" x 2½" (8); 6½" x 2½" (8) 6½" x WOF (1): 6½" x 2½" (16) 4½" x WOF (2): 4½" x 4½" (9) 4½" x WOF (1): 4½" x 4½" (6)	17½"	6½" x WOF (1): 6½" x 2½" (16) 6½" x WOF (1): 6½" x 2½" (8); 4½" x 2½" (8) 4½" x WOF (1): 4½" x 2½" (16)
26	38½"	8½" x WOF (1): 8½" x 2½" (16) 6½" x WOF (1): 6½" x 2½" (16) 4½" x WOF (2): 4½" x 4½" (9) 4½" x WOF (1): 4½" x 4½" (8) 2½" x WOF (2): 2½" x 8½" (4); 2½" x 6½" (1) 2½" x WOF (2): 2½" x 8½" (1); 2½" x 6½" (4)	20"	6½" x WOF (1): 6½" x 2½" (16) 6½" x WOF (1): 6½" x 2½" (8); 4½" x 2½" (8) 4½" x WOF (1): 4½" x 2½" (16) 2½" x WOF (1): 2½" x 6½" (2); 2½" x 4½" (2)
28	43½"	8½" x WOF (1): 8½" x 2½" (16) 8½" x WOF (1): 8½" x 2½" (12); 4½" x 4½" (1) 6½" x WOF (1): 6½" x 2½" (16) 6½" x WOF (1): 6½" x 2½" (12) 4½" x WOF (3): 4½" x 4½" (9)	22"	6½" x WOF (1): 6½" x 2½" (16) 6½" x WOF (1): 6½" x 2½" (12) 4½" x WOF (1): 4½" x 2½" (16) 4½" x WOF (1): 4½" x 2½" (12)

#	FABRIC 1		FABRIC 2	
	IN.	CUTTING REQUIREMENTS	IN.	CUTTING REQUIREMENTS
32	48"	8½" x WOF (2): 8½" x 2½" (16) 6½" x WOF (2): 6½" x 2½" (16) 4½" x WOF (3): 4½" x 4½" (9) 4½" x WOF (1): 4½" x 4½" (5)	22"	6½" x WOF (2): 6½" x 2½" (16) 4½" x WOF (2): 4½" x 2½" (16)
34	50½"	8½" x WOF (2): 8½" x 2½" (16) 6½" x WOF (2): 6½" x 2½" (16) 4½" x WOF (3): 4½" x 4½" (9) 4½" x WOF (1): 4½" x 4½" (7) 2½" X WOF (1): 2½" x 8½" (2); 2½" x 6½" (2)	24½"	6½" x WOF (2): 6½" x 2½" (16) 4½" x WOF (2): 4½" x 2½" (16) 2½" x WOF (1): 2½" x 6½" (2); 2½" x 4½" (2)
36	56½"	8½" x WOF (2): 8½" x 2½" (16) 8½" x WOF (1): 8½" x 2½" (4); 6½" x 2½" (4) 6½" x WOF (2): 6½" x 2½" (16) 4½" x WOF (4): 4½" x 4½" (9)	27"	6½" x WOF (2): 6½" x 2½" (16) 4½" x WOF (2): 4½" x 2½" (16) 2½" x WOF (1): 2½" x 6½" (3); 2½" x 4½" (4) 2½" x WOF (1): 2½" x 6½" (1)
40	61"	8½" x WOF (2): 8½" x 2½" (16) 8½" x WOF (1): 8½" x 2½" (8); 6½" x 2½" (8) 6½" x WOF (2): 6½" x 2½" (16) 4½" x WOF (4): 4½" x 4½" (9) 4½" x WOF (1): 4½" x 4½" (4)	28½"	6½" x WOF (2): 6½" x 2½" (16) 6½" x WOF (1): 6½" x 2½" (8); 4½" x 2½" (8) 4½" x WOF (2): 4½" x 2½" (16)
44	67½"	8½" x WOF (2): 8½" x 2½" (16) 8½" x WOF (1): 8½" x 2½" (12) 6½" x WOF (2): 6½" x 2½" (16) 6½" x WOF (1): 6½" x 2½" (12) 4½" x WOF (4): 4½" x 4½" (9) 4½" x WOF (1): 4½" x 4½" (8)	33"	6½" x WOF (2): 6½" x 2½" (16) 6½" x WOF (1): 6½" x 2½" (12) 4½" x WOF (2): 4½" x 2½" (16) 4½" x WOF (1): 4½" x 2½" (12)
45	67½"	8½" x WOF (2): 8½" x 2½" (16) 8½" x WOF (1): 8½" x 2½" (13) 6½" x WOF (2): 6½" x 2½" (16) 6½" x WOF (1): 6½" x 2½" (13) 4½" x WOF (5): 4½" x 4½" (9)	33"	6½" x WOF (2): 6½" x 2½" (16) 6½" x WOF (1): 6½" x 2½" (13) 4½" x WOF (2): 4½" x 2½" (16) 4½" x WOF (1): 4½" x 2½" (13)
48	72"	8½" x WOF (3): 8½" x 2½" (16) 6½" x WOF (3): 6½" x 2½" (16) 4½" x WOF (5): 4½" x 4½" (9) 4½" x WOF (1): 4½" x 4½" (3)	33"	6½" x WOF (3): 6½" x 2½" (16) 4½" x WOF (3): 4½" x 2½" (16)
50	74½"	8½" x WOF (3): 8½" x 2½" (16) 6½" x WOF (3): 6½" x 2½" (16) 4½" x WOF (5): 4½" x 4½" (9) 4½" x WOF (1): 4½" x 4½" (5) 2½" X WOF (1): 2½" x 8½" (2); 2½" x 6½" (2)	35½"	6½" x WOF (3): 6½" x 2½" (16) 4½" x WOF (3): 4½" x 2½" (16) 2½" x WOF (1): 2½" x 6½" (2); 2½" x 4½" (2)
52	80½"	8½" x WOF (3): 8½" x 2½" (16) 8½" x WOF (1): 8½" x 2½" (4); 6½" x 2½" (4) 6½" x WOF (3): 6½" x 2½" (16) 4½" x WOF (5): 4½" x 4½" (9) 4½" x WOF (1): 4½" x 4½" (7)	38"	6½" x WOF (3): 6½" x 2½" (16) 4½" x WOF (3): 4½" x 2½" (16) 2½" x WOF (1): 2½" x 6½" (3); 2½" x 4½" (4) 2½" x WOF (1): 2½" x 6½" (1)
56	85"	8½" x WOF (3): 8½" x 2½" (16) 8½" x WOF (1): 8½" x 2½" (8); 6½" x 2½" (8) 6½" x WOF (3): 6½" x 2½" (16) 4½" x WOF (6): 4½" x 4½" (9) 4½" x WOF (1): 4½" x 4½" (2)	39½"	6½" x WOF (3): 6½" x 2½" (16) 6½" x WOF (1): 6½" x 2½" (8); 4½" x 2½" (8) 4½" x WOF (3): 4½" x 2½" (16)

Blocks 14 and 15

DESIGN PAGES 47 AND 48

#	FABRIC 1 IN.	FABRIC 1 CUTTING REQUIREMENTS	FABRIC 2 IN.	FABRIC 2 CUTTING REQUIREMENTS
1	7¼"	7¼" x WOF (1): 7¼" x 7¼" (1)	7¼"	7¼" x WOF (1): 7¼" x 7¼" (1)
2	7¼"	7¼" x WOF (1): 7¼" x 7¼" (2)	7¼"	7¼" x WOF (1): 7¼" x 7¼" (2)
3	7¼"	7¼" x WOF (1): 7¼" x 7¼" (3)	7¼"	7¼" x WOF (1): 7¼" x 7¼" (3)
4	7¼"	7¼" x WOF (1): 7¼" x 7¼" (4)	7¼"	7¼" x WOF (1): 7¼" x 7¼" (4)
5	7¼"	7¼" x WOF (1): 7¼" x 7¼" (5)	7¼"	7¼" x WOF (1): 7¼" x 7¼" (5)
6	14½"	7¼" x WOF (1): 7¼" x 7¼" (5) 7¼" x WOF (1): 7¼" x 7¼" (1)	14½"	7¼" x WOF (1): 7¼" x 7¼" (5) 7¼" x WOF (1): 7¼" x 7¼" (1)
7	14½"	7¼" x WOF (1): 7¼" x 7¼" (5) 7¼" x WOF (1): 7¼" x 7¼" (2)	14½"	7¼" x WOF (1): 7¼" x 7¼" (5) 7¼" x WOF (1): 7¼" x 7¼" (2)
8	14½"	7¼" x WOF (1): 7¼" x 7¼" (5) 7¼" x WOF (1): 7¼" x 7¼" (3)	14½"	7¼" x WOF (1): 7¼" x 7¼" (5) 7¼" x WOF (1): 7¼" x 7¼" (3)
9	14½"	7¼" x WOF (1): 7¼" x 7¼" (5) 7¼" x WOF (1): 7¼" x 7¼" (4)	14½"	7¼" x WOF (1): 7¼" x 7¼" (5) 7¼" x WOF (1): 7¼" x 7¼" (4)
10	14½"	7¼" x WOF (2): 7¼" x 7¼" (5)	14½"	7¼" x WOF (2): 7¼" x 7¼" (5)
11	21¾"	7¼" x WOF (2): 7¼" x 7¼" (5) 7¼" x WOF (1): 7¼" x 7¼" (1)	21¾"	7¼" x WOF (2): 7¼" x 7¼" (5) 7¼" x WOF (1): 7¼" x 7¼" (1)
12	21¾"	7¼" x WOF (2): 7¼" x 7¼" (5) 7¼" x WOF (1): 7¼" x 7¼" (2)	21¾"	7¼" x WOF (2): 7¼" x 7¼" (5) 7¼" x WOF (1): 7¼" x 7¼" (2)
13	21¾"	7¼" x WOF (2): 7¼" x 7¼" (5) 7¼" x WOF (1): 7¼" x 7¼" (3)	21¾"	7¼" x WOF (2): 7¼" x 7¼" (5) 7¼" x WOF (1): 7¼" x 7¼" (3)
14	21¾"	7¼" x WOF (2): 7¼" x 7¼" (5) 7¼" x WOF (1): 7¼" x 7¼" (4)	21¾"	7¼" x WOF (2): 7¼" x 7¼" (5) 7¼" x WOF (1): 7¼" x 7¼" (4)
15	21¾"	7¼" x WOF (3): 7¼" x 7¼" (5)	21¾"	7¼" x WOF (3): 7¼" x 7¼" (5)
16	29"	7¼" x WOF (3): 7¼" x 7¼" (5) 7¼" x WOF (1): 7¼" x 7¼" (1)	29"	7¼" x WOF (3): 7¼" x 7¼" (5) 7¼" x WOF (1): 7¼" x 7¼" (1)
17	29"	7¼" x WOF (3): 7¼" x 7¼" (5) 7¼" x WOF (1): 7¼" x 7¼" (2)	29"	7¼" x WOF (3): 7¼" x 7¼" (5) 7¼" x WOF (1): 7¼" x 7¼" (2)
18	29"	7¼" x WOF (3): 7¼" x 7¼" (5) 7¼" x WOF (1): 7¼" x 7¼" (3)	29"	7¼" x WOF (3): 7¼" x 7¼" (5) 7¼" x WOF (1): 7¼" x 7¼" (3)
20	29"	7¼" x WOF (4): 7¼" x 7¼" (5)	29"	7¼" x WOF (4): 7¼" x 7¼" (5)
21	36¼"	7¼" x WOF (4): 7¼" x 7¼" (5) 7¼" x WOF (1): 7¼" x 7¼" (1)	36¼"	7¼" x WOF (4): 7¼" x 7¼" (5) 7¼" x WOF (1): 7¼" x 7¼" (1)
22	36¼"	7¼" x WOF (4): 7¼" x 7¼" (5) 7¼" x WOF (1): 7¼" x 7¼" (2)	36¼"	7¼" x WOF (4): 7¼" x 7¼" (5) 7¼" x WOF (1): 7¼" x 7¼" (2)
24	36¼"	7¼" x WOF (4): 7¼" x 7¼" (5) 7¼" x WOF (1): 7¼" x 7¼" (4)	36¼"	7¼" x WOF (4): 7¼" x 7¼" (5) 7¼" x WOF (1): 7¼" x 7¼" (4)

#	FABRIC 1		FABRIC 2	
	IN.	CUTTING REQUIREMENTS	IN.	CUTTING REQUIREMENTS
26	43½"	7¼" x WOF (5): 7¼" x 7¼" (5) 7¼" x WOF (1): 7¼" x 7¼" (1)	43½"	7¼" x WOF (5): 7¼" x 7¼" (5) 7¼" x WOF (1): 7¼" x 7¼" (1)
28	43½"	7¼" x WOF (5): 7¼" x 7¼" (5) 7¼" x WOF (1): 7¼" x 7¼" (3)	43½"	7¼" x WOF (5): 7¼" x 7¼" (5) 7¼" x WOF (1): 7¼" x 7¼" (3)
32	50¾"	7¼" x WOF (6): 7¼" x 7¼" (5) 7¼" x WOF (1): 7¼" x 7¼" (2)	50¾"	7¼" x WOF (6): 7¼" x 7¼" (5) 7¼" x WOF (1): 7¼" x 7¼" (2)
34	50¾"	7¼" x WOF (6): 7¼" x 7¼" (5) 7¼" x WOF (1): 7¼" x 7¼" (4)	50¾"	7¼" x WOF (6): 7¼" x 7¼" (5) 7¼" x WOF (1): 7¼" x 7¼" (4)
36	58"	7¼" x WOF (7): 7¼" x 7¼" (5) 7¼" x WOF (1): 7¼" x 7¼" (1)	58"	7¼" x WOF (7): 7¼" x 7¼" (5) 7¼" x WOF (1): 7¼" x 7¼" (1)
40	58"	7¼" x WOF (8): 7¼" x 7¼" (5)	58"	7¼" x WOF (8): 7¼" x 7¼" (5)
44	65¼"	7¼" x WOF (8): 7¼" x 7¼" (5) 7¼" x WOF (1): 7¼" x 7¼" (4)	65¼"	7¼" x WOF (8): 7¼" x 7¼" (5) 7¼" x WOF (1): 7¼" x 7¼" (4)
45	65¼"	7¼" x WOF (9): 7¼" x 7¼" (5)	65¼"	7¼" x WOF (9): 7¼" x 7¼" (5)
48	72½"	7¼" x WOF (9): 7¼" x 7¼" (5) 7¼" x WOF (1): 7¼" x 7¼" (3)	72½"	7¼" x WOF (9): 7¼" x 7¼" (5) 7¼" x WOF (1): 7¼" x 7¼" (3)
50	72½"	7¼" x WOF (10): 7¼" x 7¼" (5)	72½"	7¼" x WOF (10): 7¼" x 7¼" (5)
52	79¾"	7¼" x WOF (10): 7¼" x 7¼" (5) 7¼" x WOF (1): 7¼" x 7¼" (2)	79¾"	7¼" x WOF (10): 7¼" x 7¼" (5) 7¼" x WOF (1): 7¼" x 7¼" (2)
56	87"	7¼" x WOF (11): 7¼" x 7¼" (5) 7¼" x WOF (1): 7¼" x 7¼" (1)	87"	7¼" x WOF (11): 7¼" x 7¼" (5) 7¼" x WOF (1): 7¼" x 7¼" (1)

Blocks 16, 17, and 18

DESIGN PAGES 49, 50, AND 51

#	IN.	FABRIC 1 CUTTING REQUIREMENTS	IN.	FABRIC 2 CUTTING REQUIREMENTS
1	5"	5" x WOF (1): 5" x 5"" (1); 4½" x 4½" (2)	5"	5" x WOF (1): 5" x 5" (1)
2	5"	5" x WOF (1): 5" x 5" (2); 4½" x 4½" (4)	5"	5" x WOF (1): 5" x 5" (2)
3	5"	5" x WOF (1): 5" x 5" (3); 4½" x 4½" (6)	5"	5" x WOF (1): 5" x 5" (3)
4	9½"	5" x WOF (1): 5" x 5" (4) 4½" x WOF (1): 4½" x 4½" (8)	5"	5" x WOF (1): 5" x 5" (4)
5	9½"	5" x WOF (1): 5" x 5" (5); 4½" x 4½" (1) 4½" x WOF (1): 4½" x 4½" (9)	5"	5" x WOF (1): 5" x 5" (5)
6	14"	5" x WOF (1): 5" x 5" (6) 4½" x WOF (1): 4½" x 4½" (9) 4½" x WOF (1): 4½" x 4½" (3)	5"	5" x WOF (1): 5" x 5" (6)
7	14"	5" x WOF (1): 5" x 5" (7) 4½" x WOF (1): 4½" x 4½" (9) 4½" x WOF (1): 4½" x 4½" (5)	5"	5" x WOF (1): 5" x 5" (7)
8	14"	5" x WOF (1): 5" x 5" (8) 4½" x WOF (1): 4½" x 4½" (9) 4½" x WOF (1): 4½" x 4½" (7)	5"	5" x WOF (1): 5" x 5" (8)
9	19"	5" x WOF (1): 5" x 5" (8) 5" x WOF (1): 5" x 5" (1) 4½" x WOF (2): 4½" x 4½" (9)	10"	5" x WOF (1): 5" x 5" (8) 5" x WOF (1): 5" x 5" (1)
10	19"	5" x WOF (1): 5" x 5" (8) 5" x WOF (1): 5" x 5" (2); 4½" x 4½" (2) 4½" x WOF (2): 4½" x 4½" (9)	10"	5" x WOF (1): 5" x 5" (8) 5" x WOF (1): 5" x 5" (2)
11	19"	5" x WOF (1): 5" x 5" (8) 5" x WOF (1): 5" x 5" (3); 4½" x 4½" (4) 4½" x WOF (2): 4½" x 4½" (9)	10"	5" x WOF (1): 5" x 5" (8) 5" x WOF (1): 5" x 5" (3)
12	23½"	5" x WOF (1): 5" x 5" (8) 5" x WOF (1): 5" x 5" (4) 4½" x WOF (2): 4½" x 4½" (9) 4½" x WOF (1): 4½" x 4½" (6)	10"	5" x WOF (1): 5" x 5" (8) 5" x WOF (1): 5" x 5" (4)
13	23½"	5" x WOF (1): 5" x 5" (8) 5" x WOF (1): 5" x 5" (5) 4½" x WOF (2): 4½" x 4½" (9) 4½" x WOF (1): 4½" x 4½" (8)	10"	5" x WOF (1): 5" x 5" (8) 5" x WOF (1): 5" x 5" (5)
14	23½"	5" x WOF (1): 5" x 5" (8) 5" x WOF (1): 5" x 5" (6); 4½" x 4½" (1) 4½" x WOF (3): 4½" x 4½" (9)	10"	5" x WOF (1): 5" x 5" (8) 5" x WOF (1): 5" x 5" (6)
15	28"	5" x WOF (1): 5" x 5" (8) 5" x WOF (1): 5" x 5" (7) 4½" x WOF (3): 4½" x 4½" (9) 4½" x WOF (1): 4½" x 4½" (3)	10"	5" x WOF (1): 5" x 5" (8) 5" x WOF (1): 5" x 5" (7)

#	FABRIC 1		FABRIC 2	
	IN.	CUTTING REQUIREMENTS	IN.	CUTTING REQUIREMENTS
16	28"	5" x WOF (2): 5" x 5" (8) 4½ x WOF (3): 4½" x 4½" (9) 4½" x WOF (1): 4½" x 4½" (5)	10"	5" x WOF (2): 5" x 5" (8)
17	28½"	5" x WOF (2): 5" x 5" (8) 5" x WOF (1): 5" x 5" (1); 4½" x 4½" (7) 4½" x WOF (3): 4½" x 4½" (9)	15"	5" x WOF (2): 5" x 5" (8) 5" x WOF (1): 5" x 5" (1)
18	33"	5" x WOF (2): 5" x 5" (8) 5" x WOF (1): 5" x 5" (2) 4½" x WOF (4): 4½" x 4½" (9)	15"	5" x WOF (2): 5" x 5" (8) 5" x WOF (1): 5" x 5" (2)
20	33"	5" x WOF (2): 5" x 5" (8) 5" x WOF (1): 5" x 5" (4); 4½" x 4½" (4) 4½" x WOF (4): 4½" x 4½" (9)	15"	5" x WOF (2): 5" x 5" (8) 5" x WOF (1): 5" x 5" (4)
21	37½"	5" x WOF (2): 5" x 5" (8) 5" x WOF (1): 5" x 5" (5) 4½" x WOF (4): 4½" x 4½" (9) 4½" x WOF (1): 4½" x 4½" (6)	15"	5" x WOF (2): 5" x 5" (8) 5" x WOF (1): 5" x 5" (5)
22	37½"	5" x WOF (2): 5" x 5" (8) 5" x WOF (1): 5" x 5" (6) 4½" x WOF (4): 4½" x 4½" (9) 4½" x WOF (1): 4½" x 4½" (8)	15"	5" x WOF (2): 5" x 5" (8) 5" x WOF (1): 5" x 5" (6)
24	42"	5" x WOF (3): 5" x 5" (8) 4½" x WOF (5): 4½" x 4½" (9) 4½" x WOF (1): 4½" x 4½" (3)	15"	5" x WOF (3): 5" x 5" (8)
26	42½"	5" x WOF (3): 5" x 5" (8) 5" x WOF (1): 5" x 5" (2); 4½" x 4½" (7) 4½" x WOF (5): 4½" x 4½" (9)	20"	5" x WOF (3): 5" x 5" (8) 5" x WOF (1): 5" x 5" (2)
28	47"	5" x WOF (3): 5" x 5" (8) 5" x WOF (1): 5" x 5" (4); 4½" x 4½" (2) 4½ x WOF (6): 4½" x 4½" (9)	20"	5" x WOF (3): 5" x 5" (8) 5" x WOF (1): 5" x 5" (4)
32	56"	5" x WOF (4): 5" x 5" (8) 4½" x WOF (7): 4½" x 4½" (9) 4½" x WOF (1): 4½" x 4½" (1)	20"	5" x WOF (4): 5" x 5" (8)
34	56½"	5" x WOF (4): 5" x 5" (8) 5" x WOF (1): 5" x 5" (2); 4½" x 4½" (5) 4½" x WOF (7): 4½" x 4½" (9)	25"	5" x WOF (4): 5" x 5" (8) 5" x WOF (1): 5" x 5" (2)
36	61"	5" x WOF (4): 5" x 5" (8) 5" x WOF (1): 5" x 5" (4) 4½" x WOF (8): 4½" x 4½" (9)	25"	5" x WOF (4): 5" x 5" (8) 5" x WOF (1): 5" x 5" (4)
40	65½"	5" x WOF (5): 5" x 5" (8) 4½" x WOF (8): 4½" x 4½" (9) 4½" x WOF (1): 4½" x 4½" (8)	25"	5" x WOF (5): 5" x 5" (8)

continues on next page

Blocks 16, 17, and 18 continued

| | FABRIC 1 | | | FABRIC 2 | |
#	IN.	CUTTING REQUIREMENTS	IN.	CUTTING REQUIREMENTS
44	75"	5" x WOF (5): 5" x 5" (8) 5" x WOF (1): 5" x 5" (4) 4½" x WOF (9): 4½" x 4½" (9) 4½" x WOF (1): 4½" x 4½" (7)	30"	5" x WOF (5): 5" x 5" (8) 5" x WOF (1): 5" x 5" (4)
45	75"	5" x WOF (5): 5" x 5" (8) 5" x WOF (1): 5" x 5" (5) 4½" x WOF (10): 4½" x 4½" (9)	30"	5" x WOF (5): 5" x 5" (8) 5" x WOF (1): 5" x 5" (5)
48	79½"	5" x WOF (6): 5" x 5" (8) 4½" x WOF (10): 4½" x 4½" (9) 4½" x WOF (1): 4½" x 4½" (6)	30"	5" x WOF (6): 5" x 5" (8)
50	84½"	5" x WOF (6): 5" x 5" (8) 5" x WOF (1): 5" x 5" (2); 4½" x 4½" (1) 4½" x WOF (11): 4½" x 4½" (9)	35"	5" x WOF (6): 5" x 5" (8) 5" x WOF (1): 5" x 5" (2)
52	89"	5" x WOF (6): 5" x 5" (8) 5" x WOF (1): 5" x 5" (4) 4½" x WOF (11): 4½" x 4½" (9) 4½" x WOF (1): 4½" x 4½" (5)	35"	5" x WOF (6): 5" x 5" (8) 5" x WOF (1): 5" x 5" (4)
56	93½"	5" x WOF (7): 5" x 5" (8) 4½" x WOF (12): 4½" x 4½" (9) 4½" x WOF (1): 4½" x 4½" (4)	35"	5" x WOF (7): 5" x 5" (8)

Block 19

DESIGN PAGE 52

#	FABRIC 1 IN.	FABRIC 1 CUTTING REQUIREMENTS	FABRIC 2 IN.	FABRIC 2 CUTTING REQUIREMENTS
1	5"	5" x WOF (1): 5" x 5" (2); 4½" x 4½" (1)	5"	5" x WOF (1): 5" x 5" (2)
2	5"	5" x WOF (1): 5" x 5" (3); 4½" x 4½" (2)	5"	5" x WOF (1): 5" x 5" (3)
3	5"	5" x WOF (1): 5" x 5" (5); 4½" x 4½" (3)	5"	5" x WOF (1): 5" x 5" (5)
4	9½"	5" x WOF (1): 5" x 5" (6) 4½" x WOF (1): 4½" x 4½" (4)	5"	5" x WOF (1): 5" x 5" (6)
5	9½"	5" x WOF (1): 5" x 5" (8) 4½" x WOF (1): 4½" x 4½" (5)	5"	5" x WOF (1): 5" x 5" (8)
6	10"	5" x WOF (1): 5" x 5" (8) 5" x WOF (1): 5" x 5" (1); 4½" x 4½" (6)	10"	5" x WOF (1): 5" x 5" (8) 5" x WOF (1): 5" x 5" (1)
7	14½"	5" x WOF (1): 5" x 5" (8) 5" x WOF (1): 5" x 5" (3) 4½" x WOF (1): 4½" x 4½" (7)	10"	5" x WOF (1): 5" x 5" (8) 5" x WOF (1): 5" x 5" (3)
8	14½"	5" x WOF (1): 5" x 5" (8) 5" x WOF (1): 5" x 5" (4) 4½" x WOF (1): 4½" x 4½" (8)	10"	5" x WOF (1): 5" x 5" (8) 5" x WOF (1): 5" x 5" (4)
9	14½"	5" x WOF (1): 5" x 5" (8) 5" x WOF (1): 5" x 5" (6) 4½" x WOF (1): 4½" x 4½" (9)	10"	5" x WOF (1): 5" x 5" (8) 5" x WOF (1): 5" x 5" (6)
10	14½"	5" x WOF (1): 5" x 5" (8) 5" x WOF (1): 5" x 5" (7); 4½" x 4½" (1) 4½" x WOF (1): 4½" x 4½" (9)	10"	5" x WOF (1): 5" x 5" (8) 5" x WOF (1): 5" x 5" (7)
11	19½"	5" x WOF (2): 5" x 5" (8) 5" x WOF (1): 5" x 5" (1); 4½" x 4½" (2) 4½" x WOF (1): 4½" x 4½" (9)	15"	5" x WOF (2): 5" x 5" (8) 5" x WOF (1): 5" x 5" (1)
12	19½"	5" x WOF (2): 5" x 5" (8) 5" x WOF (1): 5" x 5" (2); 4½" x 4½" (3) 4½" x WOF (1): 4½" x 4½" (9)	15"	5" x WOF (2): 5" x 5" (8) 5" x WOF (1): 5" x 5" (2)
13	19½"	5" x WOF (2): 5" x 5" (8) 5" x WOF (1): 5" x 5" (4); 4½" x 4½" (4) 4½" x WOF (1): 4½" x 4½" (9)	15"	5" x WOF (2): 5" x 5" (8) 5" x WOF (1): 5" x 5" (4)
14	24"	5" x WOF (2): 5" x 5" (8) 5" x WOF (1): 5" x 5" (5) 4½" x WOF (1): 4½" x 4½" (9) 4½" x WOF (1): 4½" x 4½" (5)	15"	5" x WOF (2): 5" x 5" (8) 5" x WOF (1): 5" x 5" (5)
15	24"	5" x WOF (2): 5" x 5" (8) 5" x WOF (1): 5" x 5" (7) 4½" x WOF (1): 4½" x 4½" (9) 4½" x WOF (1): 4½" x 4½" (6)	15"	5" x WOF (2): 5" x 5" (8) 5" x WOF (1): 5" x 5" (7)
16	24"	5" x WOF (3): 5" x 5" (8) 4½" x WOF (1): 4½" x 4½" (9) 4½" x WOF (1): 4½" x 4½" (7)	15"	5" x WOF (3): 5" x 5" (8)

continues on next page

#		FABRIC 1		FABRIC 2
	IN.	CUTTING REQUIREMENTS	IN.	CUTTING REQUIREMENTS
17	29"	5" x WOF (3): 5" x 5" (8) 5" x WOF (1): 5" x 5" (2) 4½" x WOF (1): 4½" x 4½" (9) 4½" x WOF (1): 4½" x 4½" (8)	20"	5" x WOF (3): 5" x 5" (8) 5" x WOF (1): 5" x 5" (2)
18	29"	5" x WOF (3): 5" x 5" (8) 5" x WOF (1): 5" x 5" (3) 4½" x WOF (2): 4½" x 4½" (9)	20"	5" x WOF (3): 5" x 5" (8) 5" x WOF (1): 5" x 5" (3)
20	29"	5" x WOF (3): 5" x 5" (8) 5" x WOF (1): 5" x 5" (6); 4½" x 4½" (2) 4½" x WOF (2): 4½" x 4½" (9)	20"	5" x WOF (3): 5" x 5" (8) 5" x WOF (1): 5" x 5" (6)
21	33½"	5" x WOF (4): 5" x 5" (8) 4½" x WOF (2): 4½" x 4½" (9) 4½" x WOF (1): 4½" x 4½" (3)	20"	5" x WOF (4): 5" x 5" (8)
22	34"	5" x WOF (4): 5" x 5" (8) 5" x WOF (1): 5" x 5" (1); 4½" x 4½" (4) 4½" x WOF (2): 4½" x 4½" (9)	25"	5" x WOF (4): 5" x 5" (8) 5" x WOF (1): 5" x 5" (1)
24	38½"	5" x WOF (4): 5" x 5" (8) 5" x WOF (1): 5" x 5" (4) 4½" x WOF (2): 4½" x 4½" (9) 4½" x WOF (1): 4½" x 4½" (6)	25"	5" x WOF (4): 5" x 5" (8) 5" x WOF (1): 5" x 5" (4)
26	38½"	5" x WOF (4): 5" x 5" (8) 5" x WOF (1): 5" x 5" (7) 4½" x WOF (2): 4½" x 4½" (9) 4½" x WOF (1): 4½" x 4½" (8)	25"	5" x WOF (4): 5" x 5" (8) 5" x WOF (1): 5" x 5" (7)
28	43½"	5" x WOF (5): 5" x 5" (8) 5" x WOF (1): 5" x 5" (2); 4½" x 4½" (1) 4½" x WOF (3): 4½" x 4½" (9)	30"	5" x WOF (5): 5" x 5" (8) 5" x WOF (1): 5" x 5" (2)
32	48"	5" x WOF (6): 5" x 5" (8) 4½" x WOF (3): 4½" x 4½" (9) 4½" x WOF (1): 4½" x 4½" (5)	30"	5" x WOF (6): 5" x 5" (8)
34	53"	5" x WOF (6): 5" x 5" (8) 5" x WOF (1): 5" x 5" (3) 4½" x WOF (3): 4½" x 4½" (9) 4½" x WOF (1): 4½" x 4½" (7)	35"	5" x WOF (6): 5" x 5" (8) 5" x WOF (1): 5" x 5" (3)
36	53"	5" x WOF (6): 5" x 5" (8) 5" x WOF (1): 5" x 5" (6) 4½" x WOF (4): 4½" x 4½" (9)	35"	5" x WOF (6): 5" x 5" (8) 5" x WOF (1): 5" x 5" (6)
40	58"	5" x WOF (7): 5" x 5" (8) 5" x WOF (1): 5" x 5" (4); 4½" x 4½" (4) 4½" x WOF (4): 4½" x 4½" (9)	40"	5" x WOF (7): 5" x 5" (8) 5" x WOF (1): 5" x 5" (4)
44	67½"	5" x WOF (8): 5" x 5" (8) 5" x WOF (1): 5" x 5" (2) 4½" x WOF (4): 4½" x 4½" (9) 4½" x WOF (1): 4½" x 4½" (8)	45"	5" x WOF (8): 5" x 5" (8) 5" x WOF (1): 5" x 5" (2)

#	FABRIC 1 IN.	FABRIC 1 CUTTING REQUIREMENTS	FABRIC 2 IN.	FABRIC 2 CUTTING REQUIREMENTS
45	67½"	5" x WOF (8): 5" x 5" (8) 5" x WOF (1): 5" x 5" (4) 4½" x WOF (5): 4½" x 4½" (9)	45"	5" x WOF (8): 5" x 5" (8) 5" x WOF (1): 5" x 5" (4)
48	72"	5" x WOF (9): 5" x 5" (8) 4½" x WOF (5): 4½" x 4½" (9) 4½" x WOF (1): 4½" x 4½" (3)	45"	5" x WOF (9): 5" x 5" (8)
50	72½"	5" x WOF (9): 5" x 5" (8) 5" x WOF (1): 5" x 5" (3); 4½" x 4½" (5) 4½" x WOF (5): 4½" x 4½" (9)	50"	5" x WOF (9): 5" x 5" (8) 5" x WOF (1): 5" x 5" (3)
52	77"	5" x WOF (9): 5" x 5" (8) 5" x WOF (1): 5" x 5" (6) 4½" x WOF (5): 4½" x 4½" (9) 4½" x WOF (1): 4½" x 4½" (7)	50"	5" x WOF (9): 5" x 5" (8) 5" x WOF (1): 5" x 5" (6)
56	82"	5" x WOF (10): 5" x 5" (8) 5" x WOF (1): 5" x 5" (4); 4½" x 4½" (2) 4½" x WOF (6): 4½" x 4½" (9)	55"	5" x WOF (10): 5" x 5" (8) 5" x WOF (1): 5" x 5" (4)

Blocks 20 and 21

#	IN.	FABRIC 1 CUTTING REQUIREMENTS	IN.	FABRIC 2 CUTTING REQUIREMENTS
1	5"	5" x WOF (1): 5" x 5" (2)	5"	5" x WOF (1): 5" x 5" (2); 4½" x 4½" (1)
2	5"	5" x WOF (1): 5" x 5" (3)	5"	5" x WOF (1): 5" x 5" (3); 4½" x 4½" (2)
3	5"	5" x WOF (1): 5" x 5" (5)	5"	5" x WOF (1): 5" x 5" (5); 4½" x 4½" (3)
4	5"	5" x WOF (1): 5" x 5" (6)	9½"	5" x WOF (1): 5" x 5" (6) 4½" x WOF (1): 4½" x 4½" (4)
5	5"	5" x WOF (1): 5" x 5" (8)	9½"	5" x WOF (1): 5" x 5" (8) 4½" x WOF (1): 4½" x 4½" (5)
6	10"	5" x WOF (1): 5" x 5" (8) 5" x WOF (1): 5" x 5" (1)	10"	5" x WOF (1): 5" x 5" (8) 5" x WOF (1): 5" x 5" (1); 4½" x 4½" (6)
7	10"	5" x WOF (1): 5" x 5" (8) 5" x WOF (1): 5" x 5" (3)	14½"	5" x WOF (1): 5" x 5" (8) 5" x WOF (1): 5" x 5" (3) 4½" x WOF (1): 4½" x 4½" (7)
8	10"	5" x WOF (1): 5" x 5" (8) 5" x WOF (1): 5" x 5" (4)	14½"	5" x WOF (1): 5" x 5" (8) 5" x WOF (1): 5" x 5" (4) 4½" x WOF (1): 4½" x 4½" (8)
9	10"	5" x WOF (1): 5" x 5" (8) 5" x WOF (1): 5" x 5" (6)	14½"	5" x WOF (1): 5" x 5" (8) 5" x WOF (1): 5" x 5" (6) 4½" x WOF (1): 4½" x 4½" (9)
10	10"	5" x WOF (1): 5" x 5" (8) 5" x WOF (1): 5" x 5" (7)	14½"	5" x WOF (1): 5" x 5" (8) 5" x WOF (1): 5" x 5" (7); 4½" x 4½" (1) 4½" x WOF (1): 4½" x 4½" (9)
11	15"	5" x WOF (2): 5" x 5" (8) 5" x WOF (1): 5" x 5" (1)	19½"	5" x WOF (2): 5" x 5" (8) 5" x WOF (1): 5" x 5" (1); 4½" x 4½" (2) 4½" x WOF (1): 4½" x 4½" (9)
12	15"	5" x WOF (2): 5" x 5" (8) 5" x WOF (1): 5" x 5" (2)	19½"	5" x WOF (2): 5" x 5" (8) 5" x WOF (1): 5" x 5" (2); 4½" x 4½" (3) 4½" x WOF (1): 4½" x 4½" (9)
13	15"	5" x WOF (2): 5" x 5" (8) 5" x WOF (1): 5" x 5" (4)	19½"	5" x WOF (2): 5" x 5" (8) 5" x WOF (1): 5" x 5" (4); 4½" x 4½" (4) 4½" x WOF (1): 4½" x 4½" (9)
14	15"	5" x WOF (2): 5" x 5" (8) 5" x WOF (1): 5" x 5" (5)	24"	5" x WOF (2): 5" x 5" (8) 5" x WOF (1): 5" x 5" (5) 4½" x WOF (1): 4½" x 4½" (9) 4½" x WOF (1): 4½" x 4½" (5)
15	15"	5" x WOF (2): 5" x 5" (8) 5" x WOF (1): 5" x 5" (7)	24"	5" x WOF (2): 5" x 5" (8) 5" x WOF (1): 5" x 5" (7) 4½" x WOF (1): 4½" x 4½" (9) 4½" x WOF (1): 4½" x 4½" (6)
16	15"	5" x WOF (3): 5" x 5" (8)	24"	5" x WOF (3): 5" x 5" (8) 4½" x WOF (1): 4½" x 4½" (9) 4½" x WOF (1): 4½" x 4½" (7)

| # | | FABRIC 1 | | FABRIC 2 |
	IN.	CUTTING REQUIREMENTS	IN.	CUTTING REQUIREMENTS
17	20"	5" x WOF (3): 5" x 5" (8) 5" x WOF (1): 5" x 5" (2)	29"	5" x WOF (3): 5" x 5" (8) 5" x WOF (1): 5" x 5" (2) 4½" x WOF (1): 4½" x 4½" (9) 4½" x WOF (1): 4½" x 4½" (8)
18	20"	5" x WOF (3): 5" x 5" (8) 5" x WOF (1): 5" x 5" (3)	29"	5" x WOF (3): 5" x 5" (8) 5" x WOF (1): 5" x 5" (3) 4½" x WOF (2): 4½" x 4½" (9)
20	20"	5" x WOF (3): 5" x 5" (8) 5" x WOF (1): 5" x 5" (6)	29"	5" x WOF (3): 5" x 5" (8) 5" x WOF (1): 5" x 5" (6); 4½" x 4½" (2) 4½" x WOF (2): 4½" x 4½" (9)
21	20"	5" x WOF (4): 5" x 5" (8)	33½"	5" x WOF (4): 5" x 5" (8) 4½" x WOF (2): 4½" x 4½" (9) 4½" x WOF (1): 4½" x 4½" (3)
22	25"	5" x WOF (4): 5" x 5" (8) 5" x WOF (1): 5" x 5" (1)	34"	5" x WOF (4): 5" x 5" (8) 5" x WOF (1): 5" x 5" (1); 4½" x 4½" (4) 4½" x WOF (2): 4½" x 4½" (9)
24	25"	5" x WOF (4): 5" x 5" (8) 5" x WOF (1): 5" x 5" (4)	38½"	5" x WOF (4): 5" x 5" (8) 5" x WOF (1): 5" x 5" (4) 4½" x WOF (2): 4½" x 4½" (9) 4½" x WOF (1): 4½" x 4½" (6)
26	25"	5" x WOF (4): 5" x 5" (8) 5" x WOF (1): 5" x 5" (7)	38½"	5" x WOF (4): 5" x 5" (8) 5" x WOF (1): 5" x 5" (7) 4½" x WOF (2): 4½" x 4½" (9) 4½" x WOF (1): 4½" x 4½" (8)
28	30"	5" x WOF (5): 5" x 5" (8) 5" x WOF (1): 5" x 5" (2)	43½"	5" x WOF (5): 5" x 5" (8) 5" x WOF (1): 5" x 5" (2); 4½" x 4½" (1) 4½" x WOF (3): 4½" x 4½" (9)
32	30"	5" x WOF (6): 5" x 5" (8)	48"	5" x WOF (6): 5" x 5" (8) 4½" x WOF (3): 4½" x 4½" (9) 4½" x WOF (1): 4½" x 4½" (5)
34	35"	5" x WOF (6): 5" x 5" (8) 5" x WOF (1): 5" x 5" (3)	53"	5" x WOF (6): 5" x 5" (8) 5" x WOF (1): 5" x 5" (3) 4½" x WOF (3): 4½" x 4½" (9) 4½" x WOF (1): 4½" x 4½" (7)
36	35"	5" x WOF (6): 5" x 5" (8) 5" x WOF (1): 5" x 5" (6)	53"	5" x WOF (6): 5" x 5" (8) 5" x WOF (1): 5" x 5" (6) 4½" x WOF (4): 4½" x 4½" (9)
40	40"	5" x WOF (7): 5" x 5" (8) 5" x WOF (1): 5" x 5" (4)	58"	5" x WOF (7): 5" x 5" (8) 5" x WOF (1): 5" x 5" (4); 4½" x 4½" (4) 4½" x WOF (4): 4½" x 4½" (9)

continues on next page

Blocks 20 and 21 continued

#	IN.	FABRIC 1 CUTTING REQUIREMENTS	IN.	FABRIC 2 CUTTING REQUIREMENTS
44	45"	5" x WOF (8): 5" x 5" (8) 5" x WOF (1): 5" x 5" (2)	67½"	5" x WOF (8): 5" x 5" (8) 5" x WOF (1): 5" x 5" (2) 4½" x WOF (4): 4½" x 4½" (9) 4½" x WOF (1): 4½" x 4½" (8)
45	45"	5" x WOF (8): 5" x 5" (8) 5" x WOF (1): 5" x 5" (4)	67½"	5" x WOF (8): 5" x 5" (8) 5" x WOF (1): 5" x 5" (4) 4½" x WOF (5): 4½" x 4½" (9)
48	45"	5" x WOF (9): 5" x 5" (8)	72"	5" x WOF (9): 5" x 5" (8) 4½" x WOF (5): 4½" x 4½" (9) 4½" x WOF (1): 4½" x 4½" (3)
50	50"	5" x WOF (9): 5" x 5" (8) 5" x WOF (1): 5" x 5" (3)	72½"	5" x WOF (9): 5" x 5" (8) 5" x WOF (1): 5" x 5" (3); 4½" x 4½" (5) 4½" x WOF (5): 4½" x 4½" (9)
52	50"	5" x WOF (9): 5" x 5" (8) 5" x WOF (1): 5" x 5" (6)	77"	5" x WOF (9): 5" x 5" (8) 5" x WOF (1): 5" x 5" (6) 4½" x WOF (5): 4½" x 4½" (9) 4½" x WOF (1): 4½" x 4½" (7)
56	55"	5" x WOF (10): 5" x 5" (8) 5" x WOF (1): 5" x 5" (4)	82"	5" x WOF (10): 5" x 5" (8) 5" x WOF (1): 5" x 5" (4); 4½" x 4½" (2) 4½" x WOF (6): 4½" x 4½" (9)

Block 22

#	IN.	FABRIC 1 CUTTING REQUIREMENTS	IN.	FABRIC 2 CUTTING REQUIREMENTS
1	5"	5" x WOF (1): 5" x 5" (1); 4½" x 4½" (1)	5"	5" x WOF (1): 5" x 5" (1); 4½" x 4½" (1)
2	5"	5" x WOF (1): 5" x 5" (2); 4½" x 4½" (2)	5"	5" x WOF (1): 5" x 5" (2); 4½" x 4½" (2)
3	5"	5" x WOF (1): 5" x 5" (3); 4½" x 4½" (3)	5"	5" x WOF (1): 5" x 5" (3); 4½" x 4½" (3)
4	5"	5" x WOF (1): 5" x 5" (4); 4½" x 4½" (4)	5"	5" x WOF (1): 5" x 5" (4); 4½" x 4½" (4)
5	9½"	5" x WOF (1): 5" x 5" (5) 4½" x WOF (1): 4½" x 4½" (5)	9½"	5" x WOF (1): 5" x 5" (5) 4½" x WOF (1): 4½" x 4½" (5)
6	9½"	5" x WOF (1): 5" x 5" (6) 4½" x WOF (1): 4½" x 4½" (6)	9½"	5" x WOF (1): 5" x 5" (6) 4½" x WOF (1): 4½" x 4½" (6)
7	9½"	5" x WOF (1): 5" x 5" (7) 4½" x WOF (1): 4½" x 4½" (7)	9½"	5" x WOF (1): 5" x 5" (7) 4½" x WOF (1): 4½" x 4½" (7)
8	9½"	5" x WOF (1): 5" x 5" (8) 4½" x WOF (1): 4½" x 4½" (8)	9½"	5" x WOF (1): 5" x 5" (8) 4½" x WOF (1): 4½" x 4½" (8)
9	14½"	5" x WOF (1): 5" x 5" (8) 5" x WOF (1): 5" x 5" (1) 4½" x WOF (1): 4½" x 4½" (9)	14½"	5" x WOF (1): 5" x 5" (8) 5" x WOF (1): 5" x 5" (1) 4½" x WOF (1): 4½" x 4½" (9)
10	14½"	5" x WOF (1): 5" x 5" (8) 5" x WOF (1): 5" x 5" (2); 4½" x 4½" (1) 4½" x WOF (1): 4½" x 4½" (9)	14½"	5" x WOF (1): 5" x 5" (8) 5" x WOF (1): 5" x 5" (2); 4½" x 4½" (1) 4½" x WOF (1): 4½" x 4½" (9)
11	14½"	5" x WOF (1): 5" x 5" (8) 5" x WOF (1): 5" x 5" (3); 4½" x 4½" (2) 4½" x WOF (1): 4½" x 4½" (9)	14½"	5" x WOF (1): 5" x 5" (8) 5" x WOF (1): 5" x 5" (3); 4½" x 4½" (2) 4½" x WOF (1): 4½" x 4½" (9)
12	14½"	5" x WOF (1): 5" x 5" (8) 5" x WOF (1): 5" x 5" (4); 4½" x 4½" (3) 4½" x WOF (1): 4½" x 4½" (9)	14½"	5" x WOF (1): 5" x 5" (8) 5" x WOF (1): 5" x 5" (4); 4½" x 4½" (3) 4½" x WOF (1): 4½" x 4½" (9)
13	19"	5" x WOF (1): 5" x 5" (8) 5" x WOF (1): 5" x 5" (5) 4½" x WOF (1): 4½" x 4½" (9) 4½" x WOF (1): 4½" x 4½" (4)	19"	5" x WOF (1): 5" x 5" (8) 5" x WOF (1): 5" x 5" (5) 4½" x WOF (1): 4½" x 4½" (9) 4½" x WOF (1): 4½" x 4½" (4)
14	19"	5" x WOF (1): 5" x 5" (8) 5" x WOF (1): 5" x 5" (6) 4½" x WOF (1): 4½" x 4½" (9) 4½" x WOF (1): 4½" x 4½" (5)	19"	5" x WOF (1): 5" x 5" (8) 5" x WOF (1): 5" x 5" (6) 4½" x WOF (1): 4½" x 4½" (9) 4½" x WOF (1): 4½" x 4½" (5)
15	19"	5" x WOF (1): 5" x 5" (8) 5" x WOF (1): 5" x 5" (7) 4½" x WOF (1): 4½" x 4½" (9) 4½" x WOF (1): 4½" x 4½" (6)	19"	5" x WOF (1): 5" x 5" (8) 5" x WOF (1): 5" x 5" (7) 4½" x WOF (1): 4½" x 4½" (9) 4½" x WOF (1): 4½" x 4½" (6)
16	19"	5" x WOF (2): 5" x 5" (8) 4½" x WOF (1): 4½" x 4½" (9) 4½" x WOF (1): 4½" x 4½" (7)	19"	5" x WOF (2): 5" x 5" (8) 4½" x WOF (1): 4½" x 4½" (9) 4½" x WOF (1): 4½" x 4½" (7)

continues on next page

#	FABRIC 1		FABRIC 2	
	IN.	**CUTTING REQUIREMENTS**	**IN.**	**CUTTING REQUIREMENTS**
17	19½"	5" x WOF (2): 5" x 5" (8) 5" x WOF (1): 5" x 5" (1); 4½" x 4½" (8) 4½" x WOF (1): 4½" x 4½" (9)	19½"	5" x WOF (2): 5" x 5" (8) 5" x WOF (1): 5" x 5" (1); 4½" x 4½" (8) 4½" x WOF (1): 4½" x 4½" (9)
18	24"	5" x WOF (2): 5" x 5" (8) 5" x WOF (1): 5" x 5" (2) 4½" x WOF (2): 4½" x 4½" (9)	24"	5" x WOF (2): 5" x 5" (8) 5" x WOF (1): 5" x 5" (2) 4½" x WOF (2): 4½" x 4½" (9)
20	24"	5" x WOF (2): 5" x 5" (8) 5" x WOF (1): 5" x 5" (4); 4½" x 4½" (2) 4½" x WOF (2): 4½" x 4½" (9)	24"	5" x WOF (2): 5" x 5" (8) 5" x WOF (1): 5" x 5" (4); 4½" x 4½" (2) 4½" x WOF (2): 4½" x 4½" (9)
21	24"	5" x WOF (2): 5" x 5" (8) 5" x WOF (1): 5" x 5" (5); 4½" x 4½" (3) 4½" x WOF (2): 4½" x 4½" (9)	24"	5" x WOF (2): 5" x 5" (8) 5" x WOF (1): 5" x 5" (5); 4½" x 4½" (3) 4½" x WOF (2): 4½" x 4½" (9)
22	28½"	5" x WOF (2): 5" x 5" (8) 5" x WOF (1): 5" x 5" (6) 4½" x WOF (2): 4½" x 4½" (9) 4½" x WOF (1): 4½" x 4½" (4)	28½"	5" x WOF (2): 5" x 5" (8) 5" x WOF (1): 5" x 5" (6) 4½" x WOF (2): 4½" x 4½" (9) 4½" x WOF (1): 4½" x 4½" (4)
24	28½"	5" x WOF (3): 5" x 5" (8) 4½" x WOF (2): 4½" x 4½" (9) 4½" x WOF (1): 4½" x 4½" (6)	28½"	5" x WOF (3): 5" x 5" (8) 4½" x WOF (2): 4½" x 4½" (9) 4½" x WOF (1): 4½" x 4½" (6)
26	33½"	5" x WOF (3): 5" x 5" (8) 5" x WOF (1): 5" x 5" (2) 4½" x WOF (2): 4½" x 4½" (9) 4½" x WOF (1): 4½" x 4½" (8)	33½"	5" x WOF (3): 5" x 5" (8) 5" x WOF (1): 5" x 5" (2) 4½" x WOF (2): 4½" x 4½" (9) 4½" x WOF (1): 4½" x 4½" (8)
28	33½"	5" x WOF (3): 5" x 5" (8) 5" x WOF (1): 5" x 5" (4); 4½" x 4½" (1) 4½" x WOF (3): 4½" x 4½" (9)	33½"	5" x WOF (3): 5" x 5" (8) 5" x WOF (1): 5" x 5" (4); 4½" x 4½" (1) 4½" x WOF (3): 4½" x 4½" (9)
32	38"	5" x WOF (4): 5" x 5" (8) 4½" x WOF (3): 4½" x 4½" (9) 4½" x WOF (1): 4½" x 4½" (5)	38"	5" x WOF (4): 5" x 5" (8) 4½" x WOF (3): 4½" x 4½" (9) 4½" x WOF (1): 4½" x 4½" (5)
34	38½"	5" x WOF (4): 5" x 5" (8) 5" x WOF (1): 5" x 5" (2); 4½" x 4½" (7) 4½" x WOF (3): 4½" x 4½" (9)	38½"	5" x WOF (4): 5" x 5" (8) 5" x WOF (1): 5" x 5" (2); 4½" x 4½" (7) 4½" x WOF (3): 4½" x 4½" (9)
36	43"	5" x WOF (4): 5" x 5" (8) 5" x WOF (1): 5" x 5" (4) 4½" x WOF (4): 4½" x 4½" (9)	43"	5" x WOF (4): 5" x 5" (8) 5" x WOF (1): 5" x 5" (4) 4½" x WOF (4): 4½" x 4½" (9)
40	47½"	5" x WOF (5): 5" x 5" (8) 4½" x WOF (4): 4½" x 4½" (9) 4½" x WOF (1): 4½" x 4½" (4)	47½"	5" x WOF (5): 5" x 5" (8) 4½" x WOF (4): 4½" x 4½" (9) 4½" x WOF (1): 4½" x 4½" (4)
44	52½"	5" x WOF (5): 5" x 5" (8) 5" x WOF (1): 5" x 5" (4) 4½" x WOF (4): 4½" x 4½" (9) 4½" x WOF (1): 4½" x 4½" (8)	52½"	5" x WOF (5): 5" x 5" (8) 5" x WOF (1): 5" x 5" (4) 4½" x WOF (4): 4½" x 4½" (9) 4½" x WOF (1): 4½" x 4½" (8)

| | | FABRIC 1 | | FABRIC 2 |
#	IN.	CUTTING REQUIREMENTS	IN.	CUTTING REQUIREMENTS
45	52½"	5" x WOF (5): 5" x 5" (8) 5" x WOF (1): 5" x 5" (5) 4½" x WOF (5): 4½" x 4½" (9)	52½"	5" x WOF (5): 5" x 5" (8) 5" x WOF (1): 5" x 5" (5) 4½" x WOF (5): 4½" x 4½" (9)
48	57"	5" x WOF (6): 5" x 5" (8) 4½" x WOF (5): 4½" x 4½" (9) 4½" x WOF (1): 4½" x 4½" (3)	57"	5" x WOF (6): 5" x 5" (8) 4½" x WOF (5): 4½" x 4½" (9) 4½" x WOF (1): 4½" x 4½" (3)
50	57½"	5" x WOF (6): 5" x 5" (8) 5" x WOF (1): 5" x 5" (2); 4½" x 4½" (5) 4½" x WOF (5): 4½" x 4½" (9)	57½"	5" x WOF (6): 5" x 5" (8) 5" x WOF (1): 5" x 5" (2); 4½" x 4½" (5) 4½" x WOF (5): 4½" x 4½" (9)
52	62"	5" x WOF (6): 5" x 5" (8) 5" x WOF (1): 5" x 5" (4) 4½" x WOF (5): 4½" x 4½" (9) 4½" x WOF (1): 4½" x 4½" (7)	62"	5" x WOF (6): 5" x 5" (8) 5" x WOF (1): 5" x 5" (4) 4½" x WOF (5): 4½" x 4½" (9) 4½" x WOF (1): 4½" x 4½" (7)
56	66½"	5" x WOF (7): 5" x 5" (8) 4½" x WOF (6): 4½" x 4½" (9) 4½" x WOF (1): 4½" x 4½" (2)	66½"	5" x WOF (7): 5" x 5" (8) 4½" x WOF (6): 4½" x 4½" (9) 4½" x WOF (1): 4½" x 4½" (2)

Block 23

#	FABRIC 1 IN.	FABRIC 1 CUTTING REQUIREMENTS	FABRIC 2 IN.	FABRIC 2 CUTTING REQUIREMENTS
1	4½"	4½" x WOF (1): 4½" x 4½" (1); 4¼" x 4¼" (1); 2½" x 2½" (2)	4¼"	4¼" x WOF (1): 4¼" x 4¼" (1); 2½" x 4½" (2); 2½" x 2½" (2)
2	4½"	4½" x WOF (1): 4½" x 4½" (2); 4¼" x 4¼" (2); 2½" x 2½" (4)	4¼"	4¼" x WOF (1): 4¼" x 4¼" (2); 2½" x 4½" (4); 2½" x 2½" (4)
3	4½"	4½" x WOF (1): 4½" x 4½" (3); 4¼" x 4¼" (3); 2½" x 2½" (6)	6¾"	4¼" x WOF (1): 4¼" x 4¼" (3) 2½" x WOF (1): 2½" x 4½" (6); 2½" x 2½" (6)
4	7"	4½" x WOF (1): 4½" x 4½" (4); 4¼" x 4¼" (4) 2½" x WOF (1): 2½" x 2½" (8)	6¾"	4¼" x WOF (1): 4¼" x 4¼" (4); 2½" x 4½" (2); 2½" x 2½" (2) 2½" x WOF (1): 2½" x 4½" (6); 2½" x 2½" (6)
5	11¼"	4½" x WOF (1): 4½" x 4½" (5) 4¼" x WOF (1): 4¼" x 4¼" (5) 2½" x WOF (1): 2½" x 2½" (10)	9¼"	4¼" x WOF (1): 4¼" x 4¼" (5) 2½" x WOF (1): 2½" x 4½" (6); 2½" x 2½" (6) 2½" x WOF (1): 2½" x 4½" (4); 2½" x 2½" (4)
6	11¼"	4½" x WOF (1): 4½" x 4½" (6) 4¼" x WOF (1): 4¼" x 4¼" (6) 2½" x WOF (1): 2½" x 2½" (12)	9¼"	4¼" x WOF (1): 4¼" x 4¼" (6) 2½" x WOF (2): 2½" x 4½" (6); 2½" x 2½" (6)
7	11¼"	4½" x WOF (1): 4½" x 4½" (7) 4¼" x WOF (1): 4¼" x 4¼" (7) 2½" x WOF (1): 2½" x 2½" (14)	11¾"	4¼" x WOF (1): 4¼" x 4¼" (7) 2½" x WOF (2): 2½" x 4½" (6); 2½" x 2½" (6) 2½" x WOF (1): 2½" x 4½" (2); 2½" x 2½" (2)
8	11¼"	4½" x WOF (1): 4½" x 4½" (8) 4¼" x WOF (1): 4¼" x 4¼" (8) 2½" x WOF (1): 2½" x 2½" (16)	11¾"	4¼" x WOF (1): 4¼" x 4¼" (8) 2½" x WOF (2): 2½" x 4½" (6); 2½" x 2½" (6) 2½" x WOF (1): 2½" x 4½" (4); 2½" x 2½" (4)
9	13¾"	4½" x WOF (1): 4½" x 4½" (9) 4¼" x WOF (1): 4¼" x 4¼" (9) 2½" x WOF (1): 2½" x 2½" (16) 2½" x WOF (1): 2½" x 2½" (2)	11¾"	4¼" x WOF (1): 4¼" x 4¼" (9) 2½" x WOF (3): 2½" x 4½" (6); 2½" x 2½" (6)
10	15¾"	4½" x WOF (1): 4½" x 4½" (9) 4½" x WOF (1): 4½" x 4½" (1); 4¼" x 4¼" (1); 2½" x 2½" (4) 4¼" x WOF (1): 4¼" x 4¼" (9) 2½" x WOF (1): 2½" x 2½" (16)	16"	4¼" x WOF (1): 4¼" x 4¼" (9) 4¼" x WOF (1): 4¼" x 4¼" (1); 2½" x 4½" (2); 2½" x 2½" (2) 2½" x WOF (3): 2½" x 4½" (6); 2½" x 2½" (6)
11	15¾"	4½" x WOF (1): 4½" x 4½" (9) 4½" x WOF (1): 4½" x 4½" (2); 4¼" x 4¼" (2); 2½" x 2½" (6) 4¼" x WOF (1): 4¼" x 4¼" (9) 2½" x WOF (1): 2½" x 2½" (16)	16"	4¼" x WOF (1): 4¼" x 4¼" (9) 4¼" x WOF (1): 4¼" x 4¼" (2); 2½" x 4½" (4); 2½" x 2½" (4) 2½" x WOF (3): 2½" x 4½" (6); 2½" x 2½" (6)
12	18¼"	4½" x WOF (1): 4½" x 4½" (9) 4½" x WOF (1): 4½" x 4½" (3); 4¼" x 4¼" (3) 4¼" x WOF (1): 4¼" x 4¼" (9) 2½" x WOF (1): 2½" x 2½" (16) 2½" x WOF (1): 2½" x 2½" (8)	18½"	4¼" x WOF (1): 4¼" x 4¼" (9) 4¼" x WOF (1): 4¼" x 4¼" (3) 2½" x WOF (4): 2½" x 4½" (6); 2½" x 2½" (6)

#	IN.	FABRIC 1 CUTTING REQUIREMENTS	IN.	FABRIC 2 CUTTING REQUIREMENTS
13	18¼"	4½" x WOF (1): 4½" x 4½" (9) 4½" x WOF (1): 4½" x 4½" (4); 4¼" x 4¼" (4) 4¼" x WOF (1): 4¼" x 4¼" (9) 2½" x WOF (1): 2½" x 2½" (16) 2½" x WOF (1): 2½" x 2½" (10)	18½"	4¼" x WOF (1): 4¼" x 4¼" (9) 4¼" x WOF (1): 4¼" x 4¼" (4); 2½" x 4½" (2); 2½" x 2½" (2) 2½" x WOF (4): 2½" x 4½" (6); 2½" x 2½" (6)
14	22½"	4½" x WOF (1): 4½" x 4½" (9) 4½" x WOF (1): 4½" x 4½" (5) 4¼" x WOF (1): 4¼" x 4¼" (9) 4¼" x WOF (1): 4¼" x 4¼" (5) 2½" x WOF (1): 2½" x 2½" (16) 2½" x WOF (1): 2½" x 2½" (12)	21"	4¼" x WOF (1): 4¼" x 4¼" (9) 4¼" x WOF (1): 4¼" x 4¼" (5) 2½" x WOF (4): 2½" x 4½" (6); 2½" x 2½" (6) 2½" x WOF (1): 2½" x 4½" (4); 2½" x 2½" (4)
15	22½"	4½" x WOF (1): 4½" x 4½" (9) 4½" x WOF (1): 4½" x 4½" (6) 4¼" x WOF (1): 4¼" x 4¼" (9) 4¼" x WOF (1): 4¼" x 4¼" (6) 2½" x WOF (1): 2½" x 2½" (16) 2½" x WOF (1): 2½" x 2½" (14)	21"	4¼" x WOF (1): 4¼" x 4¼" (9) 4¼" x WOF (1): 4¼" x 4¼" (6) 2½" x WOF (5): 2½" x 4½" (6); 2½" x 2½" (6)
16	22½"	4½" x WOF (1): 4½" x 4½" (9) 4½" x WOF (1): 4½" x 4½" (7) 4¼" x WOF (1): 4¼" x 4¼" (9) 4¼" x WOF (1): 4¼" x 4¼" (7) 2½" x WOF (2): 2½" x 2½" (16)	23½"	4¼" x WOF (1): 4¼" x 4¼" (9) 4¼" x WOF (1): 4¼" x 4¼" (7) 2½" x WOF (5): 2½" x 4½" (6); 2½" x 2½" (6) 2½" x WOF (1): 2½" x 4½" (2); 2½" x 2½" (2)
17	22½"	4½" x WOF (1): 4½" x 4½" (9) 4½" x WOF (1): 4½" x 4½" (8); 2½" x 2½" (2) 4¼" x WOF (1): 4¼" x 4¼" (9) 4¼" x WOF (1): 4¼" x 4¼" (8) 2½" x WOF (2): 2½" x 2½" (16)	23½"	4¼" x WOF (1): 4¼" x 4¼" (9) 4¼" x WOF (1): 4¼" x 4¼" (8) 2½" x WOF (5): 2½" x 4½" (6); 2½" x 2½" (6) 2½" x WOF (1): 2½" x 4½" (4); 2½" x 2½" (4)
18	25"	4½" x WOF (2): 4½" x 4½" (9) 4¼" x WOF (2): 4¼" x 4¼" (9) 2½" x WOF (2): 2½" x 2½" (16) 2½" x WOF (1): 2½" x 2½" (4)	23½"	4¼" x WOF (2): 4¼" x 4¼" (9) 2½" x WOF (6): 2½" x 4½" (6); 2½" x 2½" (6)
20	29½"	4½" x WOF (2): 4½" x 4½" (9) 4½" x WOF (1): 4½" x 4½" (2); 4¼" x 4¼" (2) 4¼" x WOF (2): 4¼" x 4¼" (9) 2½" x WOF (2): 2½" x 2½" (16) 2½" x WOF (1): 2½" x 2½" (8)	30¼"	4¼" x WOF (2): 4¼" x 4¼" (9) 4¼" x WOF (1): 4¼" x 4¼" (2) 2½" x WOF (6): 2½" x 4½" (6); 2½" x 2½" (6) 2½" x WOF (1): 2½" x 4½" (4); 2½" x 2½" (4)
21	29½"	4½" x WOF (2): 4½" x 4½" (9) 4½" x WOF (1): 4½" x 4½" (3); 4¼" x 4¼" (3) 4¼" x WOF (2): 4¼" x 4¼" (9) 2½" x WOF (2): 2½" x 2½" (16) 2½" x WOF (1): 2½" x 2½" (10)	30¼"	4¼" x WOF (2): 4¼" x 4¼" (9) 4¼" x WOF (1): 4¼" x 4¼" (3) 2½" x WOF (7): 2½" x 4½" (6); 2½" x 2½" (6)
22	29½"	4½" x WOF (2): 4½" x 4½" (9) 4½" x WOF (1): 4½" x 4½" (4); 4¼" x 4¼" (4) 4¼" x WOF (2): 4¼" x 4¼" (9) 2½" x WOF (2): 2½" x 2½" (16) 2½" x WOF (1): 2½" x 2½" (12)	30¼"	4¼" x WOF (2): 4¼" x 4¼" (9) 4¼" x WOF (1): 4¼" x 4¼" (4); 2½" x 4½" (2); 2½" x 2½" (2) 2½" x WOF (7): 2½" x 4½" (6); 2½" x 2½" (6)

continues on next page

#	IN.	FABRIC 1 CUTTING REQUIREMENTS	IN.	FABRIC 2 CUTTING REQUIREMENTS
24	33¾"	4½" x WOF (2): 4½" x 4½" (9) 4½" x WOF (1): 4½" x 4½" (6) 4¼" x WOF (2): 4¼" x 4¼" (9) 4¼" x WOF (1): 4¼" x 4¼" (6) 2½" x WOF (3): 2½" x 2½" (16)	32¾"	4¼" x WOF (2): 4¼" x 4¼" (9) 4¼" x WOF (1): 4¼" x 4¼" (6) 2½" x WOF (8): 2½" x 4½" (6); 2½" x 2½" (6)
26	33¾"	4½" x WOF (2): 4½" x 4½" (9) 4½" x WOF (1): 4½" x 4½" (8); 2½" x 2½" (2) 4¼" x WOF (2): 4¼" x 4¼" (9) 4¼" x WOF (1): 4¼" x 4¼" (8); 2½" x 2½" (2) 2½" x WOF (3): 2½" x 2½" (16)	35¼"	4¼" x WOF (2): 4¼" x 4¼" (9) 4¼" x WOF (1): 4¼" x 4¼" (8) 2½" x WOF (8): 2½" x 4½" (6); 2½" x 2½" (6) 2½" x WOF (1): 2½" x 4½" (4); 2½" x 2½" (4)
28	38¼"	4½" x WOF (3): 4½" x 4½" (9) 4½" x WOF (1): 4½" x 4½" (1); 4¼" x 4¼" (1), 2½" x 2½" (8) 4¼" x WOF (3): 4¼" x 4¼" (9) 2½" x WOF (3): 2½" x 2½" (16)	39½"	4¼" x WOF (3): 4¼" x 4¼" (9) 4¼" x WOF (1): 4¼" x 4¼" (1); 2½" x 4½" (2); 2½" x 2½" (2) 2½" x WOF (9): 2½" x 4½" (6); 2½" x 2½" (6)
32	40¾"	4½" x WOF (3): 4½" x 4½" (9) 4½" x WOF (1): 4½" x 4½" (5) 4¼" x WOF (3): 4¼" x 4¼" (9) 4¼" x WOF (1): 4¼" x 4¼" (5) 2½" x WOF (4): 2½" x 2½" (16)	44½"	4¼" x WOF (3): 4¼" x 4¼" (9) 4¼" x WOF (1): 4¼" x 4¼" (5) 2½" x WOF (10): 2½" x 4½" (6); 2½" x 2½" (6) 2½" x WOF (1): 2½" x 4½" (4); 2½" x 2½" (4)
34	45"	4½" x WOF (3): 4½" x 4½" (9) 4½" x WOF (1): 4½" x 4½" (7); 2½" x 2½" (4) 4¼" x WOF (3): 4¼" x 4¼" (9) 4¼" x WOF (1): 4¼" x 4¼" (7) 2½" x WOF (4): 2½" x 2½" (16)	47"	4¼" x WOF (3): 4¼" x 4¼" (9) 4¼" x WOF (1): 4¼" x 4¼" (7) 2½" x WOF (11): 2½" x 4½" (6); 2½" x 2½" (6) 2½" x WOF (1): 2½" x 4½" (2); 2½" x 2½" (2)
36	47½"	4½" x WOF (4): 4½" x 4½" (9) 4¼" x WOF (4): 4¼" x 4¼" (9) 2½" x WOF (4): 2½" x 2½" (16) 2½" x WOF (1): 2½" x 2½" (8)	47"	4¼" x WOF (4): 4¼" x 4¼" (9) 2½" x WOF (12): 2½" x 4½" (6); 2½" x 2½" (6)
40	52"	4½" x WOF (4): 4½" x 4½" (9) 4½" x WOF (1): 4½" x 4½" (4); 4¼" x 4¼" (4) 4¼" x WOF (4): 4¼" x 4¼" (9) 2½" x WOF (5): 2½" x 2½" (16)	53¾"	4¼" x WOF (4): 4¼" x 4¼" (9) 4¼" x WOF (1): 4¼" x 4¼" (4); 2½" x 4½" (2); 2½" x 2½" (2) 2½" x WOF (13): 2½" x 4½" (6); 2½" x 2½" (6)
44	58¾"	4½" x WOF (4): 4½" x 4½" (9) 4½" x WOF (1): 4½" x 4½" (8) 4¼" x WOF (4): 4¼" x 4¼" (9) 4¼" x WOF (1): 4¼" x 4¼" (8) 2½" x WOF (5): 2½" x 2½" (16) 2½" x WOF (1): 2½" x 2½" (8)	58¾"	4¼" x WOF (4): 4¼" x 4¼" (9) 4¼" x WOF (1): 4¼" x 4¼" (8) 2½" x WOF (14): 2½" x 4½" (6); 2½" x 2½" (6) 2½" x WOF (1): 2½" x 4½" (4); 2½" x 2½" (4)
45	58¾"	4½" x WOF (5): 4½" x 4½" (9) 4¼" x WOF (5): 4¼" x 4¼" (9) 2½" x WOF (5): 2½" x 2½" (16) 2½" x WOF (1): 2½" x 2½" (10)	58¾"	4¼" x WOF (5): 4¼" x 4¼" (9) 2½" x WOF (15): 2½" x 4½" (6); 2½" x 2½" (6)

| | FABRIC 1 | | FABRIC 2 | |
#	IN.	CUTTING REQUIREMENTS	IN.	CUTTING REQUIREMENTS
48	63¼"	4½" x WOF (5): 4½" x 4½" (9) 4½" x WOF (1): 4½" x 4½" (3); 4¼" x 4¼" (3) 4¼" x WOF (5): 4¼" x 4¼" (9) 2½" x WOF (6): 2½" x 2½" (16)	65½"	4¼" x WOF (5): 4¼" x 4¼" (9) 4¼" x WOF (1): 4¼" x 4¼" (3) 2½" x WOF (16): 2½" x 4½" (6); 2½" x 2½" (6)
50	67½"	4½" x WOF (5): 4½" x 4½" (9) 4½" x WOF (1): 4½" x 4½" (5); 2½" x 2½" (4) 4¼" x WOF (5): 4¼" x 4¼" (9) 4¼" x WOF (1): 4¼" x 4¼" (5) 2½" x WOF (6): 2½" x 2½" (16)	68"	4¼" x WOF (5): 4¼" x 4¼" (9) 4¼" x WOF (1): 4¼" x 4¼" (5) 2½" x WOF (16): 2½" x 4½" (6); 2½" x 2½" (6) 2½" x WOF (1): 2½" x 4½" (4); 2½" x 2½" (4)
52	70"	4½" x WOF (5): 4½" x 4½" (9) 4½" x WOF (1): 4½" x 4½" (7) 4¼" x WOF (5): 4¼" x 4¼" (9) 4¼" x WOF (1): 4¼" x 4¼" (7) 2½" x WOF (6): 2½" x 2½" (16) 2½" x WOF (1): 2½" x 2½" (8)	70½"	4¼" x WOF (5): 4¼" x 4¼" (9) 4¼" x WOF (1): 4¼" x 4¼" (7) 2½" x WOF (17): 2½" x 4½" (6); 2½" x 2½" (6) 2½" x WOF (1): 2½" x 4½" (2); 2½" x 2½" (2)
56	74½"	4½" x WOF (6): 4½" x 4½" (9) 4½" x WOF (1): 4½" x 4½" (2); 4¼" x 4¼" (2) 4¼" x WOF (6): 4¼" x 4¼" (9) 2½" x WOF (7): 2½" x 2½" (16)	74¾"	4¼" x WOF (6): 4¼" x 4¼" (9) 4¼" x WOF (1): 4¼" x 4¼" (2); 2½" x 4½" (4); 2½" x 2½" (4) 2½" x WOF (18): 2½" x 4½" (6); 2½" x 2½" (6)

Block 24

DESIGN PAGE 57

#	IN.	FABRIC 1 CUTTING REQUIREMENTS	IN.	FABRIC 2 CUTTING REQUIREMENTS
1	9"	9" x WOF (1): 9" x 9" (1)	9"	9" x WOF (1): 9" x 9" (1)
2	9"	9" x WOF (1): 9" x 9" (1)	9"	9" x WOF (1): 9" x 9" (1)
3	9"	9" x WOF (1): 9" x 9" (2)	9"	9" x WOF (1): 9" x 9" (2)
4	9"	9" x WOF (1): 9" x 9" (2)	9"	9" x WOF (1): 9" x 9" (2)
5	9"	9" x WOF (1): 9" x 9" (3)	9"	9" x WOF (1): 9" x 9" (3)
6	9"	9" x WOF (1): 9" x 9" (3)	9"	9" x WOF (1): 9" x 9" (3)
7	9"	9" x WOF (1): 9" x 9" (4)	9"	9" x WOF (1): 9" x 9" (4)
8	9"	9" x WOF (1): 9" x 9" (4)	9"	9" x WOF (1): 9" x 9" (4)
9	18"	9" x WOF (1): 9" x 9" (4) 9" x WOF (1): 9" x 9" (1)	18"	9" x WOF (1): 9" x 9" (4) 9" x WOF (1): 9" x 9" (1)
10	18"	9" x WOF (1): 9" x 9" (4) 9" x WOF (1): 9" x 9" (1)	18"	9" x WOF (1): 9" x 9" (4) 9" x WOF (1): 9" x 9" (1)
11	18"	9" x WOF (1): 9" x 9" (4) 9" x WOF (1): 9" x 9" (2)	18"	9" x WOF (1): 9" x 9" (4) 9" x WOF (1): 9" x 9" (2)
12	18"	9" x WOF (1): 9" x 9" (4) 9" x WOF (1): 9" x 9" (2)	18"	9" x WOF (1): 9" x 9" (4) 9" x WOF (1): 9" x 9" (2)
13	18"	9" x WOF (1): 9" x 9" (4) 9" x WOF (1): 9" x 9" (3)	18"	9" x WOF (1): 9" x 9" (4) 9" x WOF (1): 9" x 9" (3)
14	18"	9" x WOF (1): 9" x 9" (4) 9" x WOF (1): 9" x 9" (3)	18"	9" x WOF (1): 9" x 9" (4) 9" x WOF (1): 9" x 9" (3)
15	18"	9" x WOF (2): 9" x 9" (4)	18"	9" x WOF (2): 9" x 9" (4)
16	18"	9" x WOF (2): 9" x 9" (4)	18"	9" x WOF (2): 9" x 9" (4)
17	27"	9" x WOF (2): 9" x 9" (4) 9" x WOF (1): 9" x 9" (1)	27"	9" x WOF (2): 9" x 9" (4) 9" x WOF (1): 9" x 9" (1)
18	27"	9" x WOF (2): 9" x 9" (4) 9" x WOF (1): 9" x 9" (1)	27"	9" x WOF (2): 9" x 9" (4) 9" x WOF (1): 9" x 9" (1)
20	27"	9" x WOF (2): 9" x 9" (4) 9" x WOF (1): 9" x 9" (2)	27"	9" x WOF (2): 9" x 9" (4) 9" x WOF (1): 9" x 9" (2)
21	27"	9" x WOF (2): 9" x 9" (4) 9" x WOF (1): 9" x 9" (3)	27"	9" x WOF (2): 9" x 9" (4) 9" x WOF (1): 9" x 9" (3)
22	27"	9" x WOF (2): 9" x 9" (4) 9" x WOF (1): 9" x 9" (3)	27"	9" x WOF (2): 9" x 9" (4) 9" x WOF (1): 9" x 9" (3)
24	27"	9" x WOF (3): 9" x 9" (4)	27"	9" x WOF (3): 9" x 9" (4)
26	36"	9" x WOF (3): 9" x 9" (4) 9" x WOF (1): 9" x 9" (1)	36"	9" x WOF (3): 9" x 9" (4) 9" x WOF (1): 9" x 9" (1)

#	FABRIC 1		FABRIC 2	
	IN.	CUTTING REQUIREMENTS	IN.	CUTTING REQUIREMENTS
28	36"	9" x WOF (3): 9" x 9" (4) 9" x WOF (1): 9" x 9" (2)	36"	9" x WOF (3): 9" x 9" (4) 9" x WOF (1): 9" x 9" (2)
32	36"	9" x WOF (4): 9" x 9" (4)	36"	9" x WOF (4): 9" x 9" (4)
34	45"	9" x WOF (4): 9" x 9" (4) 9" x WOF (1): 9" x 9" (1)	45"	9" x WOF (4): 9" x 9" (4) 9" x WOF (1): 9" x 9" (1)
36	45"	9" x WOF (4): 9" x 9" (4) 9" x WOF (1): 9" x 9" (2)	45"	9" x WOF (4): 9" x 9" (4) 9" x WOF (1): 9" x 9" (2)
40	45"	9" x WOF (5): 9" x 9" (4)	45"	9" x WOF (5): 9" x 9" (4)
44	54"	9" x WOF (5): 9" x 9" (4) 9" x WOF (1): 9" x 9" (2)	54"	9" x WOF (5): 9" x 9" (4) 9" x WOF (1): 9" x 9" (2)
45	54"	9" x WOF (5): 9" x 9" (4) 9" x WOF (1): 9" x 9" (3)	54"	9" x WOF (5): 9" x 9" (4) 9" x WOF (1): 9" x 9" (3)
48	54"	9" x WOF (6): 9" x 9" (4)	54"	9" x WOF (6): 9" x 9" (4)
50	63"	9" x WOF (6): 9" x 9" (4) 9" x WOF (1): 9" x 9" (1)	63"	9" x WOF (6): 9" x 9" (4) 9" x WOF (1): 9" x 9" (1)
52	63"	9" x WOF (6): 9" x 9" (4) 9" x WOF (1): 9" x 9" (2)	63"	9" x WOF (6): 9" x 9" (4) 9" x WOF (1): 9" x 9" (2)
56	63"	9" x WOF (7): 9" x 9" (4)	63"	9" x WOF (7): 9" x 9" (4)

Blocks 25, 26, and 27

#	FABRIC 1 IN.	FABRIC 1 CUTTING REQUIREMENTS	FABRIC 2 IN.	FABRIC 2 CUTTING REQUIREMENTS
1	4⅞"	4⅞" x WOF (1): 4⅞" x 4⅞" (4)	9¼"	9¼" x WOF (1): 9¼" x 9¼" (1)
2	4⅞"	4⅞" x WOF (1): 4⅞" x 4⅞" (4)	9¼"	9¼" x WOF (1): 9¼" x 9¼" (1)
3	4⅞"	4⅞" x WOF (1): 4⅞" x 4⅞" (8)	9¼"	9¼" x WOF (1): 9¼" x 9¼" (2)
4	4⅞"	4⅞" x WOF (1): 4⅞" x 4⅞" (8)	9¼"	9¼" x WOF (1): 9¼" x 9¼" (2)
5	9¾"	4⅞" x WOF (1): 4⅞" x 4⅞" (8) 4⅞" x WOF (1): 4⅞" x 4⅞" (4)	9¼"	9¼" x WOF (1): 9¼" x 9¼" (3)
6	9¾"	4⅞" x WOF (1): 4⅞" x 4⅞" (8) 4⅞" x WOF (1): 4⅞" x 4⅞" (4)	9¼"	9¼" x WOF (1): 9¼" x 9¼" (3)
7	9¾"	4⅞" x WOF (2): 4⅞" x 4⅞" (8)	9¼"	9¼" x WOF (1): 9¼" x 9¼" (4)
8	9¾"	4⅞" x WOF (2): 4⅞" x 4⅞" (8)	9¼"	9¼" x WOF (1): 9¼" x 9¼" (4)
9	14⅝"	4⅞" x WOF (2): 4⅞" x 4⅞" (8) 4⅞" x WOF (1): 4⅞" x 4⅞" (4)	18½"	9¼" x WOF (1): 9¼" x 9¼" (4) 9¼" x WOF (1): 9¼" x 9¼" (1)
10	14⅝"	4⅞" x WOF (2): 4⅞" x 4⅞" (8) 4⅞" x WOF (1): 4⅞" x 4⅞" (4)	18½"	9¼" x WOF (1): 9¼" x 9¼" (4) 9¼" x WOF (1): 9¼" x 9¼" (1)
11	14⅝"	4⅞" x WOF (3): 4⅞" x 4⅞" (8)	18½"	9¼" x WOF (1): 9¼" x 9¼" (4) 9¼" x WOF (1): 9¼" x 9¼" (2)
12	14⅝"	4⅞" x WOF (3): 4⅞" x 4⅞" (8)	18½"	9¼" x WOF (1): 9¼" x 9¼" (4) 9¼" x WOF (1): 9¼" x 9¼" (2)
13	19½"	4⅞" x WOF (3): 4⅞" x 4⅞" (8) 4⅞" x WOF (1): 4⅞" x 4⅞" (4)	18½"	9¼" x WOF (1): 9¼" x 9¼" (4) 9¼" x WOF (1): 9¼" x 9¼" (3)
14	19½"	4⅞" x WOF (3): 4⅞" x 4⅞" (8) 4⅞" x WOF (1): 4⅞" x 4⅞" (4)	18½"	9¼" x WOF (1): 9¼" x 9¼" (4) 9¼" x WOF (1): 9¼" x 9¼" (3)
15	19½"	4⅞" x WOF (4): 4⅞" x 4⅞" (8)	18½"	9¼" x WOF (2): 9¼" x 9¼" (4)
16	19½"	4⅞" x WOF (4): 4⅞" x 4⅞" (8)	18½"	9¼" x WOF (2): 9¼" x 9¼" (4)
17	24⅜"	4⅞" x WOF (4): 4⅞" x 4⅞" (8) 4⅞" x WOF (1): 4⅞" x 4⅞" (4)	27¾"	9¼" x WOF (2): 9¼" x 9¼" (4) 9¼" x WOF (1): 9¼" x 9¼" (1)
18	24⅜"	4⅞" x WOF (4): 4⅞" x 4⅞" (8) 4⅞" x WOF (1): 4⅞" x 4⅞" (4)	27¾"	9¼" x WOF (2): 9¼" x 9¼" (4) 9¼" x WOF (1): 9¼" x 9¼" (1)
20	24⅜"	4⅞" x WOF (5): 4⅞" x 4⅞" (8)	27¾"	9¼" x WOF (2): 9¼" x 9¼" (4) 9¼" x WOF (1): 9¼" x 9¼" (2)
21	29¼"	4⅞" x WOF (5): 4⅞" x 4⅞" (8) 4⅞" x WOF (1): 4⅞" x 4⅞" (4)	27¾"	9¼" x WOF (2): 9¼" x 9¼" (4) 9¼" x WOF (1): 9¼" x 9¼" (3)
22	29¼"	4⅞" x WOF (5): 4⅞" x 4⅞" (8) 4⅞" x WOF (1): 4⅞" x 4⅞" (4)	27¾"	9¼" x WOF (2): 9¼" x 9¼" (4) 9¼" x WOF (1): 9¼" x 9¼" (3)
24	29¼"	4⅞" x WOF (6): 4⅞" x 4⅞" (8)	27¾"	9¼" x WOF (3): 9¼" x 9¼" (4)

	FABRIC 1		FABRIC 2	
#	IN.	CUTTING REQUIREMENTS	IN.	CUTTING REQUIREMENTS
26	34⅛"	4⅞" x WOF (6): 4⅞" x 4⅞" (8) 4⅞" x WOF (1): 4⅞" x 4⅞" (4)	37"	9¼" x WOF (3): 9¼" x 9¼" (4) 9¼" x WOF (1): 9¼" x 9¼" (1)
28	34⅛"	4⅞" x WOF (7): 4⅞" x 4⅞" (8)	37"	9¼" x WOF (3): 9¼" x 9¼" (4) 9¼" x WOF (1): 9¼" x 9¼" (2)
32	39"	4⅞" x WOF (8): 4⅞" x 4⅞" (8)	37"	9¼" x WOF (4): 9¼" x 9¼" (4)
34	43⅞"	4⅞" x WOF (8): 4⅞" x 4⅞" (8) 4⅞" x WOF (1): 4⅞" x 4⅞" (4)	46¼"	9¼" x WOF (4): 9¼" x 9¼" (4) 9¼" x WOF (1): 9¼" x 9¼" (1)
36	43⅞"	4⅞" x WOF (9): 4⅞" x 4⅞" (8)	46¼"	9¼" x WOF (4): 9¼" x 9¼" (4) 9¼" x WOF (1): 9¼" x 9¼" (2)
40	48¾"	4⅞" x WOF (10): 4⅞" x 4⅞" (8)	46¼"	9¼" x WOF (5): 9¼" x 9¼" (4)
44	53⅜"	4⅞" x WOF (11): 4⅞" x 4⅞" (8)	55½"	9¼" x WOF (5): 9¼" x 9¼" (4) 9¼" x WOF (1): 9¼" x 9¼" (2)
45	58½"	4⅞" x WOF (11): 4⅞" x 4⅞" (8) 4⅞" x WOF (1): 4⅞" x 4⅞" (4)	55½"	9¼" x WOF (5): 9¼" x 9¼" (4) 9¼" x WOF (1): 9¼" x 9¼" (3)
48	58½"	4⅞" x WOF (12): 4⅞" x 4⅞" (8)	55½"	9¼" x WOF (6): 9¼" x 9¼" (4)
50	63⅜"	4⅞" x WOF (12): 4⅞" x 4⅞" (8) 4⅞" x WOF (1): 4⅞" x 4⅞" (4)	64¾"	9¼" x WOF (6): 9¼" x 9¼" (4) 9¼" x WOF (1): 9¼" x 9¼" (1)
52	63⅜"	4⅞" x WOF (13): 4⅞" x 4⅞" (8)	64¾"	9¼" x WOF (6): 9¼" x 9¼" (4) 9¼" x WOF (1): 9¼" x 9¼" (2)
56	68¼"	4⅞" x WOF (14): 4⅞" x 4⅞" (8)	64¾"	9¼" x WOF (7): 9¼" x 9¼" (4)

Block 28

#	IN.	FABRIC 1 CUTTING REQUIREMENTS	IN.	FABRIC 2 CUTTING REQUIREMENTS
1	9¼"	9¼" x WOF (1): 9¼" x 9¼" (1); 8½" x 4½" (1)	4⅞"	4⅞" x WOF (1): 4⅞" x 4⅞" (4)
2	9¼"	9¼" x WOF (1): 9¼" x 9¼" (1); 8½" x 4½" (2)	4⅞"	4⅞" x WOF (1): 4⅞" x 4⅞" (4)
3	9¼"	9¼" x WOF (1): 9¼" x 9¼" (1); 8½" x 4½" (3)	4⅞"	4⅞" x WOF (1): 4⅞" x 4⅞" (4)
4	9¼"	9¼" x WOF (1): 9¼" x 9¼" (1); 8½" x 4½" (4)	4⅞"	4⅞" x WOF (1): 4⅞" x 4⅞" (4)
5	9¼"	9¼" x WOF (1): 9¼" x 9¼" (2); 8½" x 4½" (5)	4⅞"	4⅞" x WOF (1): 4⅞" x 4⅞" (8)
6	13¾"	9¼" x WOF (1): 9¼" x 9¼" (2); 8½" x 4½" (2) 4½" x WOF (1): 4½" x 8½" (4)	4⅞"	4⅞" x WOF (1): 4⅞" x 4⅞" (8)
7	13¾"	9¼" x WOF (1): 9¼" x 9¼" (2); 8½" x 4½" (5) 4½" x WOF (1): 4½" x 8½" (2)	4⅞"	4⅞" x WOF (1): 4⅞" x 4⅞" (8)
8	13¾"	9¼" x WOF (1): 9¼" x 9¼" (2); 8½" x 4½" (5) 4½" x WOF (1): 4½" x 8½" (3)	4⅞"	4⅞" x WOF (1): 4⅞" x 4⅞" (8)
9	17¾"	9¼" x WOF (1): 9¼" x 9¼" (3) 8½" x WOF (1): 8½" x 4½" (9)	9¾"	4⅞" x WOF (1): 4⅞" x 4⅞" (8) 4⅞" x WOF (1): 4⅞" x 4⅞" (4)
10	17¾"	9¼" x WOF (1): 9¼" x 9¼" (3); 8½" x 4½" (1) 8½" x WOF (1): 8½" x 4½" (9)	9¾"	4⅞" x WOF (1): 4⅞" x 4⅞" (8) 4⅞" x WOF (1): 4⅞" x 4⅞" (4)
11	17¾"	9¼" x WOF (1): 9¼" x 9¼" (3); 8½" x 4½" (2) 8½" x WOF (1): 8½" x 4½" (9)	9¾"	4⅞" x WOF (1): 4⅞" x 4⅞" (8) 4⅞" x WOF (1): 4⅞" x 4⅞" (4)
12	17¾"	9¼" x WOF (1): 9¼" x 9¼" (3); 8½" x 4½" (3) 8½" x WOF (1): 8½" x 4½" (9)	9¾"	4⅞" x WOF (1): 4⅞" x 4⅞" (8) 4⅞" x WOF (1): 4⅞" x 4⅞" (4)
13	22¼"	9¼" x WOF (1): 9¼" x 9¼" (4) 8½" x WOF (1): 8½" x 4½" (9) 4½" x WOF (1): 4½" x 8½" (4)	9¾"	4⅞" x WOF (2): 4⅞" x 4⅞" (8)
14	22¼"	9¼" x WOF (1): 9¼" x 9¼" (4); 8½" x 4½" (1) 8½" x WOF (1): 8½" x 4½" (9) 4½" x WOF (1): 4½" x 8½" (4)	9¾"	4⅞" x WOF (2): 4⅞" x 4⅞" (8)
15	26¼"	9¼" x WOF (1): 9¼" x 9¼" (4) 8½" x WOF (1): 8½" x 4½" (9) 8½" x WOF (1): 8½" x 4½" (6)	9¾"	4⅞" x WOF (2): 4⅞" x 4⅞" (8)
16	26¼"	9¼" x WOF (1): 9¼" x 9¼" (4) 8½" x WOF (1): 8½" x 4½" (9) 8½" x WOF (1): 8½" x 4½" (7)	9¾"	4⅞" x WOF (2): 4⅞" x 4⅞" (8)
17	27"	9¼" x WOF (1): 9¼" x 9¼" (4); 8½" x 4½" (1) 9¼" x WOF (1): 9¼" x 9¼" (1); 8½" x 4½" (7) 8½" x WOF (1): 8½" x 4½" (9)	14⅝"	4⅞" x WOF (2): 4⅞" x 4⅞" (8) 4⅞" x WOF (1): 4⅞" x 4⅞" (4)
18	35½"	9¼" x WOF (1): 9¼" x 9¼" (4) 9¼" x WOF (1): 9¼" x 9¼" (1) 8½" x WOF (2): 8½" x 4½" (9)	14⅝"	4⅞" x WOF (2): 4⅞" x 4⅞" (8) 4⅞" x WOF (1): 4⅞" x 4⅞" (4)

	FABRIC 1		FABRIC 2	
#	**IN.**	**CUTTING REQUIREMENTS**	**IN.**	**CUTTING REQUIREMENTS**
20	35½"	9¼" x WOF (1): 9¼" x 9¼" (4) 9¼" x WOF (1): 9¼" x 9¼" (1); 8½" x 4½" (2) 8½" x WOF (2): 8½" x 4½" (9)	14⅝"	4⅞" x WOF (2): 4⅞" x 4⅞" (8) 4⅞" x WOF (1): 4⅞" x 4⅞" (4)
21	35½"	9¼" x WOF (1): 9¼" x 9¼" (4) 9¼" x WOF (1): 9¼" x 9¼" (2); 8½" x 4½" (3) 8½" x WOF (2): 8½" x 4½" (9)	14⅝"	4⅞" x WOF (3): 4⅞" x 4⅞" (8)
22	35½"	9¼" x WOF (1): 9¼" x 9¼" (4) 9¼" x WOF (1): 9¼" x 9¼" (2); 8½" x 4½" (4) 8½" x WOF (2): 8½" x 4½" (9)	14⅝"	4⅞" x WOF (3): 4⅞" x 4⅞" (8)
24	35½"	9¼" x WOF (1): 9¼" x 9¼" (4); 8½" x 4½" (1) 9¼" x WOF (1): 9¼" x 9¼" (2); 8½" x 4½" (5) 8½" x WOF (2): 8½" x 4½" (9)	14⅝"	4⅞" x WOF (3): 4⅞" x 4⅞" (8)
26	44"	9¼" x WOF (1): 9¼" x 9¼" (4) 9¼" x WOF (1): 9¼" x 9¼" (3) 8½" x WOF (2): 8½" x 4½" (9) 8½" x WOF (1): 8½" x 4½" (8)	19½"	4⅞" x WOF (3): 4⅞" x 4⅞" (8) 4⅞" x WOF (1): 4⅞" x 4⅞" (4)
28	44"	9¼" x WOF (1): 9¼" x 9¼" (4) 9¼" x WOF (1): 9¼" x 9¼" (3); 8½" x 4½" (1) 8½" x WOF (3): 8½" x 4½" (9)	19½"	4⅞" x WOF (3): 4⅞" x 4⅞" (8) 4⅞" x WOF (1): 4⅞" x 4⅞" (4)
32	52½"	9¼" x WOF (2): 9¼" x 9¼" (4) 8½" x WOF (3): 8½" x 4½" (9) 8½" x WOF (1): 8½" x 4½" (5)	19½"	4⅞" x WOF (4): 4⅞" x 4⅞" (8)
34	53¼"	9¼" x WOF (2): 9¼" x 9¼" (4) 9¼" x WOF (1): 9¼" x 9¼" (1); 8½" x 4½" (7) 8½" x WOF (3): 8½" x 4½" (9)	24⅜"	4⅞" x WOF (4): 4⅞" x 4⅞" (8) 4⅞" x WOF (1): 4⅞" x 4⅞" (4)
36	61¾"	9¼" x WOF (2): 9¼" x 9¼" (4) 9¼" x WOF (1): 9¼" x 9¼" (1) 8½" x WOF (4): 8½" x 4½" (9)	24⅜"	4⅞" x WOF (4): 4⅞" x 4⅞" (8) 4⅞" x WOF (1): 4⅞" x 4⅞" (4)
40	61¾"	9¼" x WOF (2): 9¼" x 9¼" (4) 9¼" x WOF (1): 9¼" x 9¼" (2); 8½" x 4½" (4) 8½" x WOF (4): 8½" x 4½" (9)	24⅜"	4⅞" x WOF (5): 4⅞" x 4⅞" (8)
44	70¼"	9¼" x WOF (2): 9¼" x 9¼" (4) 9¼" x WOF (1): 9¼" x 9¼" (3) 8½" x WOF (4): 8½" x 4½" (9) 8½" x WOF (1): 8½" x 4½" (8)	29¼"	4⅞" x WOF (5): 4⅞" x 4⅞" (8) 4⅞" x WOF (1): 4⅞" x 4⅞" (4)
45	70¼"	9¼" x WOF (3): 9¼" x 9¼" (4) 8½" x WOF (5): 8½" x 4½" (9)	29¼"	4⅞" x WOF (6): 4⅞" x 4⅞" (8)
48	71"	9¼" x WOF (2): 9¼" x 9¼" (4); 8½" x 4½" (1) 9¼" x WOF (2): 9¼" x 9¼" (2); 8½" x 4½" (5) 8½" x WOF (4): 8½" x 4½" (9)	29¼"	4⅞" x WOF (6): 4⅞" x 4⅞" (8)

continues on next page

Block 28 continued

#	FABRIC 1		FABRIC 2	
	IN.	CUTTING REQUIREMENTS	IN.	CUTTING REQUIREMENTS
50	79½"	9¼" x WOF (3): 9¼" x 9¼" (4) 9¼" x WOF (1): 9¼" x 9¼" (1); 8½" x 4½" (5) 8½" x WOF (5): 8½" x 4½" (9)	34⅛"	4⅞" x WOF (6): 4⅞" x 4⅞" (8) 4⅞" x WOF (1): 4⅞" x 4⅞" (4)
52	79½"	9¼" x WOF (3): 9¼" x 9¼" (4) 9¼" x WOF (1): 9¼" x 9¼" (1); 8½" x 4½" (7) 8½" x WOF (5): 8½" x 4½" (9)	34⅛"	4⅞" x WOF (6): 4⅞" x 4⅞" (8) 4⅞" x WOF (1): 4⅞" x 4⅞" (4)
56	88"	9¼" x WOF (3): 9¼" x 9¼" (4) 9¼" x WOF (1): 9¼" x 9¼" (2); 8½" x 4½" (2) 8½" x WOF (6): 8½" x 4½" (9)	34⅛"	4⅞" x WOF (7): 4⅞" x 4⅞" (8)

QUILT YOUR OWN ADVENTURE

Blocks 29 and 30

DESIGN PAGES 62 AND 63

#	IN.	FABRIC 1 CUTTING REQUIREMENTS	IN.	FABRIC 2 CUTTING REQUIREMENTS
1	4½"	4½" x WOF (1): 4½" x 4½" (1); 2⅞" x 2⅞" (4); 2½" x 2½" (4)	5¼"	5¼" x WOF (1): 5¼" x 5¼" (1)
2	7"	4½" x WOF (1): 4½" x 4½" (2); 2⅞" x 2⅞" (8) 2½" x WOF (1): 2½" x 2½" (8)	5¼"	5¼" x WOF (1): 5¼" x 5¼" (2)
3	9⅞"	4½" x WOF (1): 4½" x 4½" (3) 2⅞" x WOF (1): 2⅞" x 2⅞" (12) 2½" x WOF (1): 2½" x 2½" (12)	5¼"	5¼" x WOF (1): 5¼" x 5¼" (3)
4	9⅞"	4½" x WOF (1): 4½" x 4½" (4); 2⅞" x 2⅞" (2) 2⅞" x WOF (1): 2⅞" x 2⅞" (14) 2½" x WOF (1): 2½" x 2½" (16)	5¼"	5¼" x WOF (1): 5¼" x 5¼" (4)
5	12¾"	4½" x WOF (1): 4½" x 4½" (5); 2½" x 2½" (4) 2⅞" x WOF (1): 2⅞" x 2⅞" (14) 2⅞" x WOF (1): 2⅞" x 2⅞" (6) 2½" x WOF (1): 2½" x 2½" (16)	5¼"	5¼" x WOF (1): 5¼" x 5¼" (5)
6	15¼"	4½" x WOF (1): 4½" x 4½" (6) 2⅞" x WOF (1): 2⅞" x 2⅞" (14) 2⅞" x WOF (1): 2⅞" x 2⅞" (10) 2½" x WOF (1): 2½" x 2½" (16) 2½" x WOF (1): 2½" x 2½" (8)	5¼"	5¼" x WOF (1): 5¼" x 5¼" (6)
7	15¼"	4½" x WOF (1): 4½" x 4½" (7) 2⅞" x WOF (2): 2⅞" x 2⅞" (14) 2½" x WOF (1): 2½" x 2½" (16) 2½" x WOF (1): 2½" x 2½" (12)	5¼"	5¼" x WOF (1): 5¼" x 5¼" (7)
8	18⅛"	4½" x WOF (1): 4½" x 4½" (8) 2⅞" x WOF (2): 2⅞" x 2⅞" (14) 2⅞" x WOF (1): 2⅞" x 2⅞" (4) 2½" x WOF (2): 2½" x 2½" (16)	5¼"	5¼" x WOF (1): 5¼" x 5¼" (8)
9	18⅛"	4½" x WOF (1): 4½" x 4½" (9) 2⅞" x WOF (2): 2⅞" x 2⅞" (14) 2⅞" x WOF (1): 2⅞" x 2⅞" (8); 2½" x 2½" (4) 2½" x WOF (2): 2½" x 2½" (16)	10½"	5¼" x WOF (1): 5¼" x 5¼" (8) 5¼" x WOF (1): 5¼" x 5¼" (1)
10	22⅜"	4½" x WOF (1): 4½" x 4½" (9) 4½" x WOF (1): 4½" x 4½" (1); 2½" x 2½" (8) 2⅞" x WOF (2): 2⅞" x 2⅞" (14) 2⅞" x WOF (1): 2⅞" x 2⅞" (12) 2½" x WOF (2): 2½" x 2½" (16)	10½"	5¼" x WOF (1): 5¼" x 5¼" (8) 5¼" x WOF (1): 5¼" x 5¼" (2)
11	25⅛"	4½" x WOF (1): 4½" x 4½" (9) 4½" x WOF (1): 4½" x 4½" (2); 2⅞" x 2⅞" (2) 2⅞" x WOF (3): 2⅞" x 2⅞" (14) 2½" x WOF (2): 2½" x 2½" (16) 2½" x WOF (1): 2½" x 2½" (12)	10½"	5¼" x WOF (1): 5¼" x 5¼" (8) 5¼" x WOF (1): 5¼" x 5¼" (3)

continues on next page

THE MATH

#	IN.	FABRIC 1 CUTTING REQUIREMENTS	IN.	FABRIC 2 CUTTING REQUIREMENTS
12	25⅛"	4½" x WOF (1): 4½" x 4½" (9) 4½" x WOF (1): 4½" x 4½" (3); 2⅞" x 2⅞" (6) 2⅞" x WOF (3): 2⅞" x 2⅞" (14) 2½" x WOF (3): 2½" x 2½" (16)	10½"	5¼" x WOF (1): 5¼" x 5¼" (8) 5¼" x WOF (1): 5¼" x 5¼" (4)
13	28"	4½" x WOF (1): 4½" x 4½" (9) 4½" x WOF (1): 4½" x 4½" (4); 2½" x 2½" (4) 2⅞" x WOF (3): 2⅞" x 2⅞" (14) 2⅞" x WOF (1): 2⅞" x 2⅞" (10) 2½" x WOF (3): 2½" x 2½" (16)	10½"	5¼" x WOF (1): 5¼" x 5¼" (8) 5¼" x WOF (1): 5¼" x 5¼" (5)
14	30½"	4½" x WOF (1): 4½" x 4½" (9) 4½" x WOF (1): 4½" x 4½" (5) 2⅞" x WOF (4): 2⅞" x 2⅞" (14) 2½" x WOF (3): 2½" x 2½" (16) 2½" x WOF (1): 2½" x 2½" (8)	10½"	5¼" x WOF (1): 5¼" x 5¼" (8) 5¼" x WOF (1): 5¼" x 5¼" (6)
15	30½"	4½" x WOF (1): 4½" x 4½" (9) 4½" x WOF (1): 4½" x 4½" (6); 2⅞" x 2⅞" (4) 2⅞" x WOF (4): 2⅞" x 2⅞" (14) 2½" x WOF (3): 2½" x 2½" (16) 2½" x WOF (1): 2½" x 2½" (12)	10½"	5¼" x WOF (1): 5¼" x 5¼" (8) 5¼" x WOF (1): 5¼" x 5¼" (7)
16	33⅜"	4½" x WOF (1): 4½" x 4½" (9) 4½" x WOF (1): 4½" x 4½" (7) 2⅞" x WOF (4): 2⅞" x 2⅞" (14) 2⅞" x WOF (1): 2⅞" x 2⅞" (8) 2½" x WOF (4): 2½" x 2½" (16)	10½"	5¼" x WOF (2): 5¼" x 5¼" (8)
17	35⅞"	4½" x WOF (1): 4½" x 4½" (9) 4½" x WOF (1): 4½" x 4½" (8) 2⅞" x WOF (4): 2⅞" x 2⅞" (14) 2⅞" x WOF (1): 2⅞" x 2⅞" (12) 2½" x WOF (4): 2½" x 2½" (16) 2½" x WOF (1): 2½" x 2½" (4)	15¾"	5¼" x WOF (2): 5¼" x 5¼" (8) 5¼" x WOF (1): 5¼" x 5¼" (1)
18	36¼"	4½" x WOF (2): 4½" x 4½" (9) 2⅞" x WOF (5): 2⅞" x 2⅞" (14) 2⅞" x WOF (1): 2⅞" x 2⅞" (2); 2½" x 2½" (8) 2½" x WOF (4): 2½" x 2½" (16)	15¾"	5¼" x WOF (2): 5¼" x 5¼" (8) 5¼" x WOF (1): 5¼" x 5¼" (2)
20	40⅜"	4½" x WOF (2): 4½" x 4½" (9) 4½" x WOF (1): 4½" x 4½" (2); 2⅞" x 2⅞" (10) 2⅞" x WOF (5): 2⅞" x 2⅞" (14) 2½" x WOF (5): 2½" x 2½" (16)	15¾"	5¼" x WOF (2): 5¼" x 5¼" (8) 5¼" x WOF (1): 5¼" x 5¼" (4)
21	43¼"	4½" x WOF (2): 4½" x 4½" (9) 4½" x WOF (1): 4½" x 4½" (3); 2½" x 2½" (4) 2⅞" x WOF (6): 2⅞" x 2⅞" (14) 2½" x WOF (5): 2½" x 2½" (16)	15¾"	5¼" x WOF (2): 5¼" x 5¼" (8) 5¼" x WOF (1): 5¼" x 5¼" (5)

	FABRIC 1		FABRIC 2	
#	IN.	CUTTING REQUIREMENTS	IN.	CUTTING REQUIREMENTS
22	46⅛"	4½" x WOF (2): 4½" x 4½" (9) 4½" x WOF (1): 4½" x 4½" (4); 2½" x 2½" (8) 2⅞" x WOF (6): 2⅞" x 2⅞" (14) 2⅞" x WOF (1): 2⅞" x 2⅞" (4) 2½" x WOF (5): 2½" x 2½" (16)	15¾"	5¼" x WOF (2): 5¼" x 5¼" (8) 5¼" x WOF (1): 5¼" x 5¼" (6)
24	48⅜"	4½" x WOF (2): 4½" x 4½" (9) 4½" x WOF (1): 4½" x 4½" (6) 2⅞" x WOF (6): 2⅞" x 2⅞" (14) 2⅞" x WOF (1): 2⅞" x 2⅞" (12) 2½" x WOF (6): 2½" x 2½" (16)	15¾"	5¼" x WOF (3): 5¼" x 5¼" (8)
26	51½"	4½" x WOF (2): 4½" x 4½" (9) 4½" x WOF (1): 4½" x 4½" (8) 2⅞" x WOF (7): 2⅞" x 2⅞" (14) 2⅞" x WOF (1): 2⅞" x 2⅞" (6); 2½" x 2½" (8) 2½" x WOF (6): 2½" x 2½" (16)	21"	5¼" x WOF (3): 5¼" x 5¼" (8) 5¼" x WOF (1): 5¼" x 5¼" (2)
28	58½"	4½" x WOF (3): 4½" x 4½" (9) 4½" x WOF (1): 4½" x 4½" (1) 2⅞" x WOF (8): 2⅞" x 2⅞" (14) 2½" x WOF (7): 2½" x 2½" (16)	21"	5¼" x WOF (3): 5¼" x 5¼" (8) 5¼" x WOF (1): 5¼" x 5¼" (4)
32	63⅞"	4½" x WOF (3): 4½" x 4½" (9) 4½" x WOF (1): 4½" x 4½" (5); 2⅞" x 2⅞" (2) 2⅞" x WOF (9): 2⅞" x 2⅞" (14) 2½" x WOF (8): 2½" x 2½" (16)	21"	5¼" x WOF (4): 5¼" x 5¼" (8)
34	69¼"	4½" x WOF (3): 4½" x 4½" (9) 4½" x WOF (1): 4½" x 4½" (7) 2⅞" x WOF (9): 2⅞" x 2⅞" (14) 2⅞" x WOF (1): 2⅞" x 2⅞" (10) 2½" x WOF (8): 2½" x 2½" (16) 2½" x WOF (1): 2½" x 2½" (8)	26¼"	5¼" x WOF (4): 5¼" x 5¼" (8) 5¼" x WOF (1): 5¼" x 5¼" (2)
36	72⅛"	4½" x WOF (4): 4½" x 4½" (9) 2⅞" x WOF (10): 2⅞" x 2⅞" (14) 2⅞" x WOF (1): 2⅞" x 2⅞" (4) 2½" x WOF (9): 2½" x 2½" (16)	26¼"	5¼" x WOF (4): 5¼" x 5¼" (8) 5¼" x WOF (1): 5¼" x 5¼" (4)
40	79⅛"	4½" x WOF (4): 4½" x 4½" (9) 4½" x WOF (1): 4½" x 4½" (4); 2⅞" x 2⅞" (6) 2⅞" x WOF (11): 2⅞" x 2⅞" (14) 2½" x WOF (10): 2½" x 2½" (16)	26¼"	5¼" x WOF (5): 5¼" x 5¼" (8)
44	87⅜"	4½" x WOF (4): 4½" x 4½" (9) 4½" x WOF (1): 4½" x 4½" (8) 2⅞" x WOF (12): 2⅞" x 2⅞" (14) 2⅞" x WOF (1): 2⅞" x 2⅞" (8) 2½" x WOF (11): 2½" x 2½" (16)	31½"	5¼" x WOF (5): 5¼" x 5¼" (8) 5¼" x WOF (1): 5¼" x 5¼" (4)

continues on next page

THE MATH

Blocks 29 and 30 continued

#	IN.	FABRIC 1 CUTTING REQUIREMENTS	IN.	FABRIC 2 CUTTING REQUIREMENTS
45	89⅞"	4½" x WOF (5): 4½" x 4½" (9) 2⅞" x WOF (12): 2⅞" x 2⅞" (14) 2⅞" x WOF (1): 2⅞" x 2⅞" (12) 2½" x WOF (11): 2½" x 2½" (16) 2½" x WOF (1): 2½" x 2½" (4)	31½"	5¼" x WOF (5): 5¼" x 5¼" (8) 5¼" x WOF (1): 5¼" x 5¼" (5)
48	97¼"	4½" x WOF (5): 4½" x 4½" (9) 4½" x WOF (1): 4½" x 4½" (3) 2⅞" x WOF (13): 2⅞" x 2⅞" (14) 2⅞" x WOF (1): 2⅞" x 2⅞" (10) 2½" x WOF (12): 2½" x 2½" (16)	31½"	5¼" x WOF (6): 5¼" x 5¼" (8)
50	100⅛"	4½" x WOF (5): 4½" x 4½" (9) 4½" x WOF (1): 4½" x 4½" (5) 2⅞" x WOF (14): 2⅞" x 2⅞" (14) 2⅞" x WOF (1): 2⅞" x 2⅞" (4); 2½" x 2½" (8) 2½" x WOF (12): 2½" x 2½" (16)	36¾"	5¼" x WOF (6): 5¼" x 5¼" (8) 5¼" x WOF (1): 5¼" x 5¼" (2)
52	102⅝"	4½" x WOF (5): 4½" x 4½" (9) 4½" x WOF (1): 4½" x 4½" (7) 2⅞" x WOF (14): 2⅞" x 2⅞" (14) 2⅞" x WOF (1): 2⅞" x 2⅞" (12) 2½" x WOF (13): 2½" x 2½" (16)	36¾"	5¼" x WOF (6): 5¼" x 5¼" (8) 5¼" x WOF (1): 5¼" x 5¼" (4)
56	112½"	4½" x WOF (6): 4½" x 4½" (9) 4½" x WOF (1): 4½" x 4½" (2) 2⅞" x WOF (16): 2⅞" x 2⅞" (14) 2½" x WOF (14): 2½" x 2½" (16)	36¾"	5¼" x WOF (7): 5¼" x 5¼" (8)

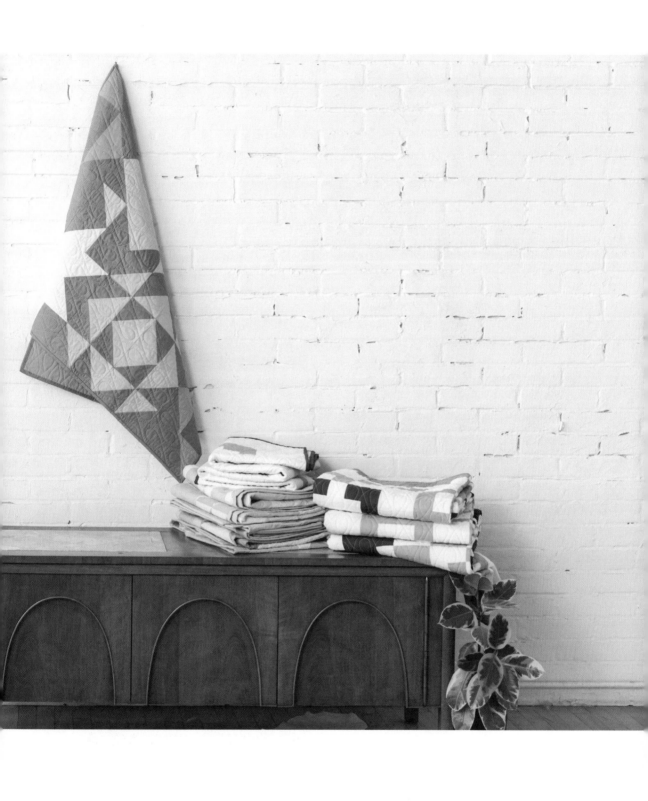

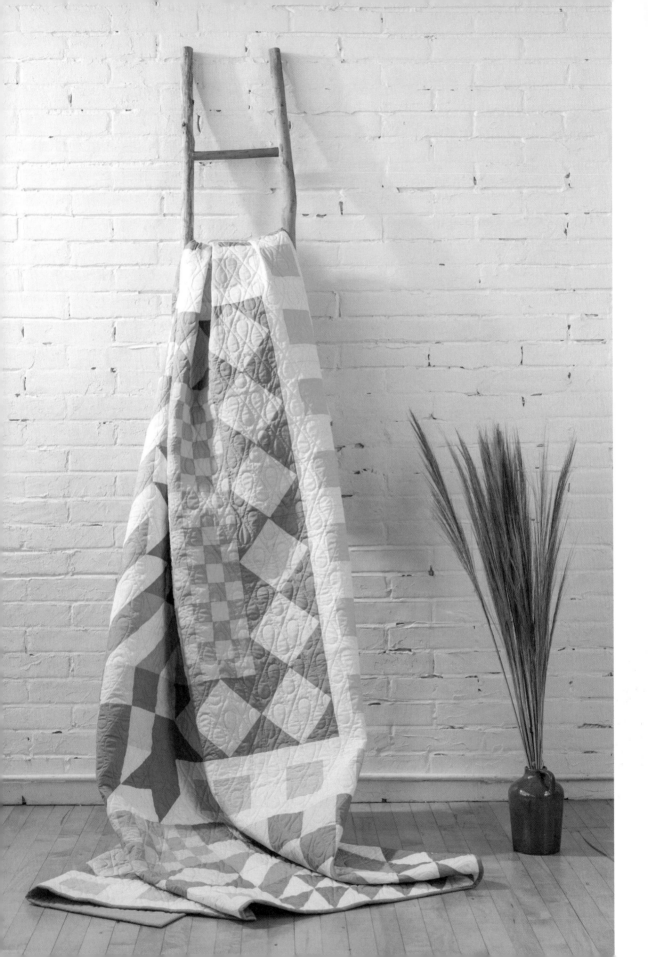

Case Studies & Sample Patterns

How does this process work in real life, beyond these design exercises and step-by-step instructions? On the following pages I've captured how I approached using the blocks and quilt top layouts to create the samples photographed throughout the book. You'll quickly notice that the process truly is a mix of playing with the blocks and experimenting with different ideas! If you'd like to recreate any of these, I've included my own worksheets for you to follow (or perhaps use them as a jumping-off point for your own designs)!

Bullseye

Quadrant

Patches

Log Cabin

Offset

Stripes

Sampler

Patches: Baby Size

FABRIC REQUIREMENTS

COLOR/FABRIC NAME	YARDS
Chambray	1 yd.
Teal	⅓ yd.
Pink	¼ yd.
Gold	¼ yd.
Light Blue	⅓ yd.
Lilac	⅓ yd.
Backing	1¾ yds.
Binding	⅜ yd.

FINISHED QUILT SIZE: 32" X 48"

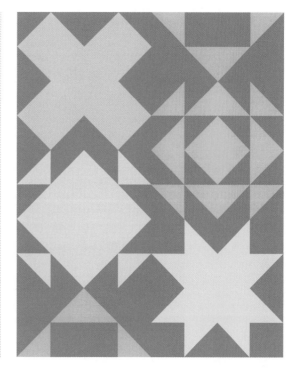

Notes

When I was playing around with different ideas for the four-block center of the Bullseye layout, it dawned on me that it would be so cool to create a patchwork of all the center blocks layouts! And so, "Patches" was born.

For my sample quilt, I wanted to use combinations that had a center point, so I focused on the blocks that weren't symmetrical. And from there I narrowed it down to those that looked vaguely star-like. I swapped them around until I felt the stars were balanced.

Then I thought, how cool would it look if it was offset and not on a four-patch grid? So, I nixed one of the patches and split another one in half, adding one half to the bottom of one side and one half to the top of the other side.

And in order to highlight the center "star" patterns, I used the same color as one of the fabrics in each block to create a sense of a "background" fabric. Then I dipped into my stash to find some fun colors to play with for the "stars."

Another option is to use only two "patches" repeating to create a cool checkerboard effect. Or, on the flip side, try to not have any repeating patches and see how many different patches you can come up with!

FABRIC & CUTTING PLANNER (COMBINED VERSION)

BLOCK	ID	QTY.	FABRIC	COLOR/FABRIC NAME	CUTTING INSTRUCTIONS
BLOCK A	14	(4)	FABRIC 1	Chambray	7¼" x WOF (1): 7¼" x 7¼" (4)
			FABRIC 2	Pink	7¼" x WOF (1): 7¼" x 7¼" (4)
BLOCK B	21	(4)	FABRIC 1	Chambray	5" x WOF (1): 5" x 5" (6)
			FABRIC 2	Teal	5" x WOF (1): 5" x 5" (6) 4½" x WOF (1): 4½" x 4½" (4)
BLOCK C	22	(4)	FABRIC 1	Chambray	5" x WOF (1): 5" x 5" (4); 4½" x 4½" (4)
			FABRIC 2	Light Blue	5" x WOF (1): 5" x 5" (4); 4½" x 4½" (4)
BLOCK D	20	(4)	FABRIC 1	Chambray	5" x WOF (1): 5" x 5" (6)
			FABRIC 2	Lilac	5" x WOF (1): 5" x 5" (6) 4½" x WOF (1): 4½" x 4½" (4)
BLOCK E	N/A	(0)	FABRIC 1		
			FABRIC 2		
BLOCK F	18	(4)	FABRIC 1	Chambray	5" x WOF (1): 5" x 5" (4) 4½ x WOF (1): 4½" x 4½" (8)
			FABRIC 2	Gold	5" x WOF (1): 5" x 5" (4)
BLOCK G	N/A	(0)	FABRIC 1		
			FABRIC 2		
CORNERS	N/A	(0)	FABRIC 1		
			FABRIC 2		
CENTER	N/A	(0)	FABRIC 1		
			FABRIC 2		

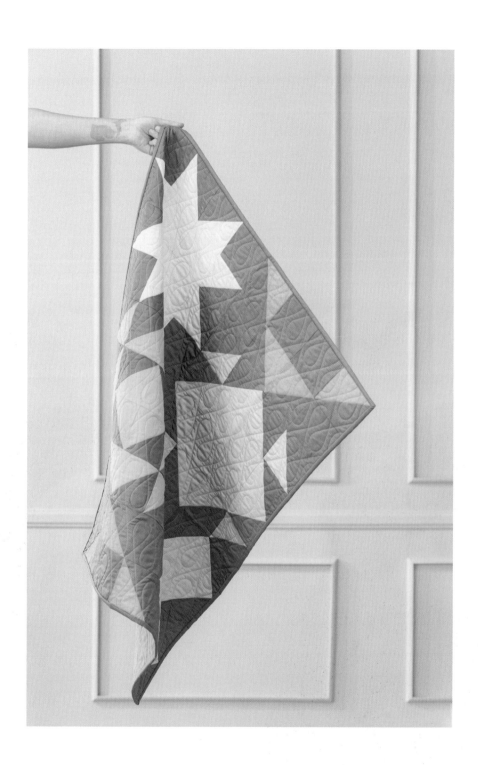

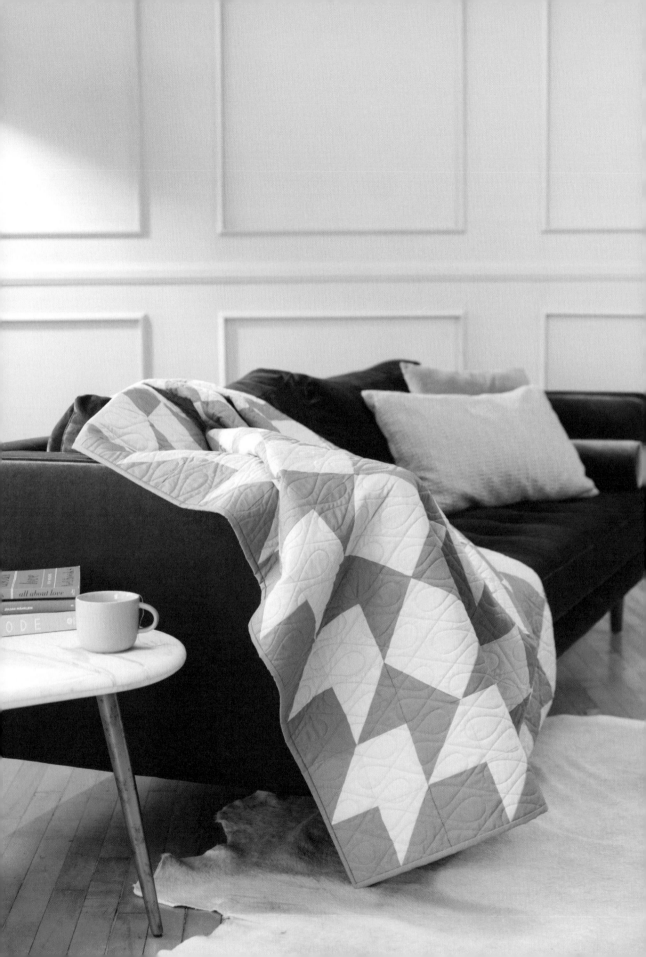

Bullseye: Square Throw Size

FABRIC REQUIREMENTS

COLOR/FABRIC NAME	YARDS
Dark Green	2½ yds.
Light Green	2½ yds.
Backing	4 yds.
Binding	½ yd.

FINISHED QUILT SIZE: 64" X 64"

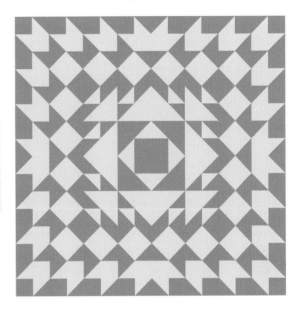

Notes

The Bullseye pattern is a great opportunity to use asymmetrical blocks to create a starburst effect. Rotating some of the blocks so that the design is always "pointing" toward the center allows you to create a design that bursts out from the center!

For the center of this sample quilt top, I used a four-patch to create a square center focal point. Then I encircled the center using blocks that almost repeated the center four-patch (it's almost like a giant square-within-a-diamond-within-a-square-within-a-diamond). I then decided to echo the center diamond by adding a layer of simple diamonds. And then, to top it all off, I wanted to use a block that literally pointed toward the center, so that's what I did!

In order to emphasize the patterns and shapes the different blocks create together, I decided to use only two colors. One way to take this layout to the next level would be to invert the colors on half of the quilt or create an ombre effect using different shades of the same color, starting with the darkest in the center and lightest toward the edges (or vice versa).

FABRIC & CUTTING PLANNER (COMBINED VERSION)

BLOCK	ID	QTY.	FABRIC	COLOR/FABRIC NAME	CUTTING INSTRUCTIONS
BLOCK A	N/A	(0)	FABRIC 1		
			FABRIC 2		
BLOCK B	N/A	(0)	FABRIC 1		
			FABRIC 2		
BLOCK C	N/A	(0)	FABRIC 1		
			FABRIC 2		
BLOCK D	22	(28)	FABRIC 1	Dark Green	5" x WOF (3): 5" x 5" (8) 5" x WOF (1): 5" x 5" (4); 4½" x 4½" (1) 4½" x WOF (3): 4½" x 4½" (9)
			FABRIC 2	Light Green	5" x WOF (3): 5" x 5" (8) 5" x WOF (1): 5" x 5" (4); 4½" x 4½" (1) 4½" x WOF (3): 4½" x 4½" (9)
BLOCK E	26	(20)	FABRIC 1	Dark Green	4⅞" x WOF (5): 4⅞" x 4⅞" (8)
			FABRIC 2	Light Green	9¼" x WOF (2): 9¼" x 9¼" (4) 9¼" x WOF (1): 9¼" x 9¼" (2)
BLOCK F	20	(12)	FABRIC 1	Dark Green	5" x WOF (2): 5" x 5" (8) 5" x WOF (1): 5" x 5" (2)
			FABRIC 2	Light Green	5" x WOF (2): 5" x 5" (8) 5" x WOF (1): 5" x 5" (2); 4½" x 4½" (3) 4½" x WOF (1): 4½" x 4½" (9)
BLOCK G	18	(4)	FABRIC 1	Dark Green	5" x WOF (1): 5" x 5" (4) 4½ x WOF (1): 4½" x 4½" (8)
			FABRIC 2	Light Green	5" x WOF (1): 5" x 5" (4)
CORNERS	N/A	(0)	FABRIC 1		
			FABRIC 2		
CENTER	N/A	(0)	FABRIC 1		
			FABRIC 2		

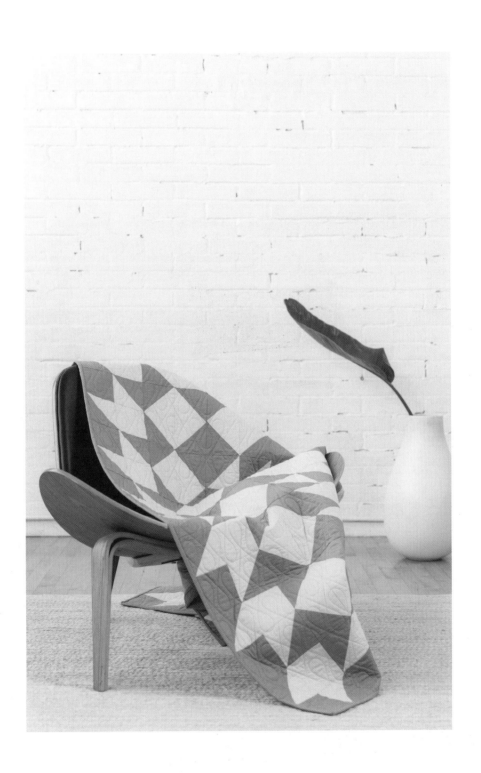

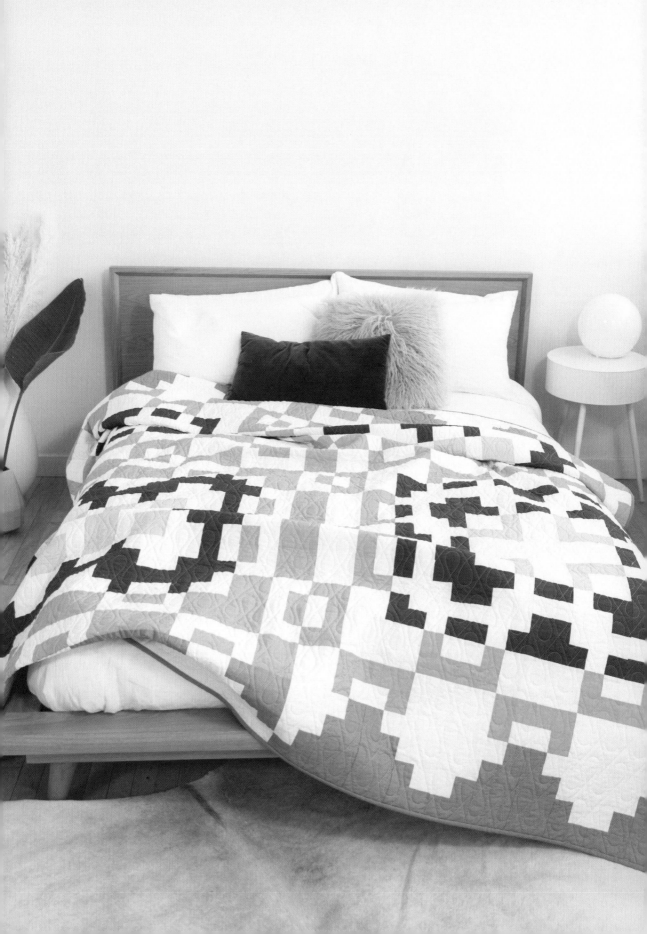

Quadrants: Queen Size

FABRIC REQUIREMENTS

COLOR/FABRIC NAME	YARDS
Lilac	¾ yd.
Forest Green	1¾ yds.
Yellow	2½ yds.
Light Green	1 yd.
White	5¾ yds.
Backing	10 yds.
Binding	⅞ yd.

FINISHED QUILT SIZE: 96" X 112"

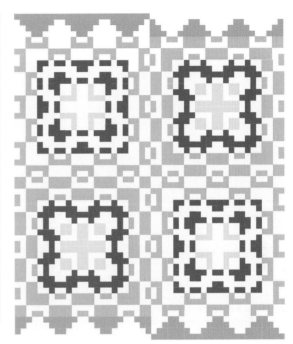

Notes

I sped through the prep steps of this quilt: I knew I wanted to make a queen-size quilt and I knew I wanted to use the quadrant design. Determine quilt size? Check. Choose a quilt top layout? Check.

When it came to which blocks to work with, I decided to challenge myself to only use L-shaped blocks and play with how they could "connect" to each other. As I rotated them about and swapped around which would be Block A and which would be B, it became a puzzle to figure out how to have them connect with each other through their Fabric 2.

And as I continued to play with the blocks, I found myself returning again and again to one quadrant layout using three of the blocks. So, I explored the idea more by inverting the Fabric 1 and Fabric 2. I was having such fun alternating the two layouts

that I decided to lean into it and override the original layout: instead of using seven different blocks, I would use only four.

As I played more and more with this pared down four-block design, I decided that two different quadrants would be the inverse of each other. And to underline this relationship between the two quadrants, I decided to use one color in all my blocks (white).

I love how the inversion played out across the quilt top, though I also think this would look killer in just two colors. Maybe I'll simply have to make a second one!

FABRIC & CUTTING PLANNER (COMBINED VERSION)

BLOCK	ID	QTY.	FABRIC	COLOR/FABRIC NAME	CUTTING INSTRUCTIONS
BLOCK A	10	(12)	FABRIC 1	Light Green	4½" x WOF (1): 4½" x 4½" (9); 4½" x WOF (1): 4½" x 4½" (3); 4½" x 2½" (8) 4½" x WOF (1): 4½" x 2½" (16) 2½" x WOF (1): 2½" x 2½" (16) 2½" x WOF (1): 2½" x 2½" (8)
			FABRIC 2	White	4½" x WOF (1): 4½" x 4½" (9) 4½" x WOF (1): 4½" x 4½" (3); 2½" x 2½" (8) 2½" x WOF (1): 2½" x 2½" (16)
BLOCK B	09	(40)	FABRIC 1	Yellow	4½" x WOF (8): 4½" x 4½" (9) 4½" x WOF (1): 4½" x 4½" (8) 2½" x WOF (5): 2½" x 2½" (16)
			FABRIC 2	White	2½" x WOF (13): 2½" x 4½" (6); 2½" x 2½" (6) 2½" x WOF (1): 2½" x 4½" (2); 2½" x 2½" (2)
BLOCK C	12	(24)	FABRIC 1	Forest	2½" x WOF (5): 2½" x 4½" (9) 2½" x WOF (1): 2½" x 4½" (3) 2½" x WOF (6): 2½" x 2½" (16)
			FABRIC 2	White	2½" x WOF (5): 2½" x 4½" (9) 2½" x WOF (1): 2½" x 4½" (3) 2½" x WOF (6): 2½" x 2½" (16)
BLOCK D	13	(8)	FABRIC 1	Lilac	8½" x WOF (1): 8½" x 2½" (8); 6½" x 2½" (8) 4½" x WOF (1): 4½" x 4½" (8)
			FABRIC 2	White	6½" x WOF (1): 2½" x 6½" (8); 2½" x 4½" (8)
BLOCK E	09	(40)	FABRIC 1	White	4½" x WOF (8): 4½" x 4½" (9) 4½" x WOF (1): 4½" x 4½" (8) 2½" x WOF (5): 2½" x 2½" (16)
			FABRIC 2	Yellow	2½" x WOF (13): 2½" x 4½" (6); 2½" x 2½" (6) 2½" x WOF (1): 2½" x 4½" (2); 2½" x 2½" (2)
BLOCK F	12	(24)	FABRIC 1	White	2½" x WOF (5): 2½" x 4½" (9) 2½" x WOF (1): 2½" x 4½" (3) 2½" x WOF (6): 2½" x 2½" (16)
			FABRIC 2	Forest	2½" x WOF (5): 2½" x 4½" (9) 2½" x WOF (1): 2½" x 4½" (3) 2½" x WOF (6): 2½" x 2½" (16)

BLOCK	ID	QTY.	FABRIC	COLOR/FABRIC NAME	CUTTING INSTRUCTIONS
BLOCK G	13	(8)	FABRIC 1	White	8½" x WOF (1): 8½" x 2½" (8); 6½" x 2½" (8) 4½" x WOF (1): 4½" x 4½" (8)
			FABRIC 2	Lilac	6½" x WOF (1): 2½" x 6½" (8); 2½" x 4½" (8)
EXTRA	10	(12)	FABRIC 1	White	4½" x WOF (1): 4½" x 4½" (9); 4½" x WOF (1): 4½" x 4½" (3); 4½" x 2½" (8) 4½" x WOF (1): 4½" x 2½" (16) 2½" x WOF (1): 2½" x 2½" (16) 2½" x WOF (1): 2½" x 2½" (8)
			FABRIC 2	Light Green	4½" x WOF (1): 4½" x 4½" (9) 4½" x WOF (1): 4½" x 4½" (3); 2½" x 2½" (8) 2½" x WOF (1): 2½" x 2½" (16)

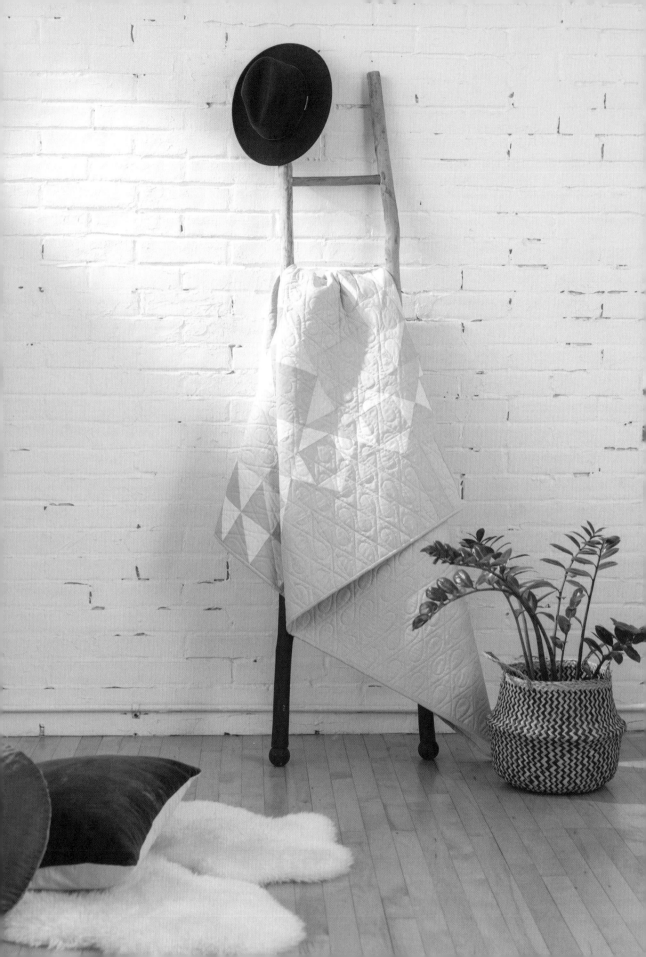

Stripes: Square Throw Size

FABRIC REQUIREMENTS

FINISHED QUILT SIZE: 64" X 64"

COLOR/FABRIC NAME	YARDS
Peach	1 yd.
Orange	1 yds.
Light Pink	2 yds.
Lilac	1 yd.
Icy Mint	½ yd.
Backing	4 yds.
Binding	½ yd.

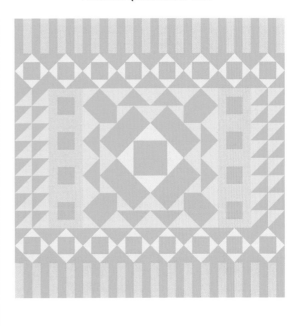

Notes

One of my favorite things about the square throw size of the Stripes layout is the equal number of columns and rows surrounding the two-block-deep center. When flipping through the blocks, I knew I wanted to use the stripes as the top and bottom border (it reminds me of the fringe tassels on a rug). And I also wanted to use the square-in-square block, as it reminded me of columns (fitting for the vertical stripe). For the center blocks, I used one of the asymmetrical blocks to create a larger four-block center pattern and realized that the four center blocks created a larger version of one of the diamond blocks, so I added in the smaller version to the other two rows.

For the outer ring of the center, I loved how the flying geese pointed out from the center, especially when balanced with a different corner block that pointed inward (this just came from me playing with different blocks in all sorts of different combos).

To balance the repeating stripes of the top and bottom rows, I wanted to use another repeating motif, but I decided to use triangles instead. And just to keep things interesting, I flipped the orientation of the blocks, so the quilt isn't a perfect mirror image.

When it came time to pull fabrics for this quilt, I wanted to challenge myself to use purple and orange, colors I rarely use. Using those two as my "must-haves," I layered in two different shades of peach: one very light and one medium tone. And for an unexpected twist, I threw in a bright turquoise for fun in the center and the mini center blocks.

BLOCK	ID	QTY.	FABRIC	COLOR/FABRIC NAME	CUTTING INSTRUCTIONS
BLOCK A	01	(16)	FABRIC 1	Lilac	2½" x WOF (8): 2½" x 8½" (4)
			FABRIC 2	Light Pink	2½" x WOF (8): 2½" x 8½" (4)
BLOCK B	30	(16)	FABRIC 1	Light Pink	4½" x WOF (1): 4½" x 4½" (9) 4½" x WOF (1): 4½" x 4½" (7) 2⅞" x WOF (4): 2⅞" x 2⅞" (14) 2⅞" x WOF (1): 2⅞" x 2⅞" (8) 2½" x WOF (4): 2½" x 2½" (16)
			FABRIC 2	Icy Mint	5¼" x WOF (2): 5¼" x 5¼" (8)
BLOCK C	N/A	(0)	FABRIC 1	N/A	
			FABRIC 2	N/A	
BLOCK D	14	(8)	FABRIC 1	Peach	7¼" x WOF (1): 7¼" x 7¼" (5) 7¼" x WOF (1): 7¼" x 7¼" (3)
			FABRIC 2	Orange	7¼" x WOF (1): 7¼" x 7¼" (5) 7¼" x WOF (1): 7¼" x 7¼" (3)
BLOCK E	04	(8)	FABRIC 1	Lilac	2½" x WOF (5): 2½" x 4½" (3); 2½" x 8½" (3) 2½" x WOF (1): 2½" x 4½" (1); 2½" x 8½" (1)
			FABRIC 2	Light Pink	4½" x WOF (1): 4½" x 4½" (8)
BLOCK F	25	(8)	FABRIC 1	Peach	4⅞" x WOF (2): 4⅞" x 4⅞" (8)
			FABRIC 2	Yellow	9¼" x WOF (1): 9¼" x 9¼" (4)
BLOCK G	18	(4)	FABRIC 1	Light Pink	5" x WOF (1): 5" x 5" (4) 4½" x WOF (1): 4½" x 4½" (8)
			FABRIC 2	Icy Mint	5" x WOF (1): 5" x 5" (4)
CORNERS*	21	(4)	FABRIC 1	Peach	5" x WOF (1): 5" x 5" (6)
			FABRIC 2	Orange	5" x WOF (1): 5" x 5" (6) 4½" x WOF (1): 4½" x 4½" (4)
CENTER*	N/A	(0)	FABRIC 1		
			FABRIC 2		

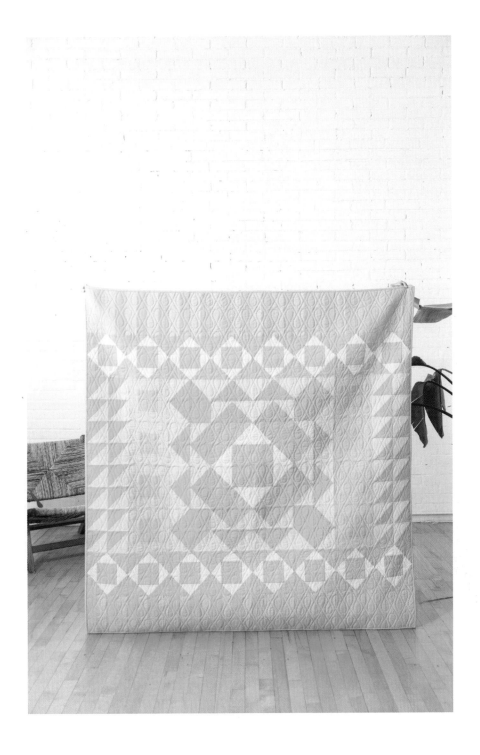

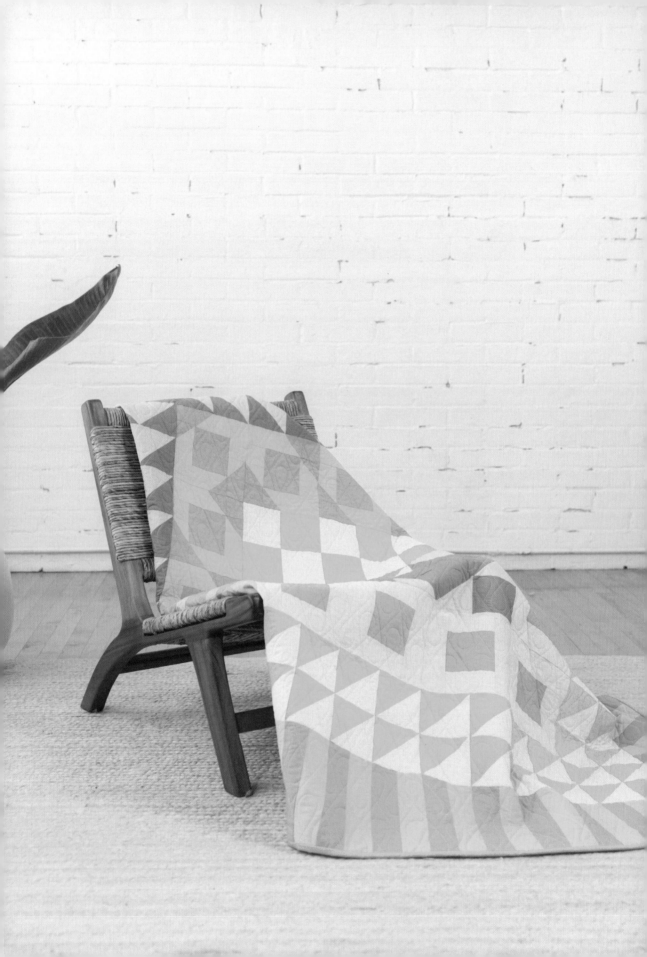

Log Cabin: Square Throw Size

FABRIC REQUIREMENTS

FINISHED QUILT SIZE: 64" X 64"

COLOR/FABRIC NAME	YARDS
Dark Green	¾ yd.
Medium Green	¾ yd.
Dark Pink	1½ yds.
Medium Pink	1⅛ yd.
Peach	½ yd.
Orange	1 yd.
Blush Pink	1 yd.
Backing	4 yds.
Binding	½ yd.

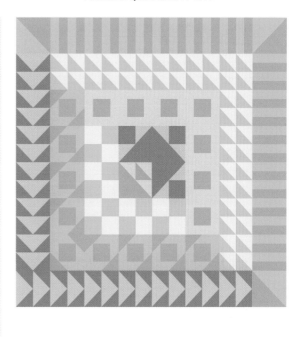

Notes

Years ago, I saw a set of teacups that were each made up of two halves of two different teacups. I immediately fell in love with the energy that came from where the two different patterns met in the middle and how nothing quite lined up. I've always loved that similar uneven aspect of the log cabin block. When picking which blocks to use for this giant log cabin, it almost felt like I was creating my own fabric designs for a giant log cabin layout!

This quilt top started from the outside. I knew I wanted to use big HSTs in the corners alongside a simple stripe block. And I knew I wanted to balance out the stripes with flying geese on the opposite side. From there, I looked for blocks that had similar elements. I loved how the four HSTs played against the

stripes and echoed the diagonals of the flying geese. I also knew I wanted to use the four-patch block as a balance to the four HSTs.

To break up all the 4" grids, I added the square-within-a-square block and then one of the diamond blocks with a square in the center to counterbalance the simplicity of the square-in-a-square. And for the center, I decided not to use the same Block B stripes; instead, I wanted a four-block patch that would be "interrupted" by Block D. So, I looked through all the asymmetrical blocks with HSTs and settled on this combo.

FABRIC & CUTTING PLANNER (COMBINED VERSION)

BLOCK	ID	QTY.	FABRIC	COLOR/FABRIC NAME	CUTTING INSTRUCTIONS
BLOCK A	14	(11)	FABRIC 1	Orange	7¼" x WOF (2): 7¼" x 7¼" (5) 7¼" x WOF (1): 7¼" x 7¼" (1)
			FABRIC 2	Blush Pink	7¼" x WOF (2): 7¼" x 7¼" (5) 7¼" x WOF (1): 7¼" x 7¼" (1)
BLOCK B	01	(12)	FABRIC 1	Dark Pink	2½" x WOF (6): 2½" x 8½" (4)
			FABRIC 2	Medium Pink	2½" x WOF (6): 2½" x 8½" (4)
BLOCK C	04	(7)	FABRIC 1	Peach	2½" x WOF (4): 2½" x 4½" (3); 2½" x 8½" (3) 2½" x WOF (1): 2½" x 4½" (2); 2½" x 8½" (2)
			FABRIC 2	Dark Pink	4½" x WOF (1): 4½" x 4½" (7)
BLOCK D	20	(1)	FABRIC 1	Peach	5" x WOF (1): 5" x 5" (2); 4½" x 4½" (1)
			FABRIC 2	Dark Pink	5" x WOF (1): 5" x 5" (2)
BLOCK E	25	(13)	FABRIC 1	Dark Green	4⅞" x WOF (3): 4⅞" x 4⅞" (8) 4⅞" x WOF (1): 4⅞" x 4⅞" (4)
			FABRIC 2	Medium Green	9¼" x WOF (1): 9¼" x 9¼" (4) 9¼" x WOF (1): 9¼" x 9¼" (3)
BLOCK F	23	(9)	FABRIC 1	Dark Pink	4½" x WOF (1): 4½" x 4½" (9) 4¼" x WOF (1): 4¼" x 4¼" (9) 2½" x WOF (1): 2½" x 2½" (16) 2½" x WOF (1): 2½" x 2½" (2)
			FABRIC 2	Medium Pink	4¼" x WOF (1): 4¼" x 4¼" (9) 2½" x WOF (3): 2½" x 4½" (6); 2½" x 2½" (6)
BLOCK G	02	(5)	FABRIC 1	Blush Pink	4½" x WOF (1): 4½" x 4½" (9) 4½" x WOF (1): 4½" x 4½" (1)
			FABRIC 2	Orange	4½" x WOF (1): 4½" x 4½" (9) 4½" x WOF (1): 4½" x 4½" (1)
CORNERS*	24	(3)	FABRIC 1	Dark Pink	9" x WOF (1): 9" x 9" (2)
			FABRIC 2	Medium Pink	9" x WOF (1): 9" x 9" (2)
CENTER*	18	(3)	FABRIC 1	Medium Green	5 x 5" x WOF (1): 5" x 5" (3); 4½" x 4½" (6)
			FABRIC 2	Dark Green	5" x WOF (1): 5" x 5" (3)

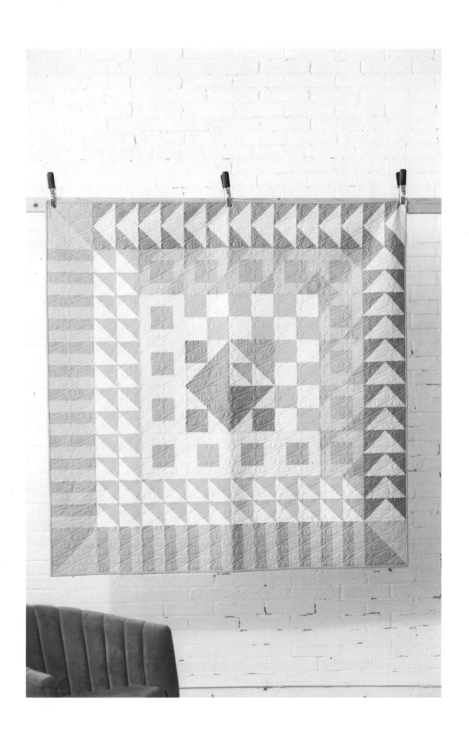

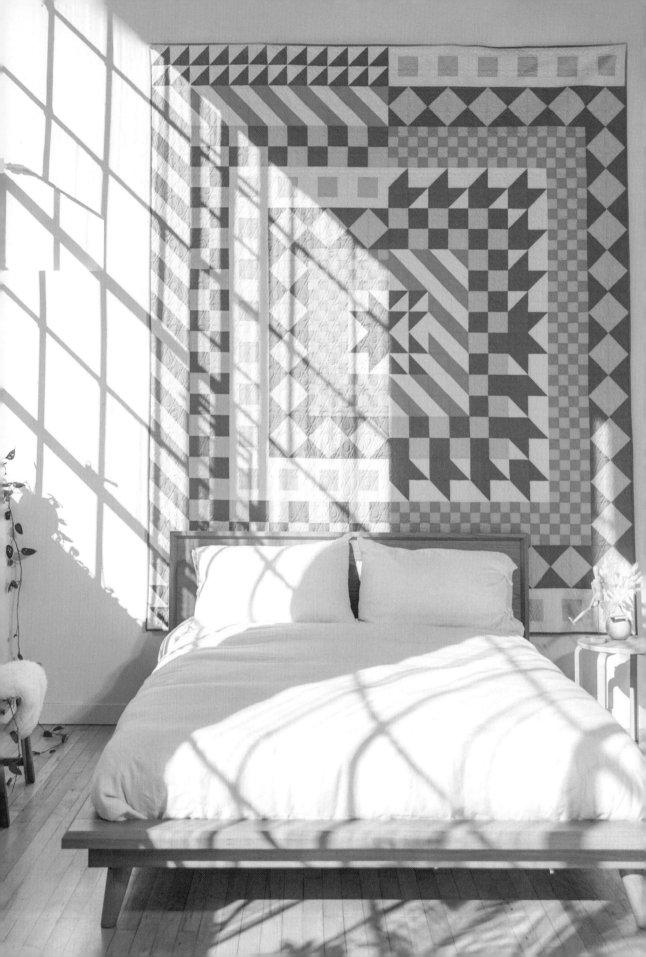

Offset: Queen Size

FABRIC REQUIREMENTS

COLOR/FABRIC NAME	YARDS
Mint Green	¾ yd.
Dark Green	3¼ yds.
Medium Green	2 yds.
Yellow	2¼ yds.
Blush Pink	3¼ yds.
Light Pink	1¼ yds.
Backing	10 yds.
Binding	⅞ yd.

FINISHED QUILT SIZE: 96" X 112"

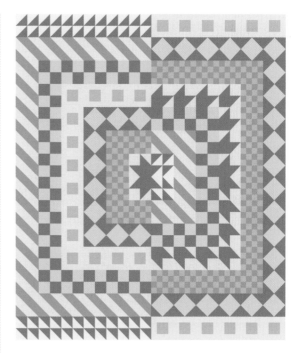

Notes

I made this quilt with a fabric color scheme already in mind: I knew I wanted lots of greens, a touch of yellow-gold, and a pop of pink! I also decided I wanted to use only blocks that I love to make (hello, strip piecing!)—queen-size quilts are large, so why not love every minute of making them?

I started with the two checkerboard blocks and used one for Block C and one for Block F so they created a checkerboard ring. Then I identified my square-in-a-square blocks and my diamond-in-a-square blocks as blocks I definitely wanted to use next. I played with those two blocks, figuring out where to put them to make sure that they worked with all the checkerboards. Once I had that balanced, I added in some triangles and diagonal lines. This was a bit of experimentation, swapping them in and out and round about until I liked how they looked.

I wasn't trying to highlight how the different layers played together in this quilt top, so as I played with my fabric colors, my main rule of thumb was trying to have one light color and one dark in each block (I broke my own rule for the tiny checkerboard!). At this scale, I found working with my colors on the computer to be extremely helpful! If you'd like to swap out colors and try different combos, make sure to check out the downloadable templates of all the blocks in the resources section.

FABRIC & CUTTING PLANNER (COMBINED VERSION)

BLOCK	ID	QTY.	FABRIC	COLOR/FABRIC NAME	CUTTING INSTRUCTIONS
BLOCK A	15	(14)	FABRIC 1	Mint Green	7¼" x WOF (2): 7¼" x 7¼" (5) 7¼" x WOF (1): 7¼" x 7¼" (4)
			FABRIC 2	Dark Green	7¼" x WOF (2): 7¼" x 7¼" (5) 7¼" x WOF (1): 7¼" x 7¼" (4)
BLOCK B	15	(28)	FABRIC 1	Yellow	7¼" x WOF (5): 7¼" x 7¼" (5) 7¼" x WOF (1): 7¼" x 7¼" (3)
			FABRIC 2	Blush Pink	7¼" x WOF (5): 7¼" x 7¼" (5) 7¼" x WOF (1): 7¼" x 7¼" (3)
BLOCK C	02	(28)	FABRIC 1	Medium Green	4½" x WOF (6): 4½" x 4½" (9) 4½" x WOF (1): 4½" x 4½" (2)
			FABRIC 2	Dark Green	4½" x WOF (6): 4½" x 4½" (9) 4½" x WOF (1): 4½" x 4½" (2)
BLOCK D	04	(26)	FABRIC 1	Blush Pink	2½" x WOF (17): 2½" x 4½" (3); 2½" x 8½" (3) 2½" x WOF (1): 2½" x 4½" (1); 2½" x 8½" (1)
			FABRIC 2	Light Pink	4½" x WOF (2): 4½" x 4½" (9) 4½" x WOF (1): 4½" x 4½" (8)
BLOCK E	26	(32)	FABRIC 1	Dark Green	4⅞" x WOF (8): 4⅞" x 4⅞" (8)
			FABRIC 2	Medium Green	9¼" x WOF (4): 9¼" x 9¼" (4)
BLOCK F	03	(24)	FABRIC 1	Yellow	2½" x WOF (12): 2½" x 2½" (16)
			FABRIC 2	Light Pink	2½" x WOF (12): 2½" x 2½" (16)
BLOCK G	22	(16)	FABRIC 1	Blush Pink	5" x WOF (2): 5" x 5" (8) 4½" x WOF (1): 4½" x 4½" (9) 4½" x WOF (1): 4½" x 4½" (7)
			FABRIC 2	Dark Green	5" x WOF (2): 5" x 5" (8) 4½" x WOF (1): 4½" x 4½" (9) 4½" x WOF (1): 4½" x 4½" (7)
CORNERS*	N/A	(0)	FABRIC 1		
			FABRIC 2		
CENTER*	N/A	(0)	FABRIC 1		
			FABRIC 2		

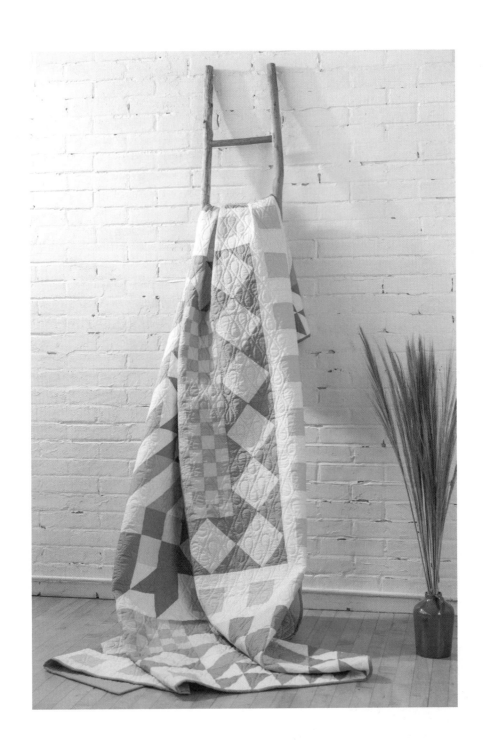

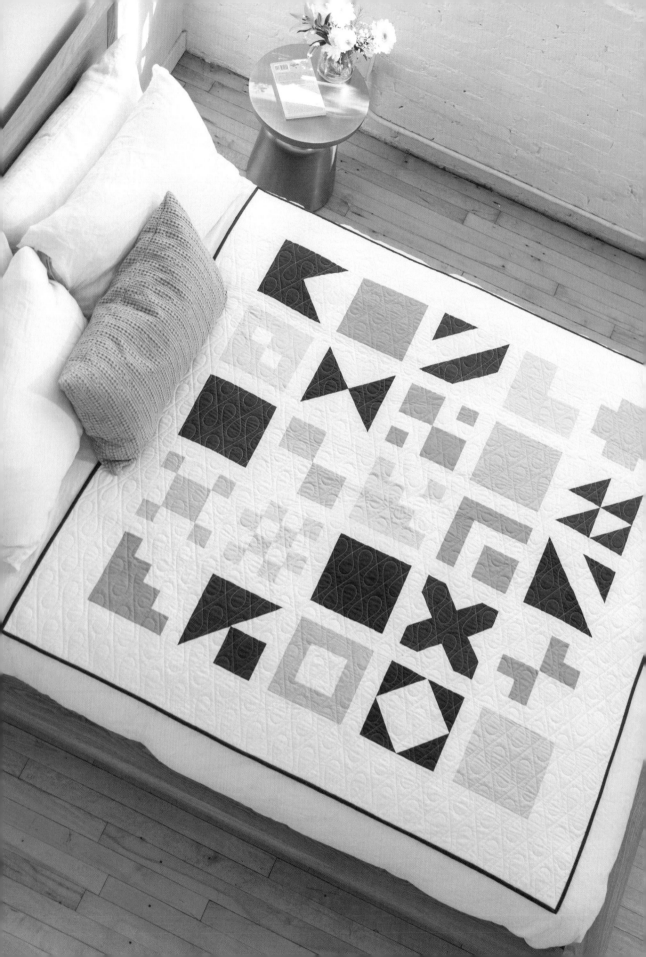

Sampler: Square Throw Size

FABRIC REQUIREMENTS

COLOR/FABRIC NAME	YARDS
Lilac	½ yd.
Burgundy	½ yd.
Yellow	½ yd.
Mint Green	½ yd.
Forest Green	½ yd.
Background	2½ yds.
Backing	4 yds.
Binding	½ yd.

FINISHED QUILT SIZE: 60" X 60"

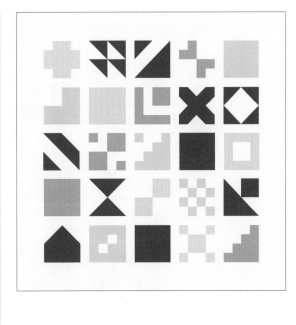

Notes

For well over a year, I had a sampler-style sketch taped on the wall behind my desk. Every block was different, but each was a simple, approachable design (sound familiar?). I don't know why I never made it, but every so often I would find myself looking up and one of the blocks would catch my eye and I'd think, "that'd be the cool basis for a patchwork motif," and I'd run with the idea.

While most of the quilt top layouts in this book support and encourage thinking about how the blocks work together, I also wanted to include a nod to this original sampler idea since its blocks provided the backbone for this book. For my sampler, I picked my blocks somewhat haphazardly: I aimed to pick four blocks from each grouping, plus I also added five solid 8½" color blocks (because, why not?).

Making the blocks one by one was a fun way to slow the process down. I was able to spend time with each design, without feeling the need to try to make things more efficient—though that didn't stop me from daydreaming that this would be an awesome quilt top with a scrappy assortment of fabrics . . . or with wider or narrower sashing . . . or with just a single row of blocks . . . or maybe a column . . . or create larger blocks out of four-blocks (like Patches) . . . or just swap out different blocks using this classic layout provided!

Sampler Layout

The Sampler layout follows a different format than the other quilt tops, more like a traditional pattern. I used a selection of fabric scraps I had lying about to make the following blocks. Head to page 24 to find the sashing and binding cutting instructions.

ROW	BLOCKS				
1	Block 05	Block 14	Block 19	Block 09	8½" Square
2	Block 07	8½" Square	Block 13	Block 29	Block 26
3	Block 15	Block 09	Block 11	8½" Square	Block 04
4	8½" Square	Block 27	Block 02	Block 03	Block 18
5	Block 28	Block 08	8½" Square	Block 06	Block 10

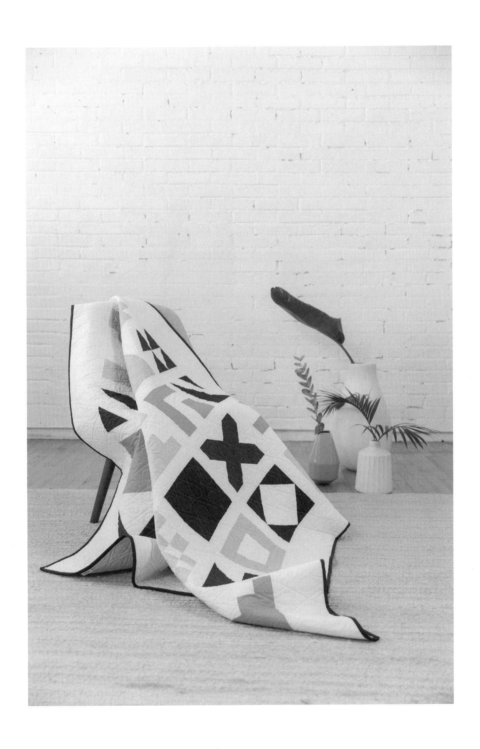

Quilting Resources & Further Reading

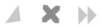

One quilt book can't cover all the things, and this one is no exception! But once you've tackled the design of your quilt top and constructed your quilt top, you might need a refresher of what's next. For all finishing instructions, I have step-by-step how-tos on broadclothstudio.com, including:

• Marking a quilting design

• Preparing the backing fabric

• Basting the layers of the quilt

• Quilting by hand

• Quilting by machine

• Binding the quilt

• Caring for your quilts (cleaning and storing)

• Displaying/hanging your quilts

For even further reading, here are some of my favorite books about quilting:

• Soup-to-nuts how to make a quilt (this is the book I learned from): *The New Sampler Quilt* by Diana Leone

• Quilting on your domestic machine: *WALK: Master Machine Quilting with Your Walking Foot* by Jacquie Gering

• Fabric and color selection: *Color Harmony for Quilts* by Weeks Ringle and Bill Kerr

• Materials and tools suggestions (plus basic how-tos): *Last-Minute Patchwork + Quilted Gifts* by Joelle Hoverson

• Design choices, from fabric, pattern, through to the quilting: *Savor Each Stitch* by Carolyn Friedlander

Appendix

Design Worksheets
(and Links to Printable Digital Versions)

On the following pages you'll find copies of the planning worksheets you need to get started. For printer-friendly copies of these, as well as the full suite of Quilt Top Layout Charts and Block Cutouts for you to print off or play with on your computer, just follow this QR code or go to www.broadclothstudio.com/bookdownloads. Any corrections or updates to this book will be available on my website via this QR code as well.

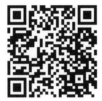

Worksheet Checklist

Here's a summary of the worksheet process, detailed in Getting Started (page 9), Determining Your Layout (page 12), and Planning Your Fabric (page 13):

1. Determine your final quilt size (baby, crib, throw, etc.).
2. Determine your quilt top layout (Patches, Bullseye, Stripes, etc.)
3. Determine which blocks will be A, B, C, D, etc. (use the Quilt Top Layout Chart Worksheets and the Block Cutouts available to download and print via the QR Code) and the colors you'll be using.
4. Fill in the Fabric Planner Worksheet to map out how many inches of each fabric you'll need.
5. Fill in the Yardage Planner Worksheet, adding up how much of each fabric from across the blocks you'll need to make your quilt top (don't forget your backing and binding fabric!).
6. Use the Cutting Planner Worksheet to consolidate all the cutting instructions in one place—or just flip back and forth to the individual reference pages in the Block Index, if that's more your style.
7. Start sewing!

Quilt Top Layout Chart Worksheets and Block Cutouts

To help you get started visualizing your quilt top layout, I've created Layout Charts as a map when laying out your blocks. I've also created digital and printout versions of all the Block Cutouts. You can access both at the QR code above.

Fabric Planner Worksheet

Use this worksheet to map out how many inches of Fabric 1 and Fabric 2 you'll need for each block. To start, fill in which block design will be Block A, B, C, etc. (refer to the Block Index) and how many of each block you will need to make (refer to the Quilt Top Layout tables). Look up the Block ID in The Block Index's Math section to determine the number of inches of each fabric you will need to make that number of blocks.

If helpful, use the Quilt Top Planner Worksheet to map out your blocks. Please note that a ¼" seam allowance has already been factored in to all cutting instructions and yardage calculations.

QUILT LAYOUT: _____

QUILT SIZE: _____

	BLOCK ID	QTY. BLOCKS TO MAKE		INCHES REQ.	COLOR/FABRIC NAME
BLOCK A		FABRIC 1			
		FABRIC 2			
BLOCK B		FABRIC 1			
		FABRIC 2			
BLOCK C		FABRIC 1			
		FABRIC 2			
BLOCK D		FABRIC 1			
		FABRIC 2			
BLOCK E		FABRIC 1			
		FABRIC 2			
BLOCK F		FABRIC 1			
		FABRIC 2			
BLOCK G		FABRIC 1			
		FABRIC 2			
EXTRA (CORNERS ETC.)		FABRIC 1			
		FABRIC 2			

Yardage Planner Worksheet

Use this worksheet to determine how many yards you will need of each fabric. Fill in the first column with the fabrics you'll be using. Transfer the Inches Req. per block from the Fabric Planner Worksheet (some of these may be zero!). Once you've captured all the information, add up your rows in the Total column. Then divide your Total column number by 36 and round up to the nearest eighth, third, or quarter yard (depending on the smallest increment your local quilt shop cuts to) to determine how much fabric you'll need to order. And, of course, don't forget your backing and binding fabric (see the reference chart at the end of this Appendix)!

Please note that a ¼" seam allowance has already been factored in to all cutting instructions and yardage calculations.

QUILT LAYOUT: _____

QUILT SIZE: _____

	COLOR/FABRIC NAME	YARDS
BACKING		
BINDING		

COLOR/ FABRIC NAME	INCHES/BLOCK								TOTAL	TOTAL/36	ROUNDED YARDS
	A	B	C	D	E	F	G	EX.			

Cutting Planner Worksheet

When I'm making my blocks, I like to flip back and forth between the individual block pages to follow the cutting instructions, but if you'd prefer to copy them into one easy-to-reference place, this is the worksheet for you!

Please note that a ¼" seam allowance has already been factored in to all cutting instructions and yardage calculations.

QUILT LAYOUT: _____

QUILT SIZE: _____

		WOF CUTS	SUB-CUTS
BLOCK A	FABRIC 1		
	FABRIC 2		
BLOCK B	FABRIC 1		
	FABRIC 2		
BLOCK C	FABRIC 1		
	FABRIC 2		
BLOCK D	FABRIC 1		
	FABRIC 2		
BLOCK E	FABRIC 1		
	FABRIC 2		
BLOCK F	FABRIC 1		
	FABRIC 2		
BLOCK G	FABRIC 1		
	FABRIC 2		
EXTRA (CORNERS ETC.)	FABRIC 1		
	FABRIC 2		

Backing & Binding Requirements

In addition to calculating your quilt top fabric requirements, don't forget to factor in the fabric you'll need for the backing and binding.

Please note that a ¼" seam allowance has already been factored in to all cutting instructions and yardage calculations.

	WIDTH	HEIGHT	BACKING	BINDING	BINDING WOF CUTS
BABY	32"	48"	1¾ yds.	⅜ yd.	2½" X WOF (5)
SQ. BABY	40"	40"	2½ yds.	⅜ yd.	2½" X WOF (5)
CRIB	40"	48"	3¼ yds.	½ yd.	2½" X WOF (6)
SQ. CRIB	48"	48"	3¼ yds.	½ yd.	2½" X WOF (6)
THROW	48"	64"	4 yds.	½ yd.	2½" X WOF (6)
SQ. THROW	64"	64"	4 yds.	½ yd.	2½" X WOF (7)
TWIN	80"	96"	8½ yds.	¾ yd.	2½" X WOF (10)
FULL/QUEEN	96"	112"	10 yds.	⅞ yd.	2½" X WOF (11)
KING	112"	112"	10 yds.	⅞ yd.	2½" X WOF (12)

Fabric Credits

I don't know about you, but whenever I'm flipping through a quilt book, I love to know what fabrics were used in the photos—I can't count the number of times I've fallen in love with a fabric in a quilt book! For anyone else like me, who wants to know the details, here are the fabrics I used in the quilts throughout the book:

All the fabrics listed below are from the Art Gallery Fabrics PURE Solids line. Thank you to Art Gallery Fabrics for supplying the majority of fabrics used in this book (the extra came from my own stash of Pure Solids).

Patches: Baby Size

Quilt Top Patchwork: Swimming Pool, Fresh Water, Icy Mint, Grapefruit, Field of Lavender, and Lemon Tart

Binding: Swimming Pool

Backing: Lemon Tart

Bullseye: Square Throw

Quilt Top Patchwork: Spruce and Light Green

Binding: Spruce

Backing: Half Spruce and half Light Green

Quadrants: Queen Size

Quilt Top Patchwork: Spruce, Lemon Tart, Evergreen, and Field of Lavender

Binding: Spruce

Backing: Lemon Tart

Stripes: Square Throw

Quilt Top Patchwork: Peach Sherbet, Summer Sun, Apricot Crepe, Field of Lavender, and Icy Mint

Binding: Field of Lavender

Backing: Field of Lavender

Offset: Queen Size

Quilt Top Patchwork: Sweet Mint, Spruce, Tender Green, Lemon Tart, Sweet Macadamia, Apricot Crepe, and Spruce

Binding: Spruce

Backing: Lemon Tart

Log Cabin: Square Throw

Quilt Top Patchwork: Spruce, Tender Green, Miami Sunset, Grapefruit, Peach Sherbet, Summer Sun, Sweet Macadamia, and Miami Sunset

Binding: Summer Sun

Backing: Half Miami Sunset and half Grapefruit

Sampler: Square Throw

Quilt Top Patchwork: Plum Preserve, Lemon Tart, Light Green, Field of Lavender, and Evergreen

Binding: Evergreen

Backing: Light Green

All the quilts were made using Quilters Dream Cotton 100% Pure Cotton Batting in their Deluxe Loft. These were all quilted on a longarm, but if I was to hand quilt, I would opt for Quilters Dream 100% Pure Cotton Batting in their Request Loft, as it's a joy to work with by hand!

Acknowledgments

I'm sure it goes without saying that a book isn't created in a vacuum, but is a team effort every step of the way. This book was no exception, and I couldn't have asked for a more wonderful team!

First off, thank you to the entire Blue Star team for taking a chance on me and my "quilt block book, but not really a quilt block book" idea (and for reigning in my love of parentheses without making it feel personal).

To Hale Productions for the gorgeous photos: you brought each of the samples to life with your creativity and put the patchwork in the spotlight. Can I convince you to move to NYC (or sign up for photography lessons?)?

Thank you to Marcela and Art Gallery Fabrics for providing the fabrics and for your enthusiastic support for what was just an elevator pitch, before I even had illustrations! By the way, my love of Lemon Tart knows no bounds.

Early on, I knew I needed to call in the professionals for the quilting (two queen-size quilts in a NYC apartment just wasn't going to happen). Valerie of Three Birds and Stitches and Katie of Modern Textiles stepped up to the plate, handling supply chain disruptions and broken sensors without batting an eye. Five stars!

Where to begin with my testers and readers? Claire: you take the cake when it comes to thoughtful, helpful feedback and eagle-eyed editing. And the fact you were game to read the manuscript twice?! What did I do to deserve you? Sarah: thank you for suggesting I observe you as you went through the design process—it was hands-down one of the most productive dinners I've ever had. Shannon: I am so glad I have you in my corner to challenge me to clean up my concepts. You're a rockstar. Courtney: who would've thought all those years ago sharing a desk that one day I'd ask you to read a quilting book and you'd say yes, even though you don't quilt?! Negronis are on me. And to the Quilt Buzz team! Thank you for testing (Anna) and cheering me on (Wendy). I got incredibly lucky with my first internet friends.

Last (but definitely not least), to my family. Tina & Fernand: thank you for never questioning why my suitcase is half quilts. Meghan: thank you for never blinking an eye about whatever my current endeavor is (even if it involves hauling sports equipment halfway around the world). Dad: your unquestioning support, plus the early introduction to spreadsheets, created this monster. Mom: thank you for encouraging me to try making everything and for still being my "phone a fiber friend" whenever something goes awry.

And, Franck, quilt holder and husband extraordinaire. I don't know what twist of fate put us in each other's path, but I'm not about to question it. JTM.

About the Author

Amanda Carye is the quilter, designer, and writer behind Broadcloth Studio as well as the co-host of the Quilt Buzz podcast. A New Englander who now calls New York home, Amanda has been quilting since middle school and sewing since forever. In 2017 she founded Broadcloth Studio as a collection of bold and modern quilt patterns. She received her BA and MBA from Dartmouth College. Beyond her sewing machine, Amanda is most likely to be found with her nose in a book, playing the viola, or out on the hiking trail.